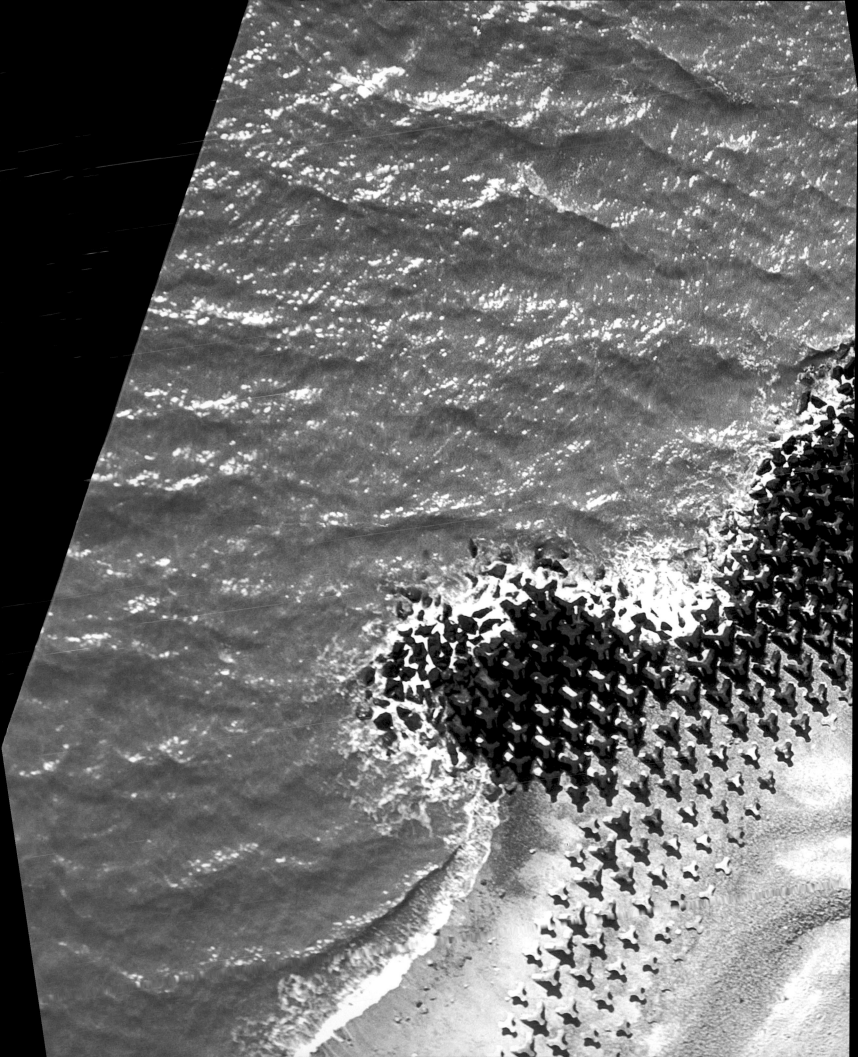

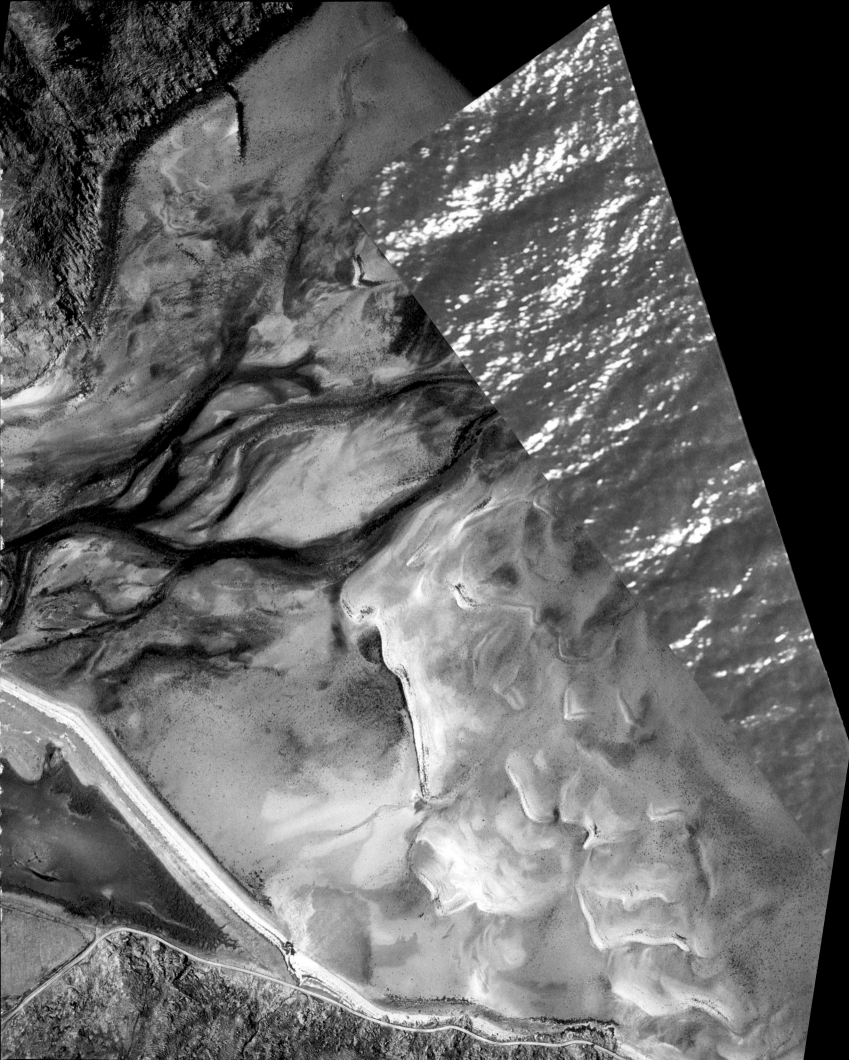

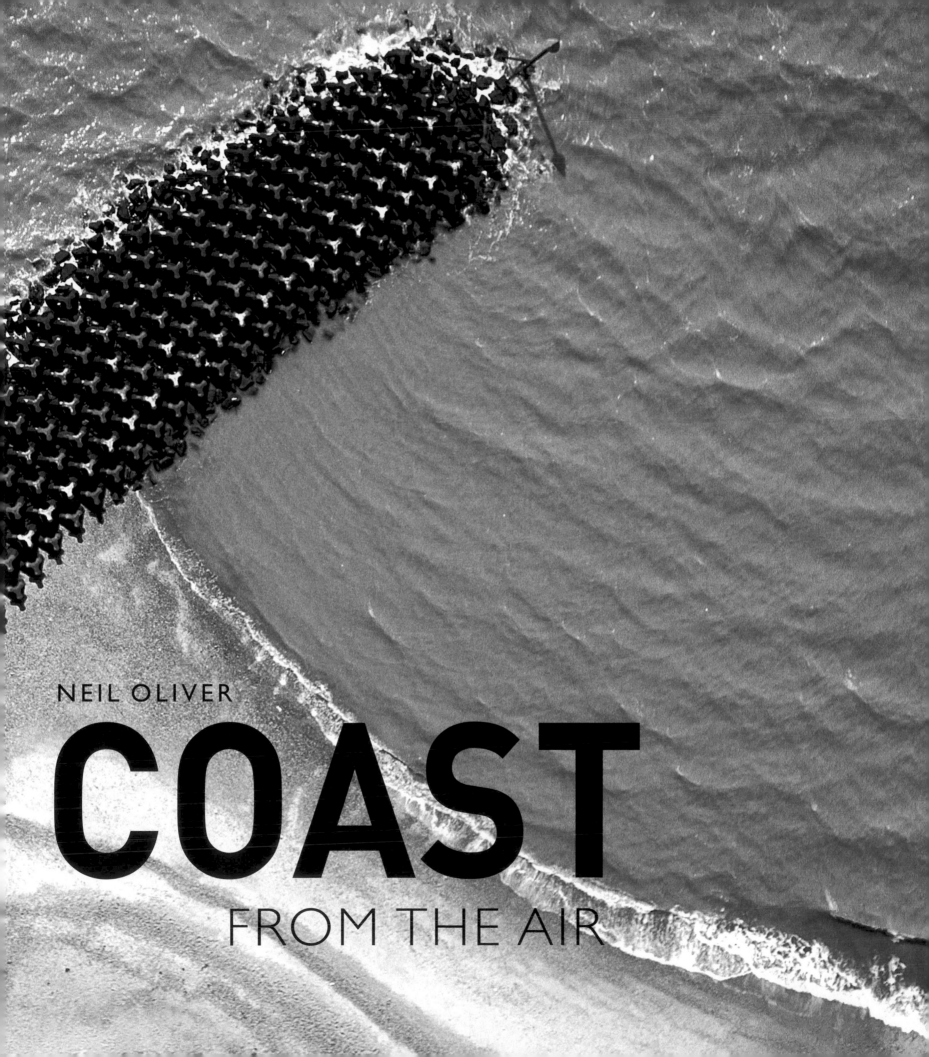

NEIL OLIVER

COAST

FROM THE AIR

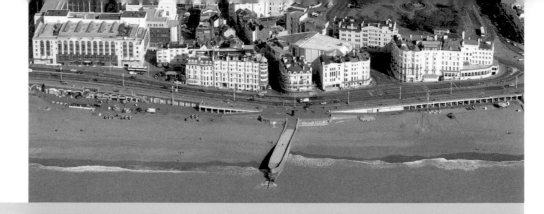

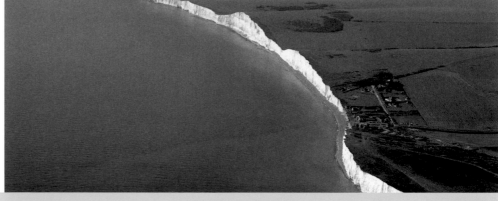

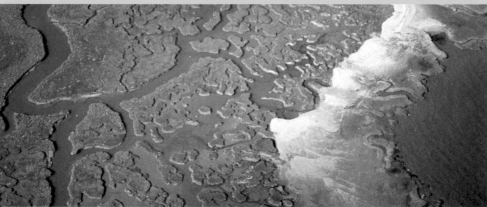

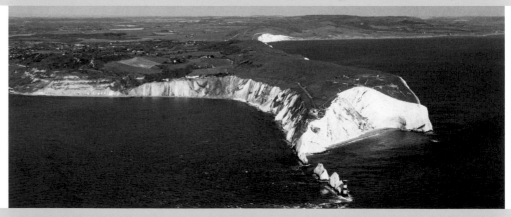

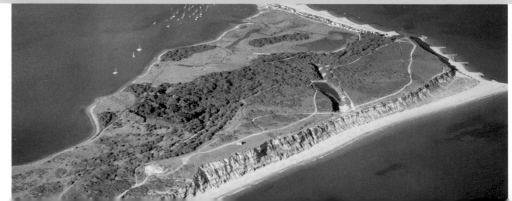

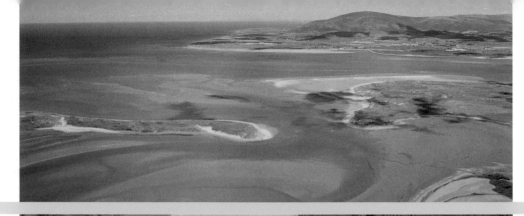

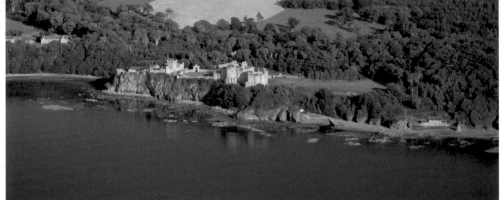

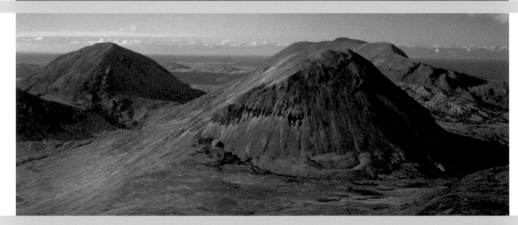

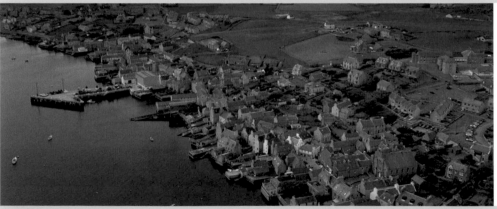

INTRODUCTION

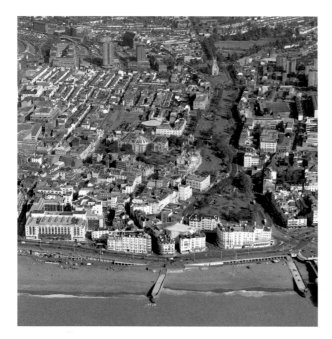

Above Brighton owes its success to royal patronage. The future George IV was first drawn here by the mid-eighteenth-century belief that bathing in sea water was a cure for all manner of ills. Where royalty went, the rich soon followed – until Brighton was the most popular seaside resort in Britain.

Right Backed by steep cliffs and cut remorselessly by the waves of the North Sea, a seemingly endless stretch of beach on the Yorkshire coast disappears into the distance.

The outlines of Britain and Ireland are as familiar to us as our own signatures. Several times each day we can watch a TV weather forecaster standing in front of a giant map, pointing out this location or that. At school we learn to recognize our homeland on the classroom globe at around the same time that we are taught the shapes of numbers and letters. Each one of us can close our eyes and visualize its unique landform. (The British mainland has always suggested to me the outline of an old lady in a long skirt, hunchbacked and wearing a tall hat. She has her back to the rest of Europe and one arm – south-west Scotland – and one leg – Cornwall – stretched towards the dumpy diamond of Ireland.)

So, in one sense we are already well aware of what our coast looks like from the air. But of course, it's not that simple. Looked at in more detail, the shape we are tricked into believing to be a permanent outline is revealed as nothing of the sort. For one thing, our coastline is being ceaselessly redrawn by the sea and the weather. Twice a day the tide reveals it anew and the most we can hope for at any given moment is a snapshot of what it looks like right now. Look again a minute later and, in truth, every inch is different – and will remain in place for just the briefest moment before the wind and the waves make their latest adjustments.

In geological terms, Britain hasn't even been an island for very long. Until perhaps 250,000 years ago, the British mainland was a peninsula of north-west Europe. Around then rising water levels in the North Sea, caused by melting glacial ice, finally forced a breach that would eventually come to be called the English Channel. Geologists used to think this breakthrough took thousands of years. Recent studies, however, suggest the waters may have overwhelmed the land bridge that joined us to Europe in a biblical-style flood that lasted just a single day. If they are correct, imagine what a sight that would have been – from the land or from the air!

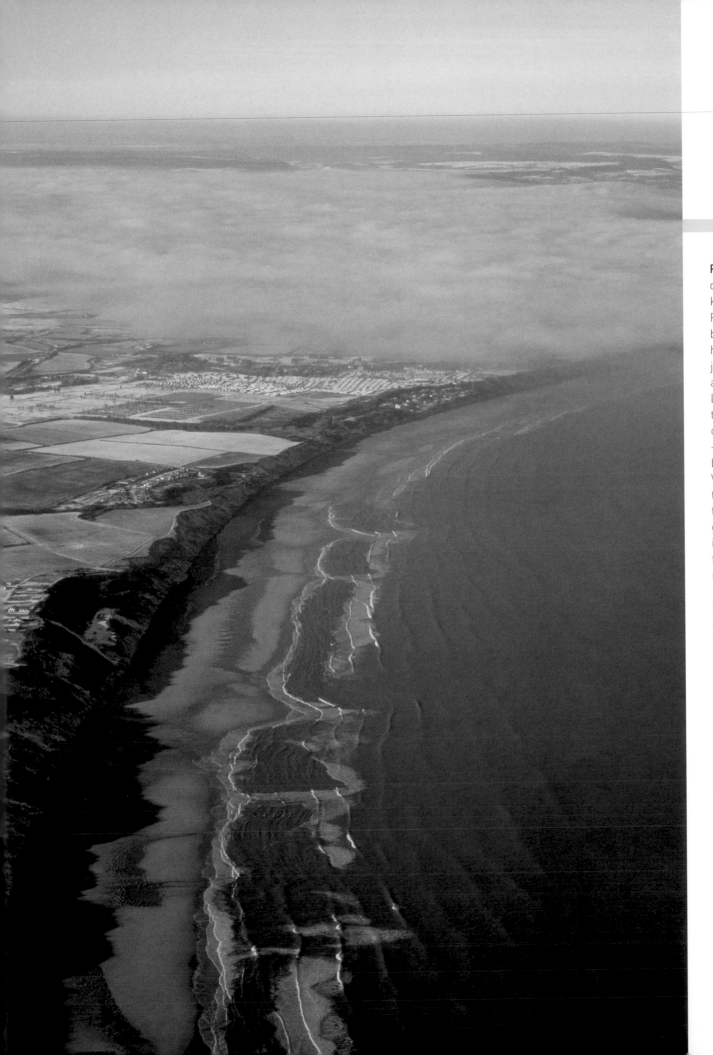

Page one Barrisdale Bay on Loch Hourn on the Knoydart penninsula. For as long as there have been people, the coast has meant more than just the place where land and sea come together. Long ago it became, in the imagination, a place of separation and parting – even the boundary between life and death Viewed from above, as the complexities and tribulations of the land give way to the impenetrable depths of the sea, the idea makes more sense.

Pages two and three Sea defences like these in Suffolk are only ever a partial solution to the problems posed to humankind by erosion. While they may fend off the tide and waves where they are built, often the negative effects are simply moved onto another stretch of coast.

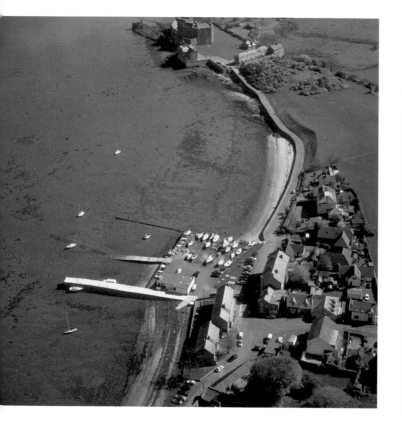

Above Until the seventeenth century, the village of Blackness on the Firth of Forth thrived as a port for the nearby town of Linlithgow. Blackness Castle, built in the mid-fifteenth century, was one of the fortifications taken by Oliver Cromwell during his invasion of Scotland in 1650.

Right Hardly the place for wayward tee shots – the manicured perfection of the fairways at Eyemouth Golf Course seems strangely at odds with the untamed rock-cut platform and open sea beyond its boundaries.

Ironically enough a Frenchman, Louis Bleriot, was among the first to enjoy an aerial view of part of Britain's coastline. He succeeded in flying the 24 miles from Calais to a point some distance north of Dover on 25 July 1909. The absence of any on-board navigational equipment meant he went slightly off his chosen line – and completely missed the white cliffs. He had been in the air for just 37 minutes. It wasn't by any means the longest flight at that time, either in terms of distance or duration – but the impact of his achievement was huge.

Chancellor of the Exchequer David Lloyd George said: 'Flying machines are no longer toys and dreams, they are established fact. The possibilities

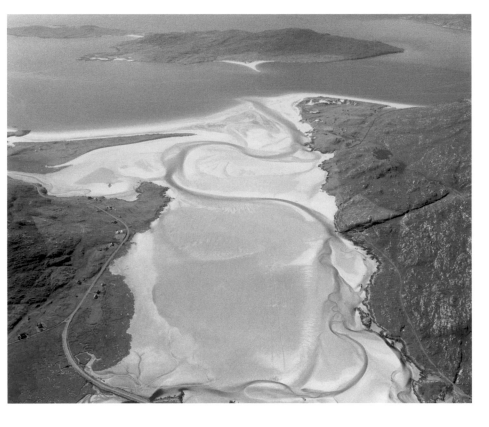

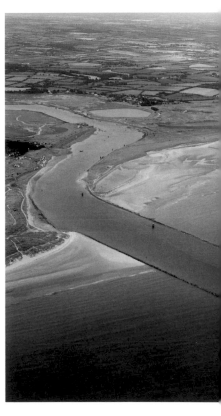

of this new system of locomotion are infinite. I feel, as a Britisher, rather ashamed that we are so completely out of it.'

Even today, the simplest pleasure to be had from flying machines is still the view they afford us of the world below. We are told all the time that we live in a small country – but spend some time looking at this land of ours through the porthole of an aeroplane and you can't help but be reminded that it's big enough – and bonny.

But none of it is for ever. Our coast is changing constantly. A headland is worn shorter here; more sand and silt is removed from a beach there, only

Above Luskentyre Bay on the western coast of South Harris in the Outer Hebrides, looking across the Sound of Taransay towards the island of Taransay.

Above Synonymous with the history of both Irelands, the River Boyne rises in the Bog of Allen in County Kildare, and flows 70 miles to the north-east before reaching the Irish Sea just below the town of Drogheda in County Louth.

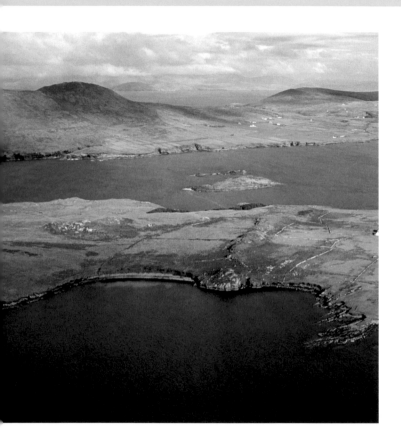

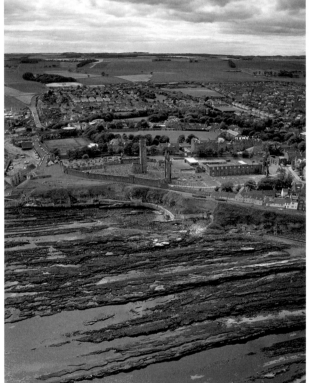

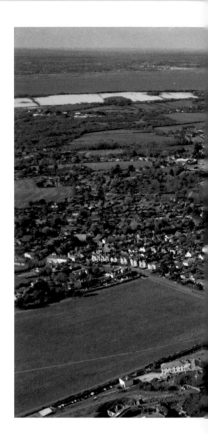

Above A view across the island of Beginish in Valentia Harbour off the Iveragh Peninsula in County Kerry, looking towards the village of Cahirciveen. Uninhabited now, a ruined monastery on the eastern side of the island, together with traces of circular stone buildings, testify to a busier time.

Right Known throughout the world as the home of golf, the town of St Andrews in Fife is also home to the oldest university in Scotland, founded in 1411. Overlooking the dark rocky spines of the foreshore are the ruins of St Andrews Cathedral.

to be deposited in another location some tens or even hundreds of miles away at the whim of the sea. Some changes are momentous and likely to make the news – the collapse of a towering sea stack perhaps, or homes left dangling precariously on a cliff edge after a winter storm. Other modifications are minute and go unnoticed – the endless shifting of shingle or the movement of individual grains of sand on a summer breeze. But it is all part of the drama – part of what makes the coast the most dynamic and exciting natural environment we have.

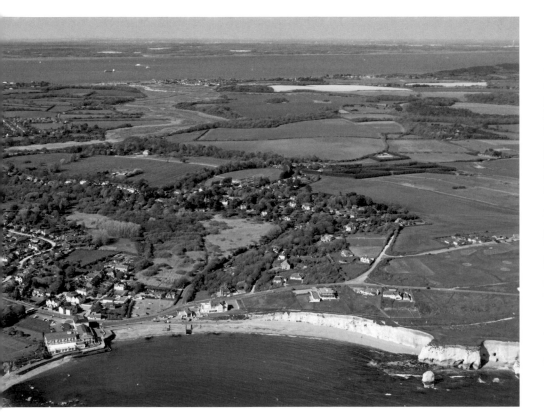

And since we live in a constant state of flux, *Coast from the Air* is made all the more priceless for being a collection of glimpses, frozen moments from the long, long story of our island. If we are to care about our natural heritage – and perhaps take steps to change our lifestyles for the sake of its protection – we must first appreciate just what it is that's at stake. Hopefully the images within these covers will go some way towards inspiring us all to value and celebrate what wonders we have in Britain – to see and understand what the gulls have always known: that ours is a beautiful land.

Left On the south-west coast of the Isle of Wight is the cove called Freshwater Bay. Open to the English Channel, the storms of winter give vent to their full force along this coast and the chalk cliffs are constantly being remodelled by erosion. In summer though, the bay is calm and a welcoming spot for sunseekers.

Above We're told we live in a small country in an increasingly small world, but there are wild and empty places still to be found. Selworthy Beacon, the highest point on a wild sprawling moorland landscape forming part of Exmoor gives a person space to breathe.

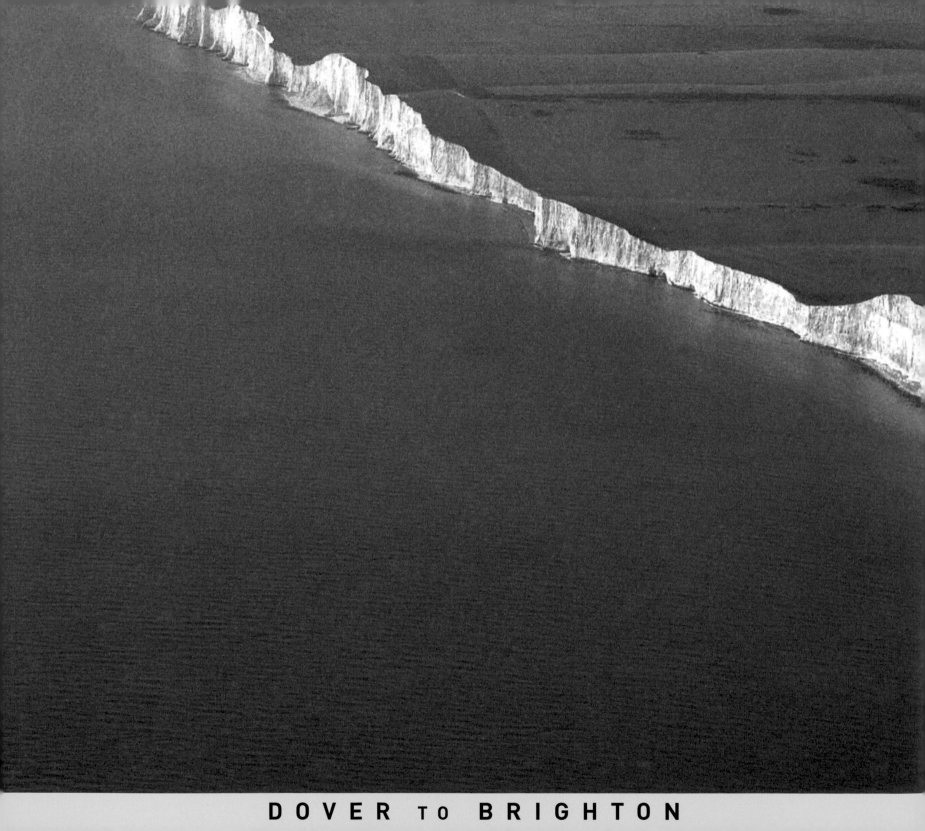

DOVER to BRIGHTON

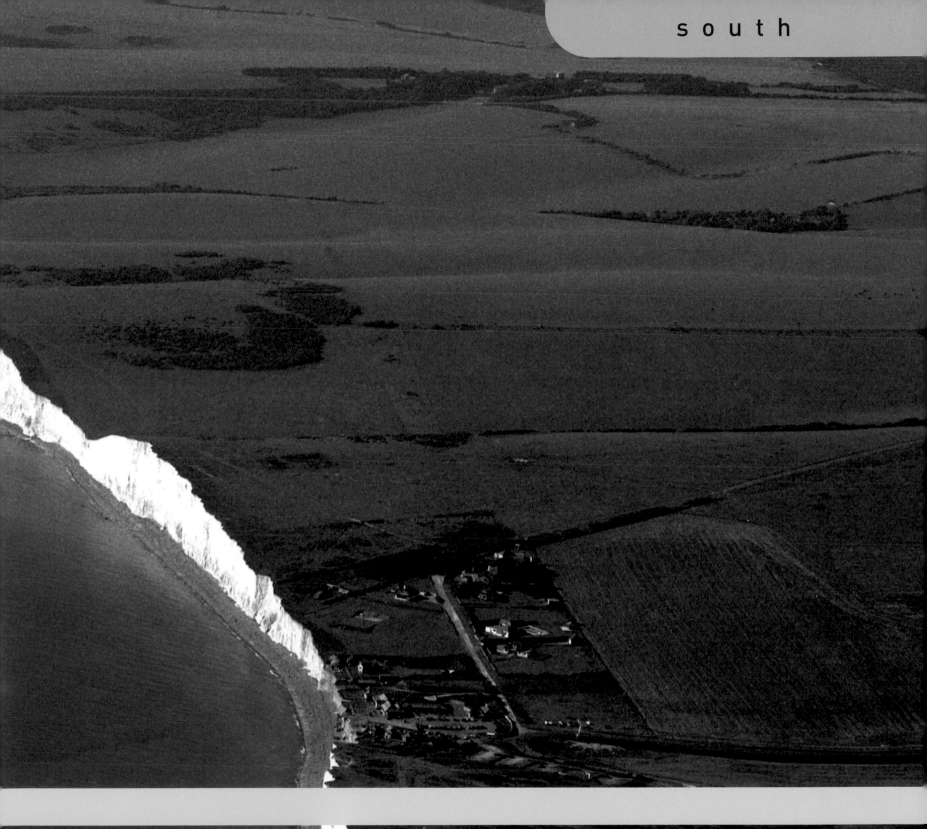
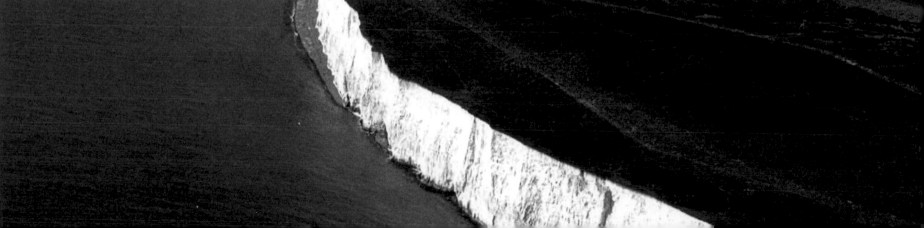

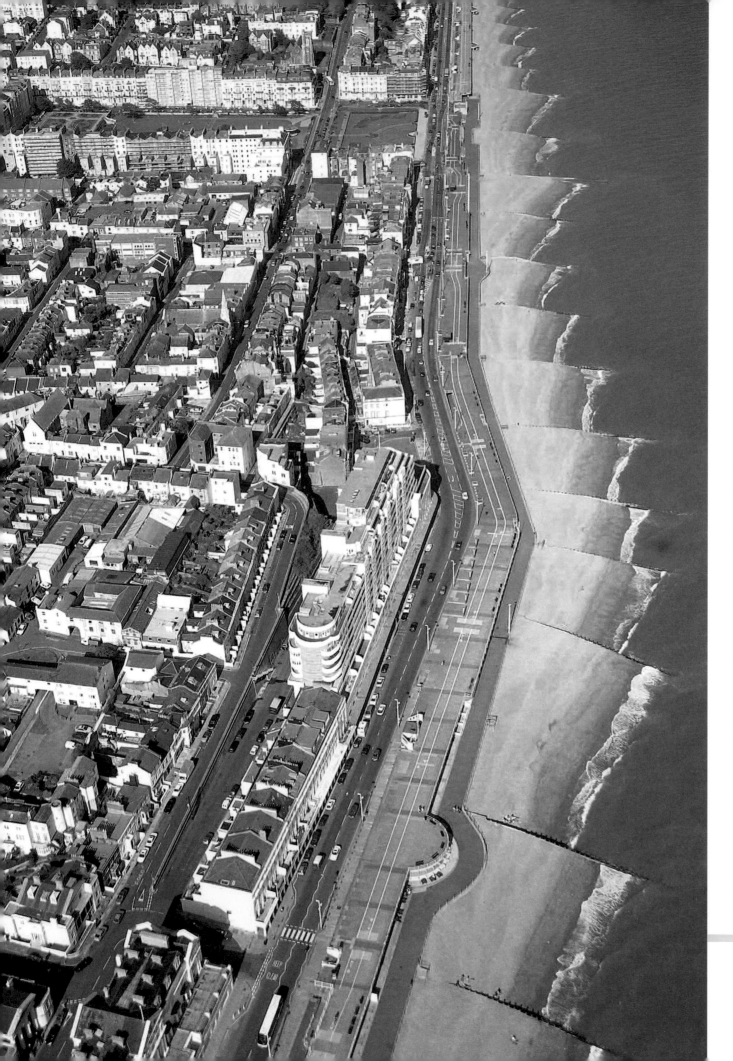

Previous pages Now perilously close to oblivion, the hamlet of Birling Gap sits towards the eastern end of the Seven Sisters cliffs on the Sussex coast. The sea has already claimed some of its cottages and the forces of erosion are grinding inexorably onwards. Time and tide wait for no man.

Left From above, the build-up of sand against timber groynes on St Leonards beach resembles a higgledy-piggledy stairway to heaven. Like neighbouring Hastings the seafront here was remodelled for the future by 1930s 'Concrete King' Sydney Little. Determined to push ahead of rival resorts Brighton and Eastbourne, this visionary engineer stamped his mark on the towns he loved.

There's no denying the atmosphere that hangs over port towns like a mist. We know that places like Dover are home to thousands of people – children grow up in them, folk have jobs and social lives, and, like everywhere else, they are where all the usual events of day and night are played out. But for those of us just passing through, ports are for two events only – arrival and departure. Hello and Goodbye.

For me, there's sadness too. Any time I've been in Dover, king of all Britain's port towns, I've left behind people and memories – either at home or in the far-off places I'm returning from. And in my mind's eye it often seems to be viewed from high up, far away. The name summons up, of course, the white cliffs, the castle, the harbour full of ferries – and when I think of it all, I see it from the air.

Dover is the fixed point where the clock marking the moments of the journey around Britain either starts, or stops. As *Coaster*s we circumnavigate our islands in the direction dictated by the hands of the clock, and so from Dover we head to the west.

Although the iconic chalk cliffs extend for just a few broken miles, there's something appropriate about their abrupt ending. If we must be cut off from the continent, they say, then a clean break is best.

This close to France we feel the south-east coast keeping watch, seeing who's coming and who's going. More than any other part of the coastline this is the edge, where Britain stops and starts; a stretch given over to endings and to beginnings.

Above Before the time of the Norman Conquest Rye was a fishing village almost surrounded by water. By the thirteenth century it was one of the Cinque Ports – towns granted privileges in return for providing ships and men to defend the realm. The sea lies two miles distant nowadays – and sheep graze where waves once broke.

Right More memorable in their way than the White Cliffs of Dover, the Seven Sisters ripple around a stretch of coast near Eastbourne like a fossilized wave. Rather than the tall headlands, the 'sisters' are in fact the truncated valleys in between.

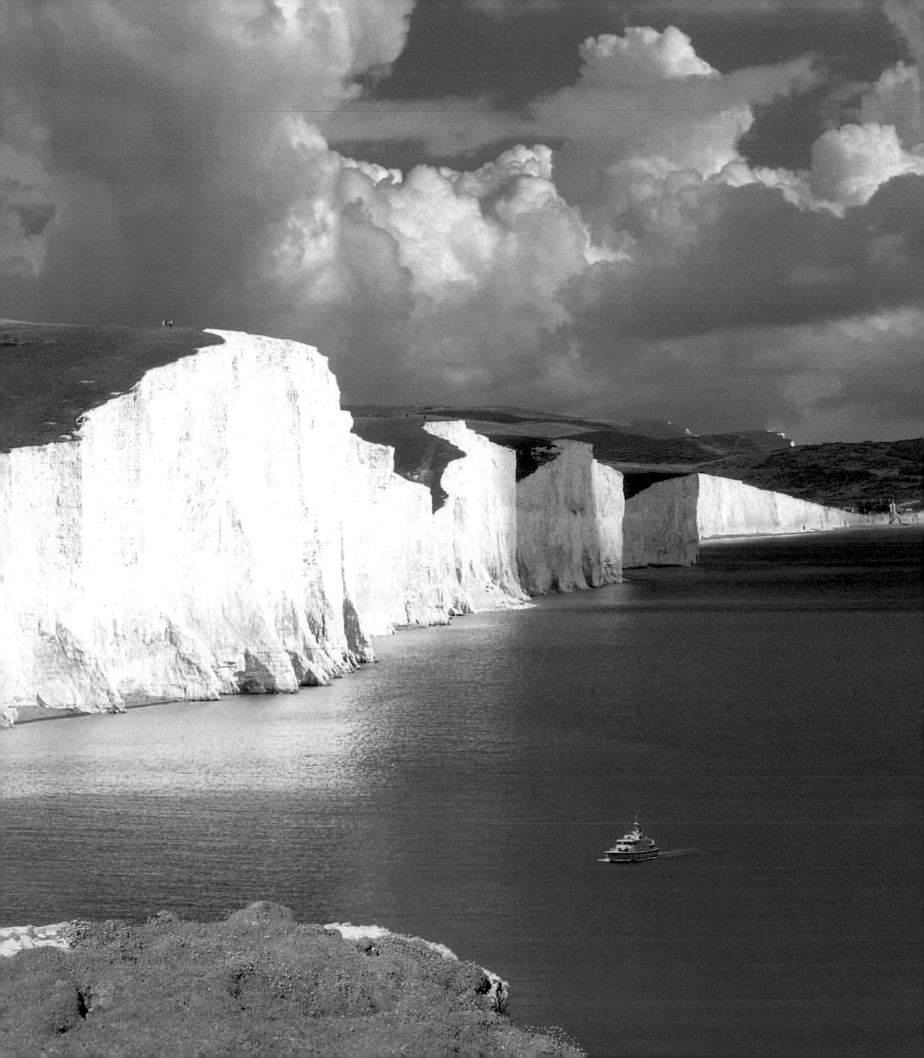

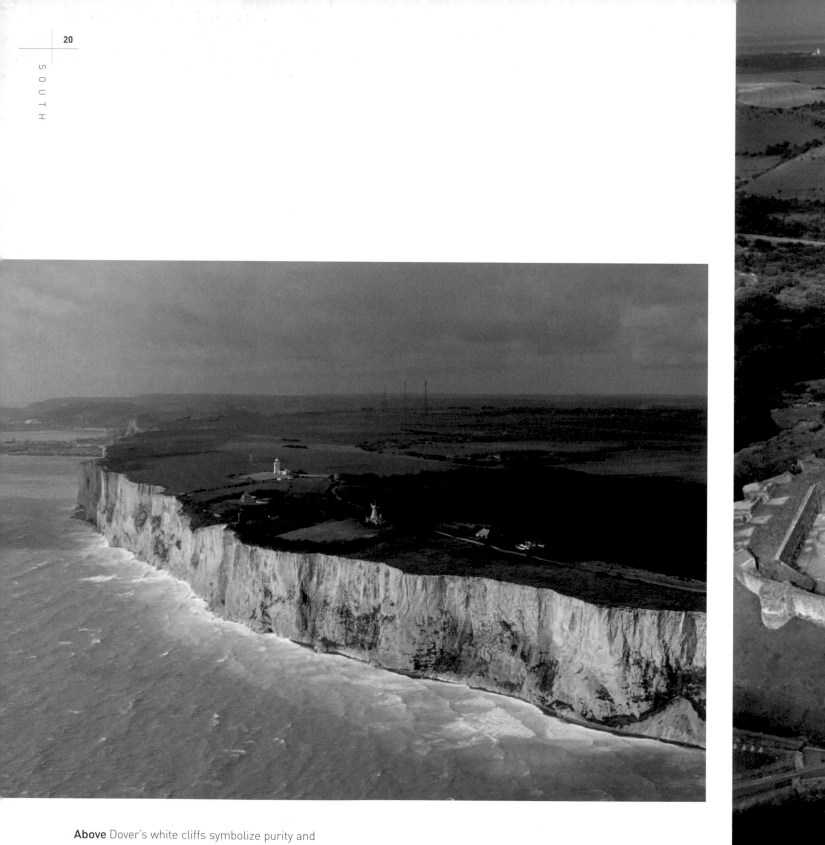

Above Dover's white cliffs symbolize purity and permanence. In fact they owe their stark appearance to ceaseless erosion. Every moment of high tide brings the impact of another wave, undermining the cliff face until more tumbles into the sea. Rather than permanence, the white cliffs are testament to steady retreat.

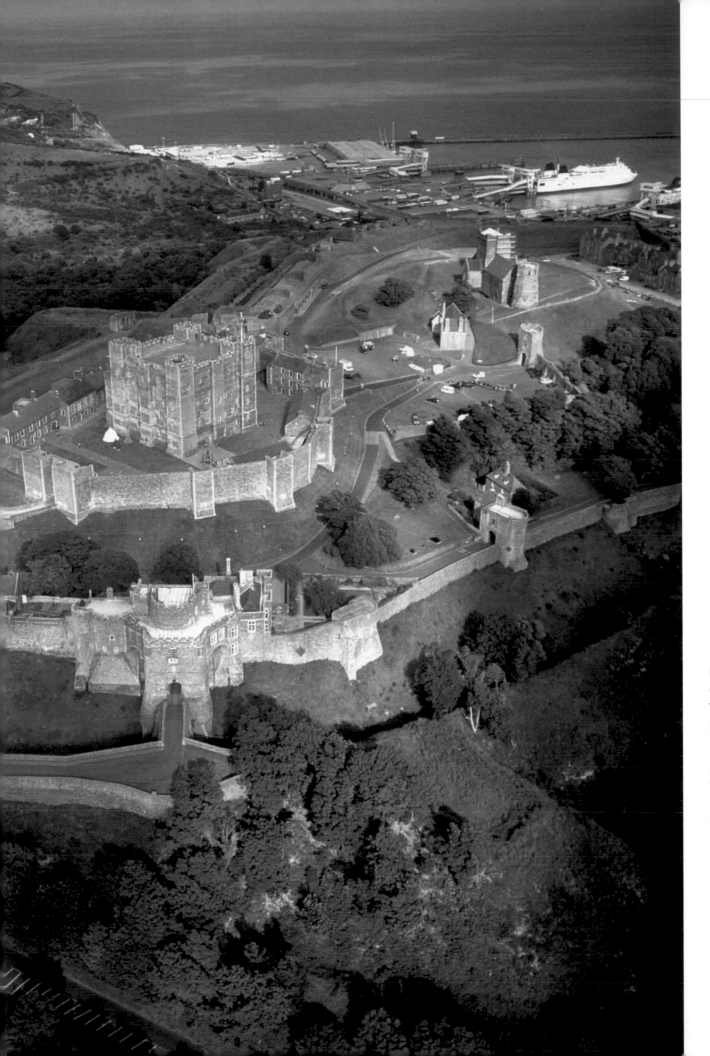

Left Dover Castle overlooks the white cliffs where France – and the prospect of invasion – looms closest. Unsurprisingly the strategic importance of this location has been understood for thousands of years – and the fortifications have long been nicknamed 'the key to England'. The giant castle there today dates from rebuilding work during the reign of Henry II.

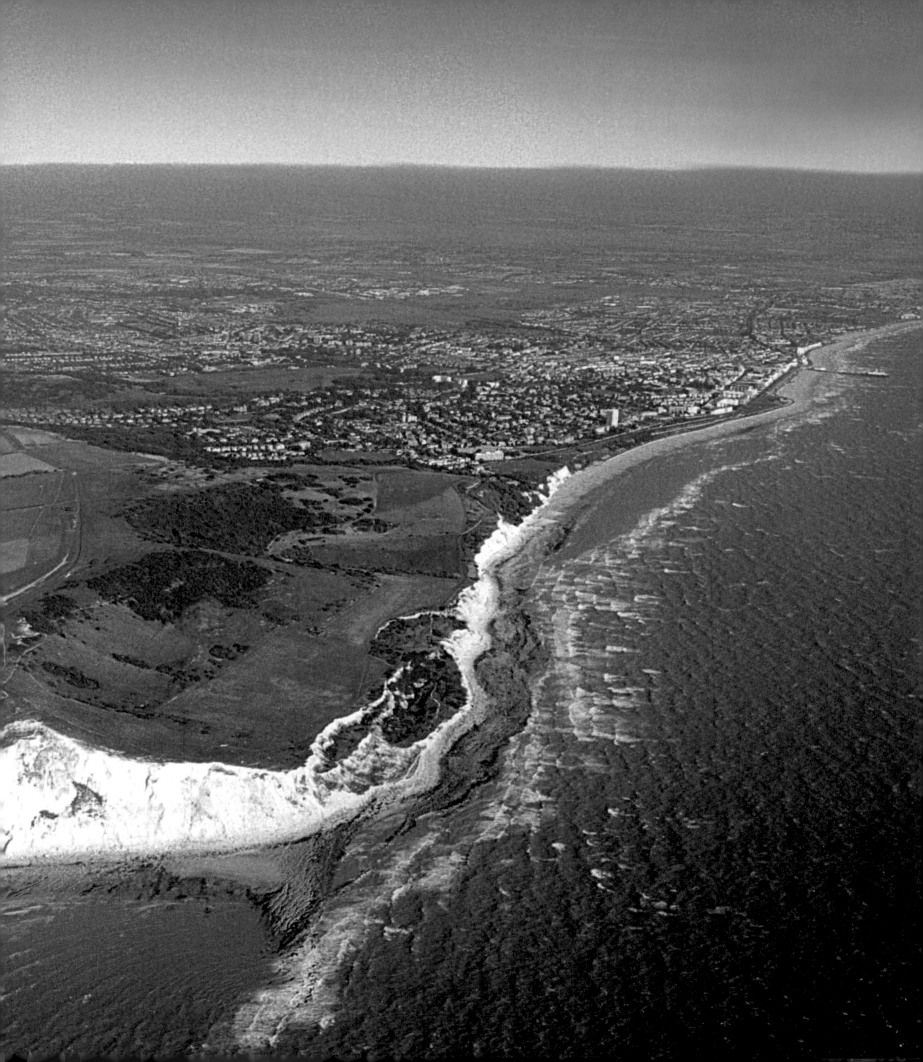

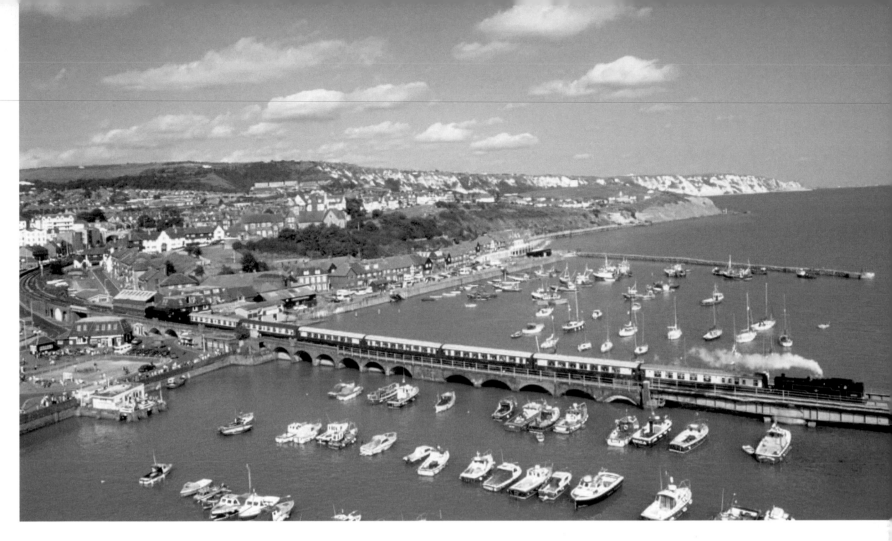

Opposite Capital of 'The Sunshine Coast', Eastbourne holds the record for Britain's sunniest month – 383.9 hours of sunshine in July 1911. Like all our resort towns, it's seen gloomier times in the recent past as more and more of us look abroad for our holiday destinations.

Above The coming of the railway to Folkestone in 1843 – followed by construction of a terminus for boat trains headed to the continent from London – ensured a heyday for the town. Today the service provided by the Venice Simplon-Orient-Express is a reminder of past glories.

Right At first sight the vast shingle spit of Dungeness seems home only to loneliness and the plaintive calls of seabirds. But huddled low beneath the endless sky are the dwellings of those who've found this bizarre landscape attracts and holds them with some irresistible power.

BRIGHTON TO SOUTHAMPTON

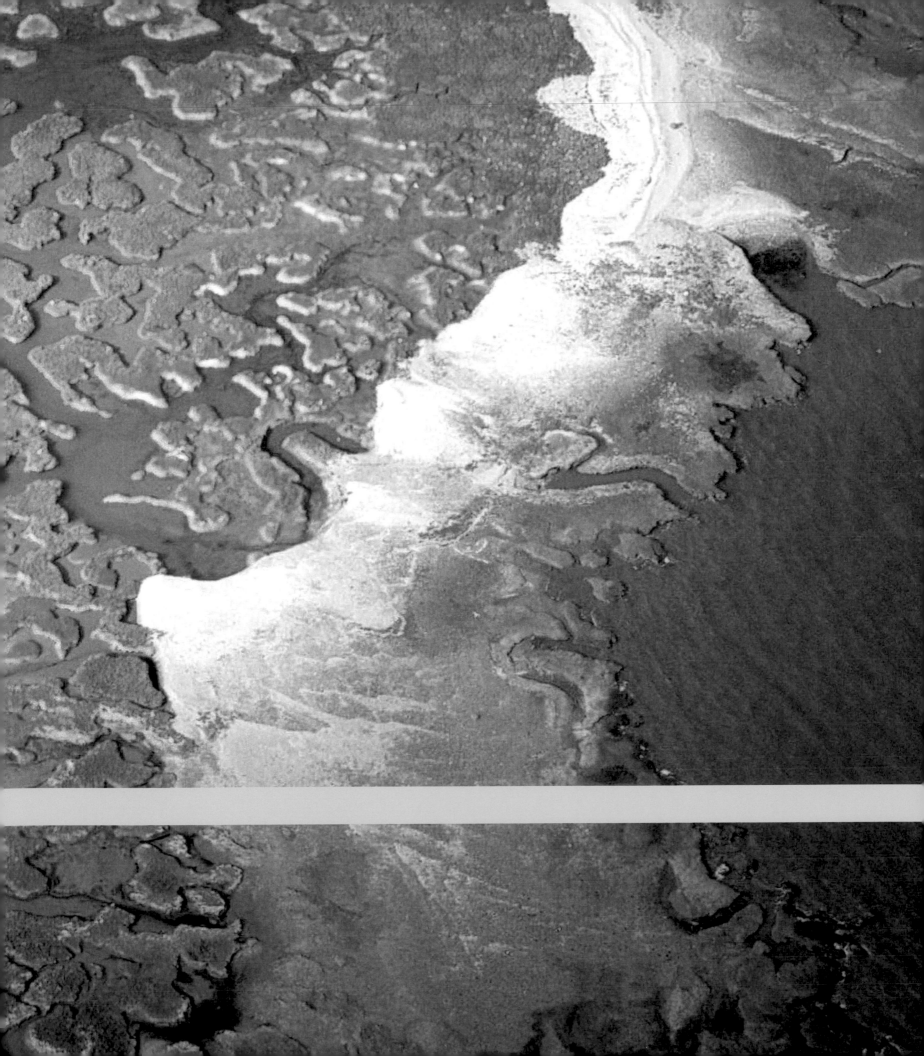

Previous pages Saltings by the Solent – where land and sea blur into one another until it's hard to say where one ends and the other begins. Here where human interference is slight, the natural world breathes easier and wildlife can flourish.

Below The boats of Hayling Island Sailing Club find safe haven within the tidal flats of the Emsworth Channel. This largely undeveloped low-lying land, riven with creeks and streams, also provides sanctuary for all manner of wildfowl and waders drawn to the area by plentiful food supplies.

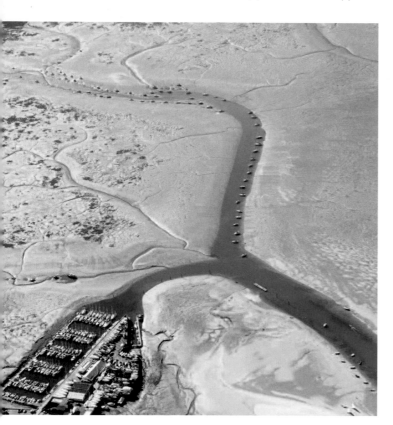

Having bowed down to make way for the teeming expanse of Romney Marsh and the great shingle swathe of Dungeness, the chalk rises again as we pass over Beachy Head towards Brighton. Just inland, like sleeping beasts, are the South Downs – '... blunt, bow-headed, whale-backed ...' in Kipling's words. Here they are tamed by the sea. In the cliffs rearing up behind Brighton and Hove the chalk has been stripped and scoured, made to divulge secrets going back millennia into the story of how our islands have been made, unmade and made again by geology and time.

We're told repeatedly that the English Channel is the busiest shipping lane in the world – but from the air the illusion is that there's plenty of room for everyone on this watery superhighway. Vessels of all kinds, whether humble leisure craft and fishing boats or gigantic fuel tankers and container ships, appear as little more than punctuation marks on a page.

Beyond the elegant decline of the holiday resort of Bognor Regis this journey west reveals the Solent, the waterway that separates the kite shape of the Isle of Wight from England's south coast. If boats and ships are punctuation marks, then this part of the page is peppered with their pauses. The attraction for the vessels comes in the form of two great anchorages – Portsmouth and Southampton – each vying with the other for the strongest claim on England's maritime past.

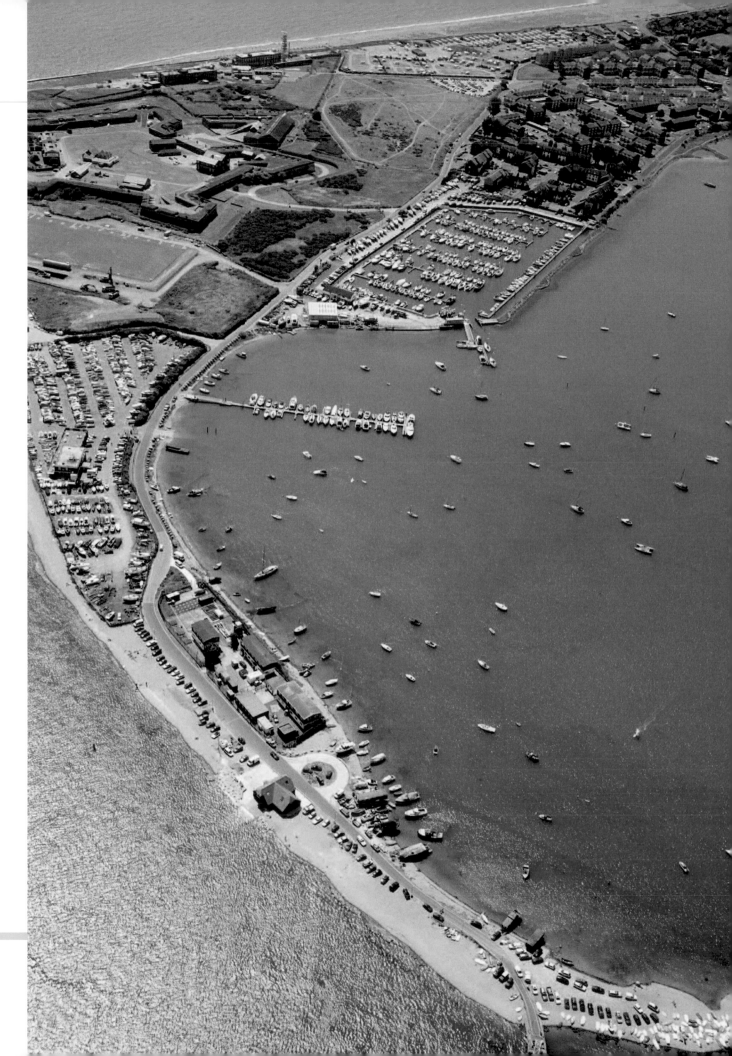

Right At the southern tip of Portsea Island, in Portsmouth, lies the seaside resort of Southsea. Henry VIII valued the place for its strategic position and built the castle here as part of his defences against all comers. His flagship *Mary Rose* sank offshore here with the loss of hundreds of lives.

Right A deep ria, or 'drowned valley', of the English Channel, Southampton Water is blessed with a double-tide that gives prolonged periods of high water. The room to manoeuvre it provides for great ships has for centuries made this stretch of water a prize beyond price for sailors.

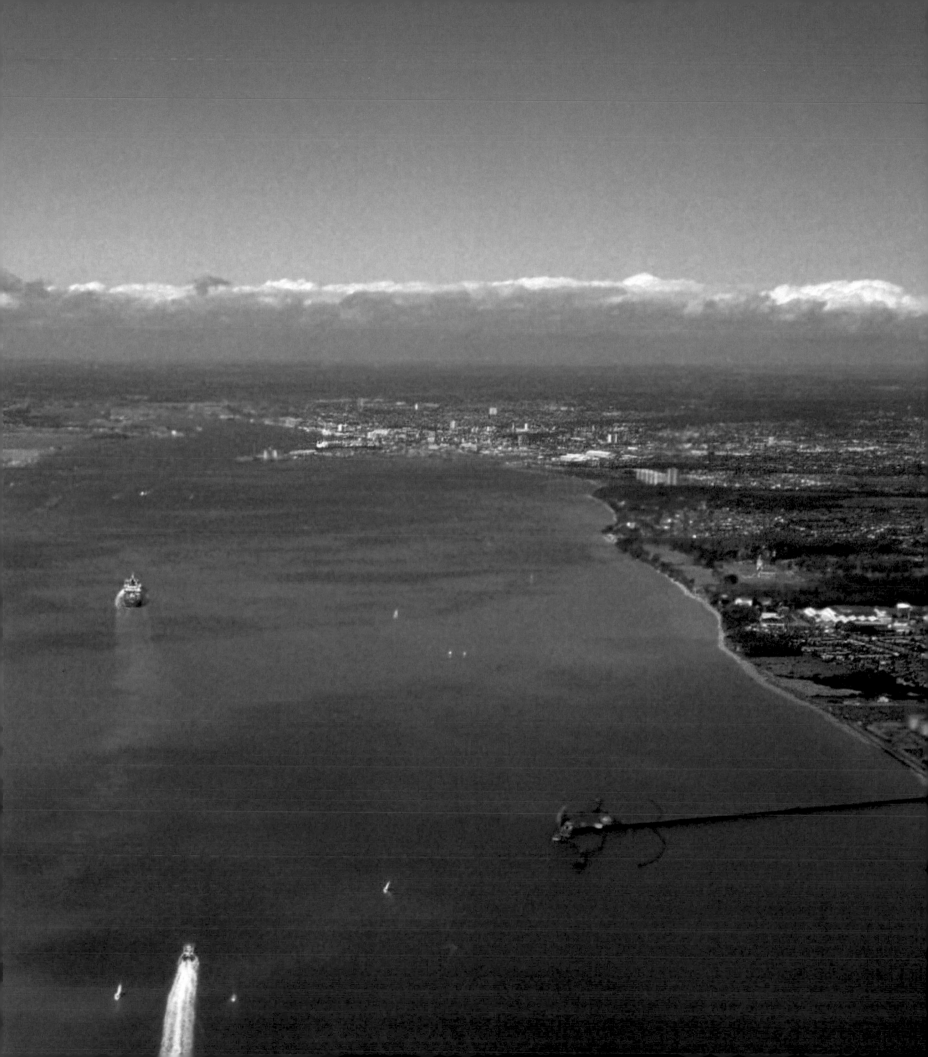

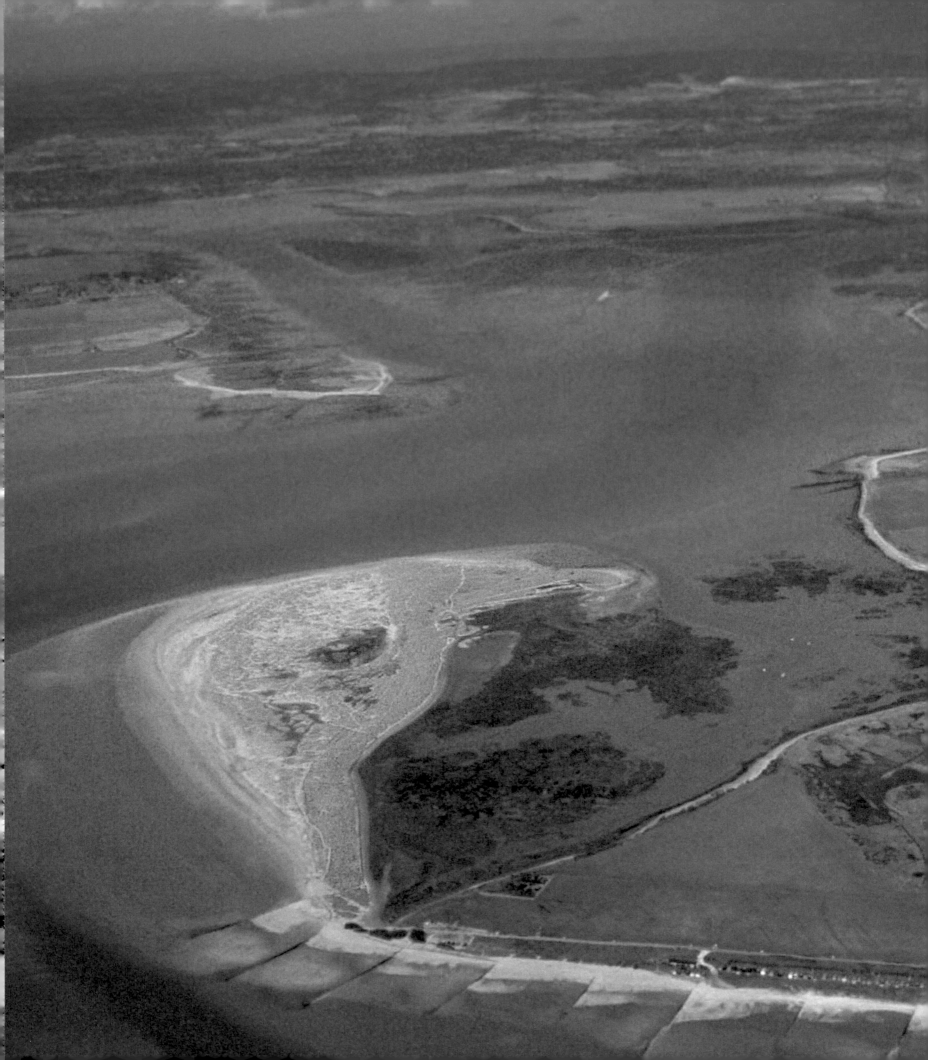

Left Only from the air is it possible to take in the easy grandeur of Chichester Harbour's 20-odd square miles of low-lying land and sheltered waterways. Still largely undeveloped this tranquil estuary attracts a startling richness of wildlife – as well as being an almost unparalleled boon for boatmen.

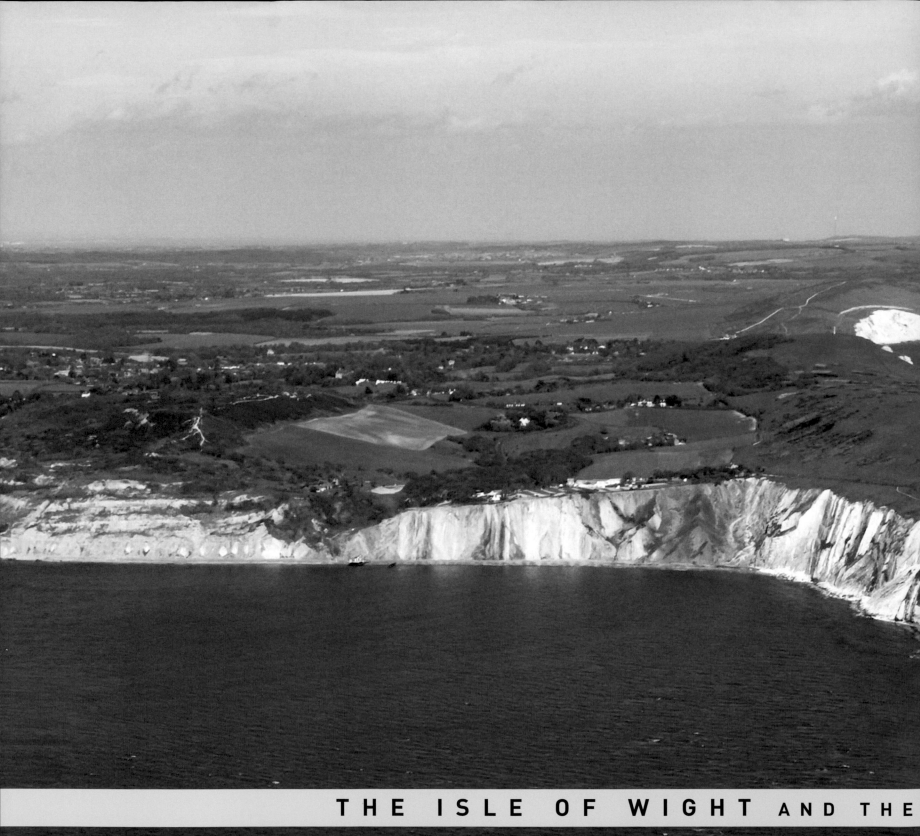

THE ISLE OF WIGHT AND THE

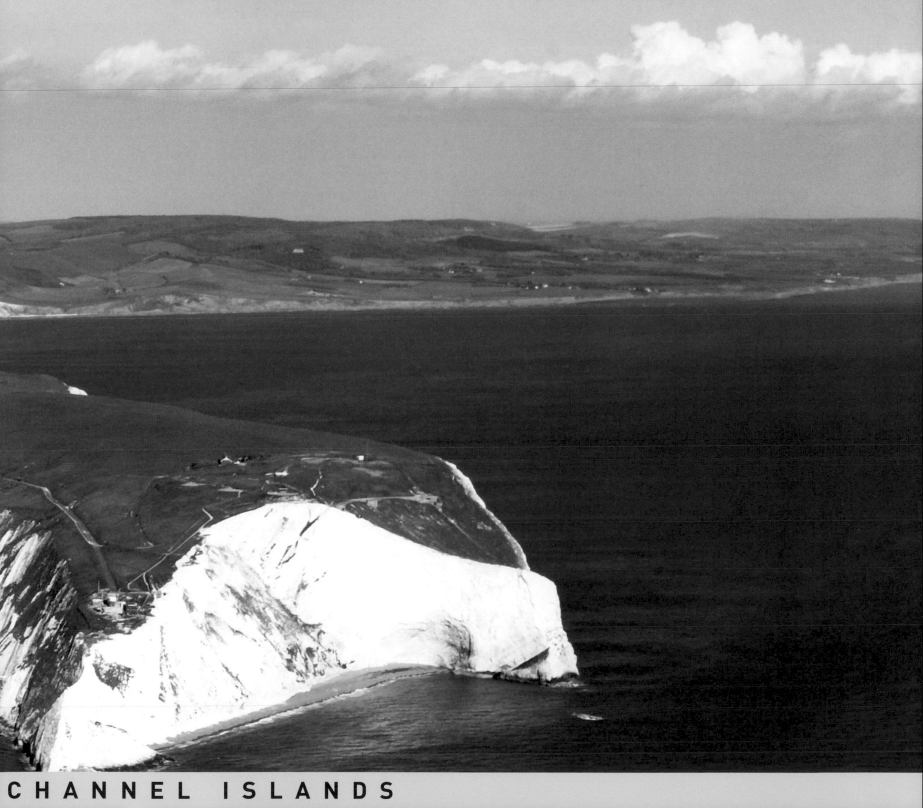

CHANNEL ISLANDS

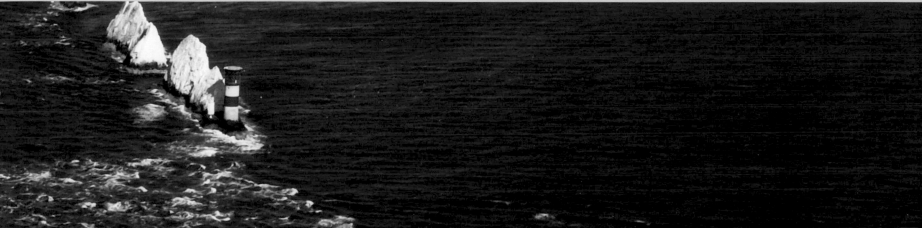

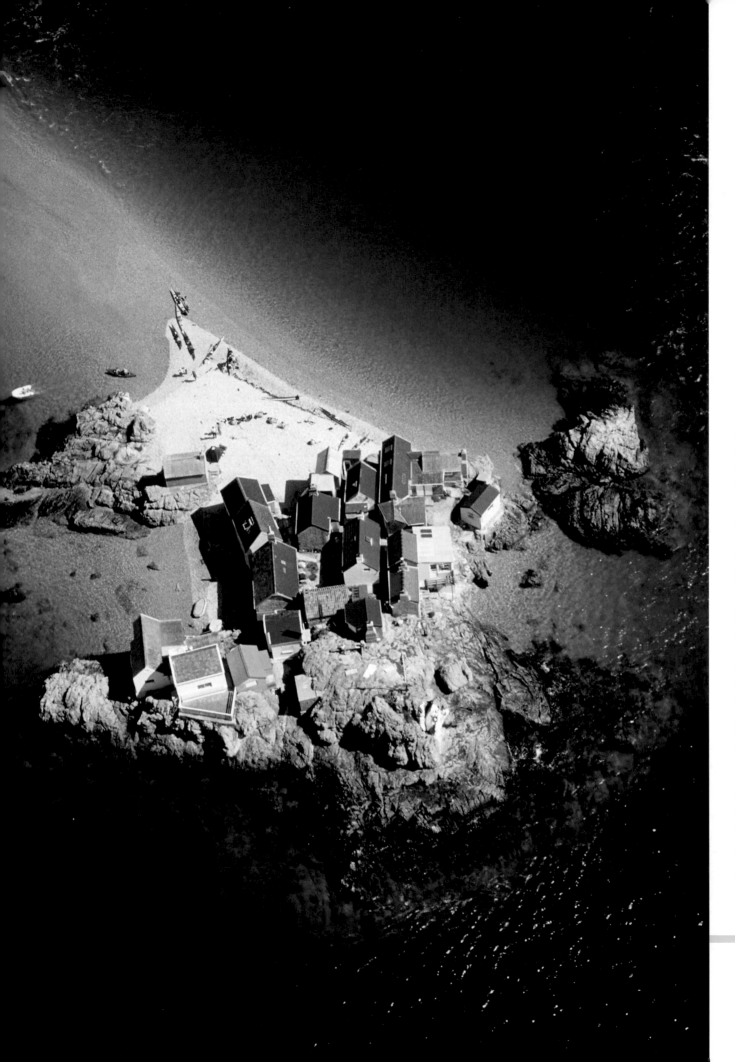

Previous pages At the westernmost tip of the Isle of Wight lie The Needles, chalk fingers reaching out of the sea as though in hope of catching and wrecking passing ships. In the days before air travel, these landmarks would often have been ship-borne visitors' first glimpse of England.

Left Huddled together as though for protection against the tide, fishermen's cottages on Les Ecrehous, a rocky outcrop of islands five miles north-west of Jersey. No running water and one toilet – yet their ownership was the subject of heated dispute with the French until the International Court of Justice at the Hague ruled in Britain's favour in 1953.

The simplest stories have a single hero who commands our loyalties. The story of our coast, however, divides those loyalties neatly in two. It's the story of the land and the sea, and each creates half the drama; demands half the respect and admiration.

It's the coming together of England's southern coast and the waters of the English Channel that, more clearly than anything else, defines Britain as a place apart. Here, where the vast continent of Europe is closest, we demonstrate our 'otherness' most strongly.

For almost all my life the Isle of Wight was just a shape on the weather map – seeming so close to the mainland I assumed I'd be able to skip a flat stone all the way from Portsmouth to Cowes. So when I made the crossing with *Coast* (a bit more than a stone's throw, I see now) the biggest surprise was how 'other' the Isle of Wight actually is. It's a place set apart not by distance, but by time. Everything here – the look of the towns and villages, the character of the locals, the atmosphere – belongs to that bit of our past when life was calmer and the climate kinder.

Further off and the most paradoxical of all our outposts, however, are the Channel Islands. With France so visible from some of them that it seems more like a headland of the same land mass than another country across open sea, it's nothing short of audacious to have them as part of Britain. And yet British they are. There's a surprising number of flagpoles on these islands – and it's the Union Jack they fly.

But it's when they are viewed from the air that the Channel Islands' 'Britishness' seems most unlikely. The right angle of coastline between France's Cap de la Hague, Saint-Malo and Ushant affords them far more in the way of shelter than does any part of Britain, and a viewer from outer space could be forgiven for thinking the little archipelago must be as French as *fromage*. The islanders themselves cheerfully admit that the Crown describes them as 'constitutional peculiarities'. So ... peculiarities they're called and peculiarities they are.

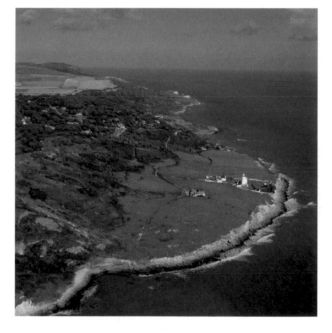

Above Visible for up to 30 nautical miles, the light from St Catherine's Lighthouse shines out from the most southerly point on the Isle of Wight. Third brightest of all the lights in the care of Trinity House it stands guard over vessels approaching the Solent and out in the Channel itself.

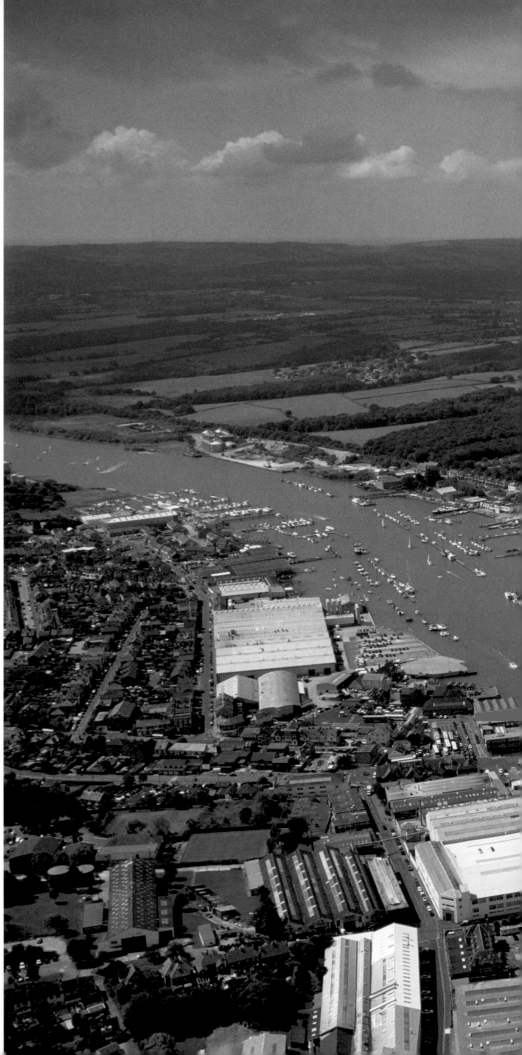

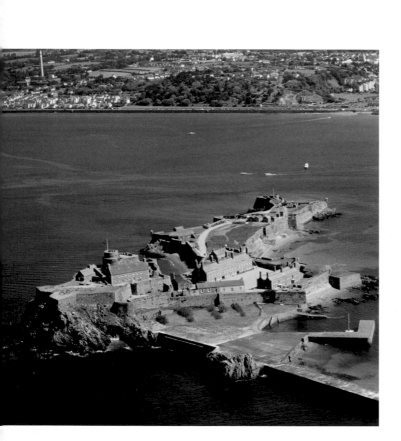

Above Sir Walter Raleigh, Governor of Jersey at the time, named this castle after Elizabeth I soon after building work was completed in the early 1600s. Situated in the bay opposite St Helier it became the official residence of the Governors of Jersey.

Right The main port on the Isle of Wight, Cowes is blessed with a natural harbour where the Medina River meets the sea. Queen Victoria and Prince Albert had a fine view of the place from their seaside home at Osborne House in the town. This was also the house in which the queen died, in 1901.

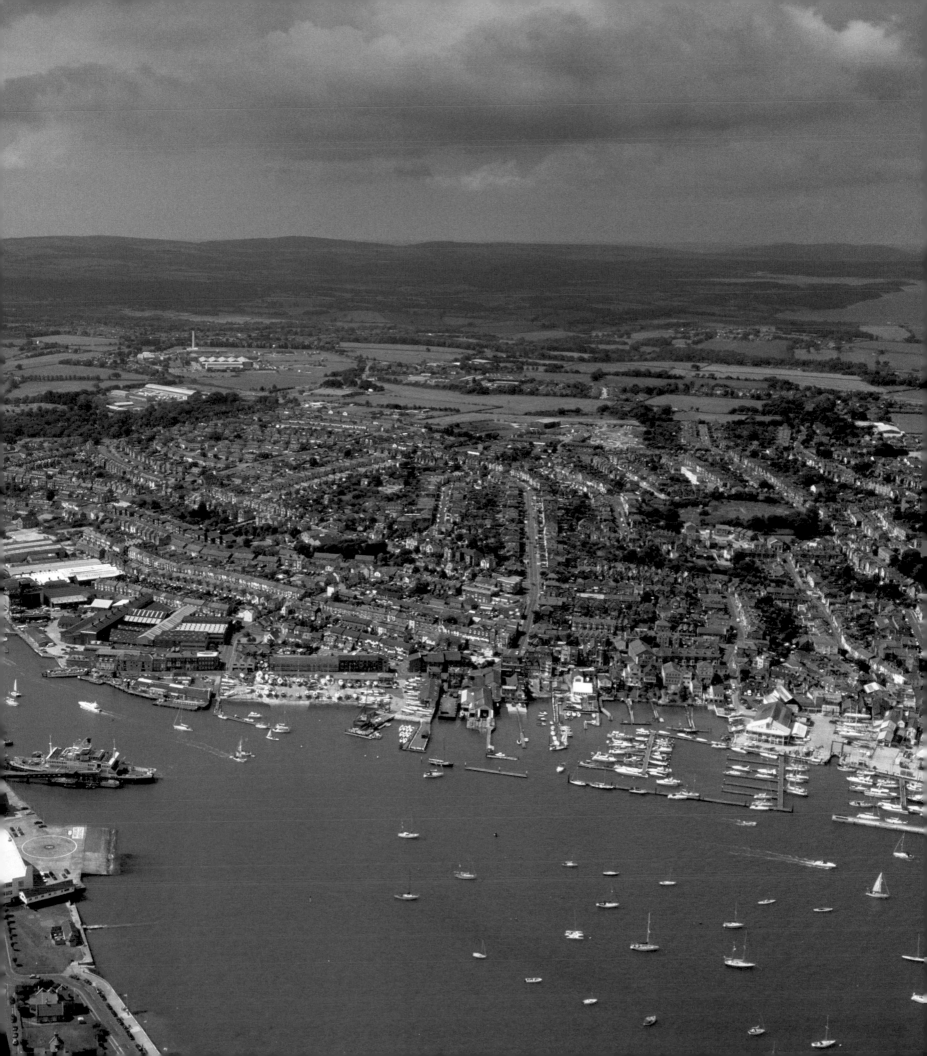

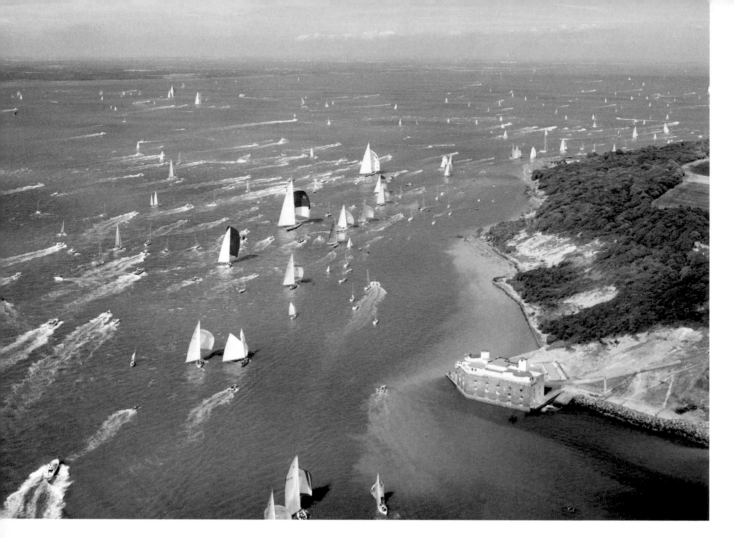

Top left Held for the first time in 1826, Cowes Week is the longest-running regular regatta in the world. Traditionally running *'from the first Saturday after the last Tuesday in July until the following Saturday'* it attracts thousands of boats and competitors confident enough to tackle the testing, strong double tides of the Solent.

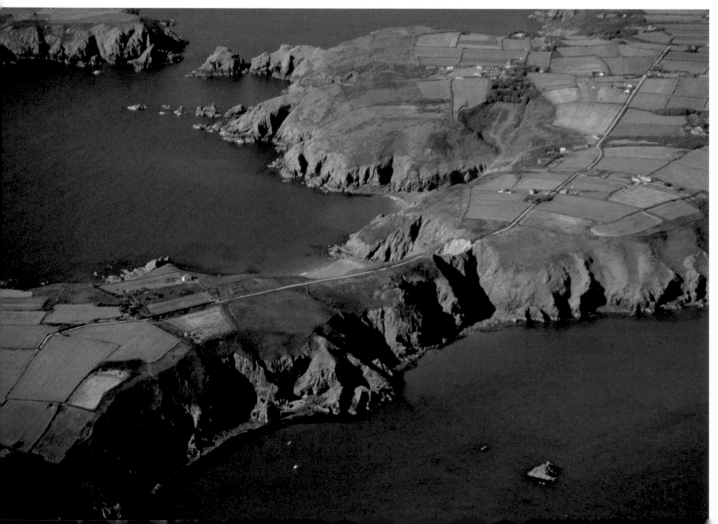

Left Tiny Sark, lost somewhere in another time where bicycle and horse still rule the roads, is almost two islands. Little Sark, to the south, is joined to its bigger brother by 'La Coupee' a narrow isthmus of land towards the centre right of the picture. Only ten feet wide and with a 328-foot drop to the beach on either side, it's not for the faint-hearted.

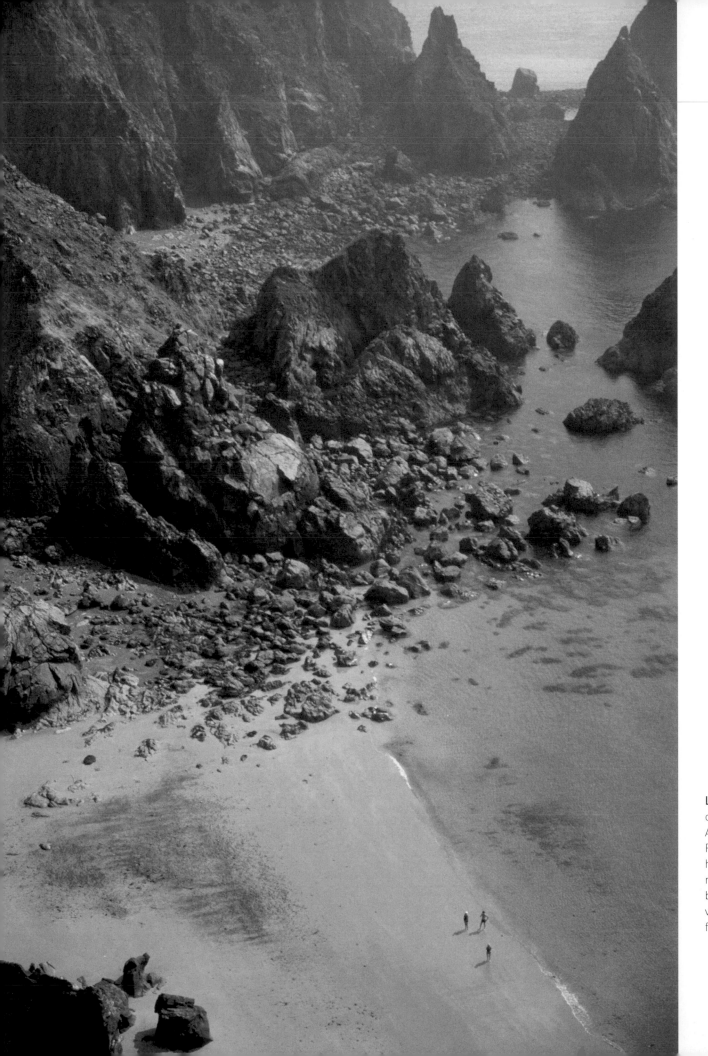

Left The most northerly of the Channel Islands, Alderney is the closest to France and to Britain. It has a wildness and a remoteness to it and on beaches like this one the visitor can feel a long way from home.

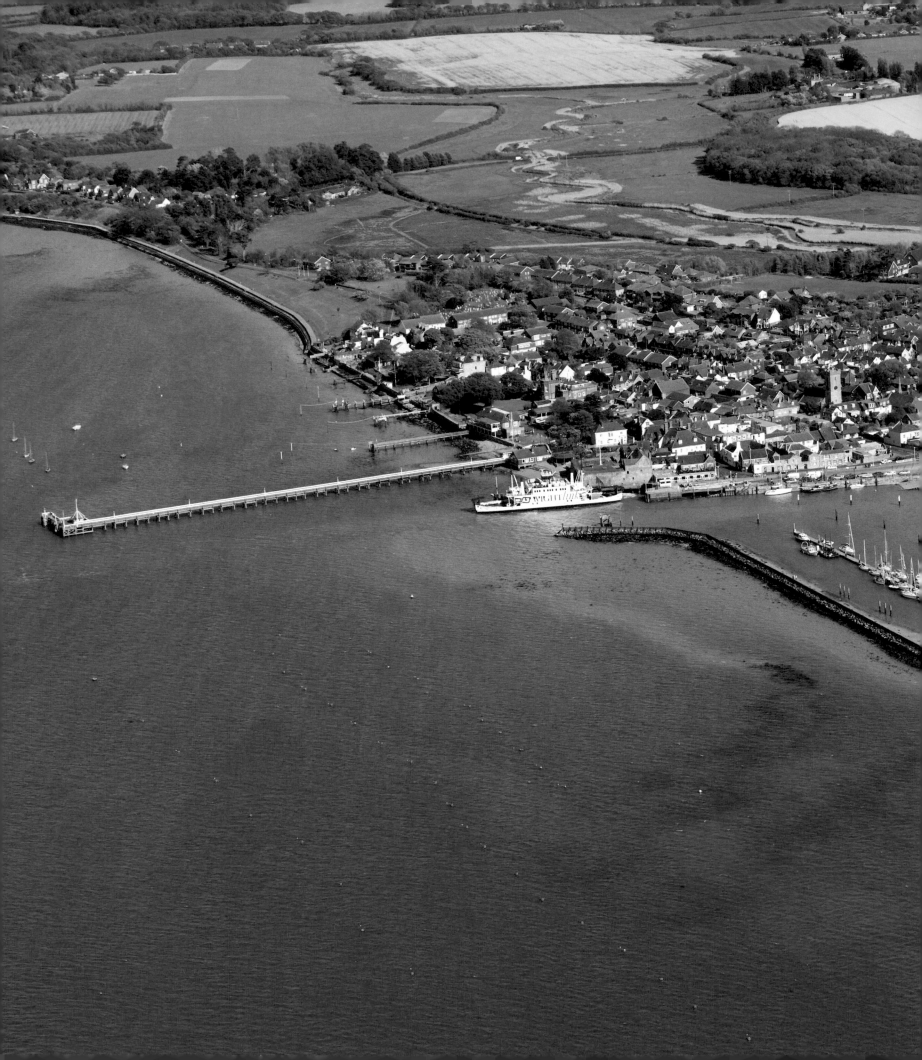

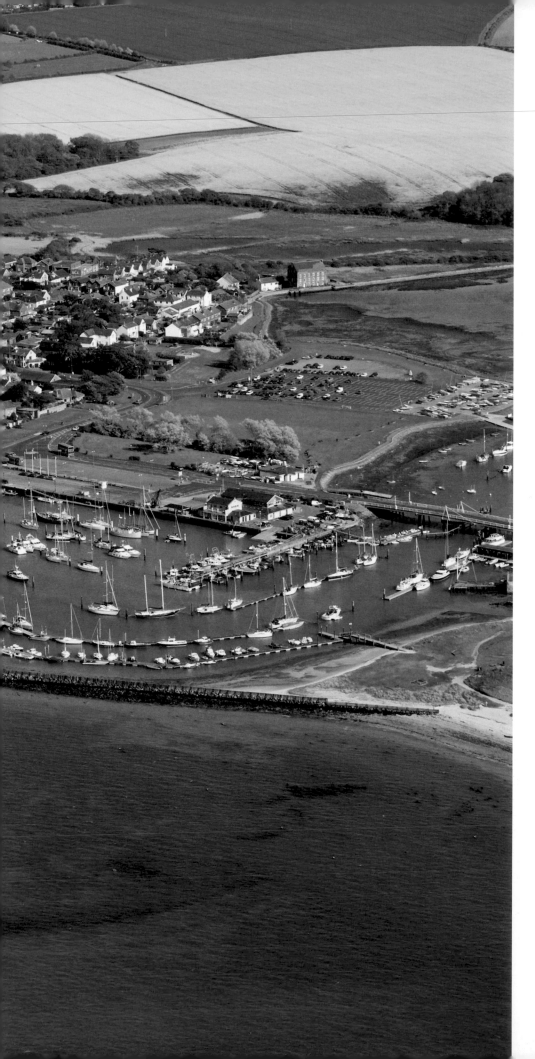

Left The port of Yarmouth faces across the Solent towards England's south coast and is one of the oldest settlements on the island, featuring in the Danegold tax records of King Ethelred the Unready in the tenth century. It sits at the mouth of the Western Yar River – not to be confused with the Eastern Yar River on the other side of the island.

Below For fossil hunters, the Isle of Wight might be called Dinosaur Island, such is the richness of the deposits there. And Sandown Bay, stretching for six miles along the isle's south-eastern coast from Culver Cliff to the town of Shanklin, offers some of the richest pickings of all.

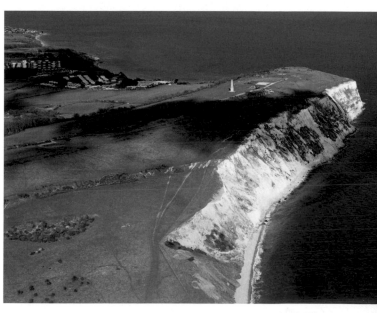

DORSET TO **DEVON**

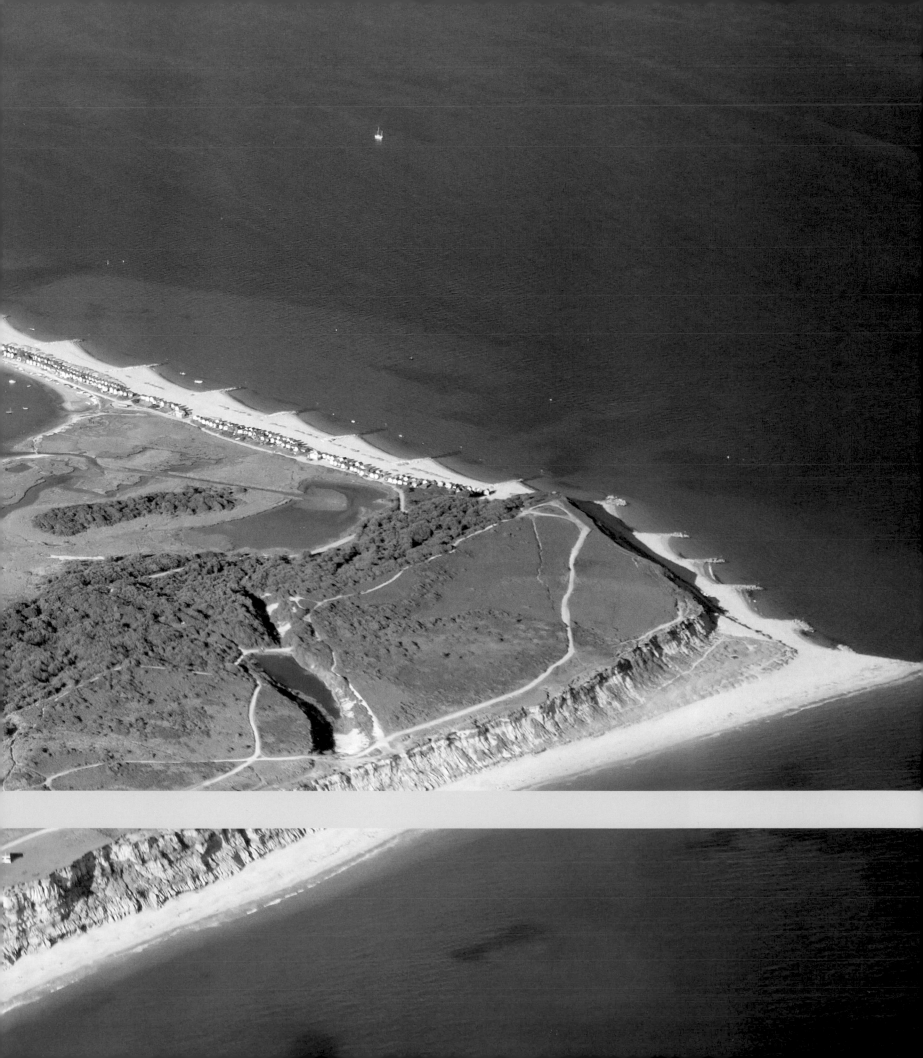

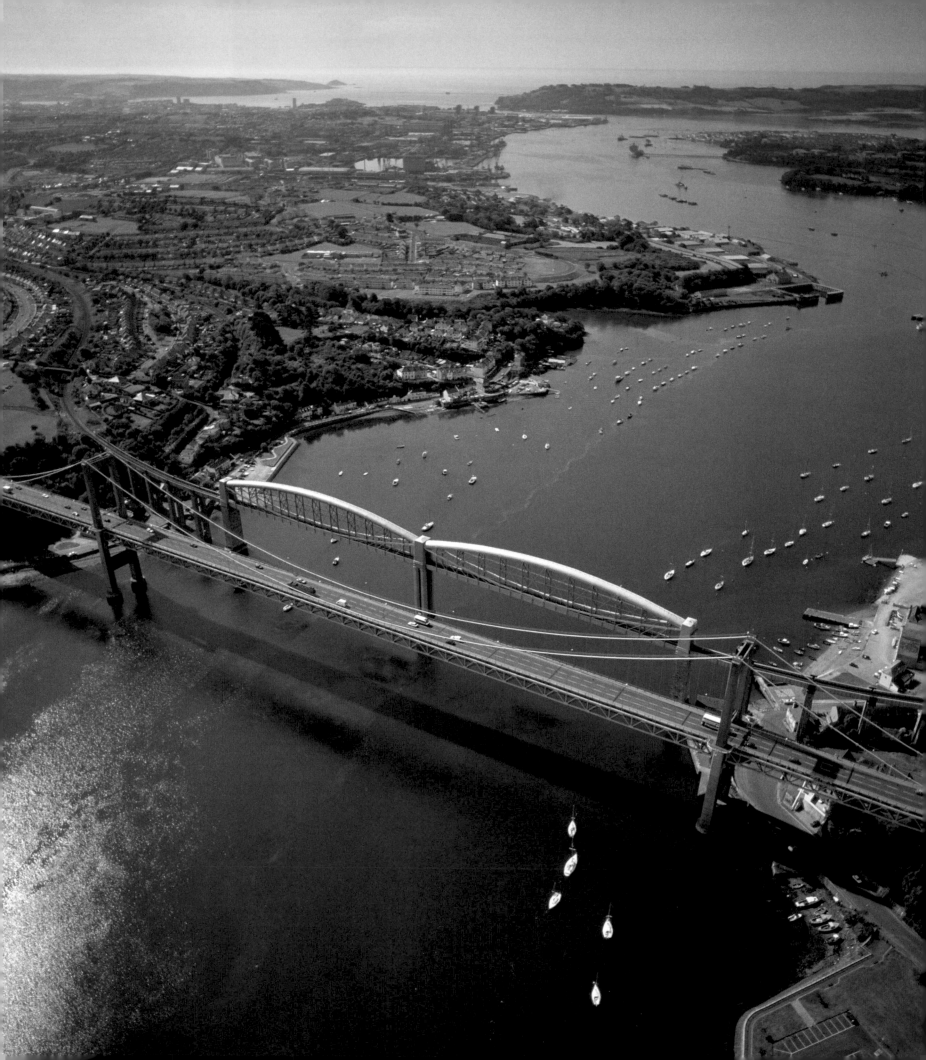

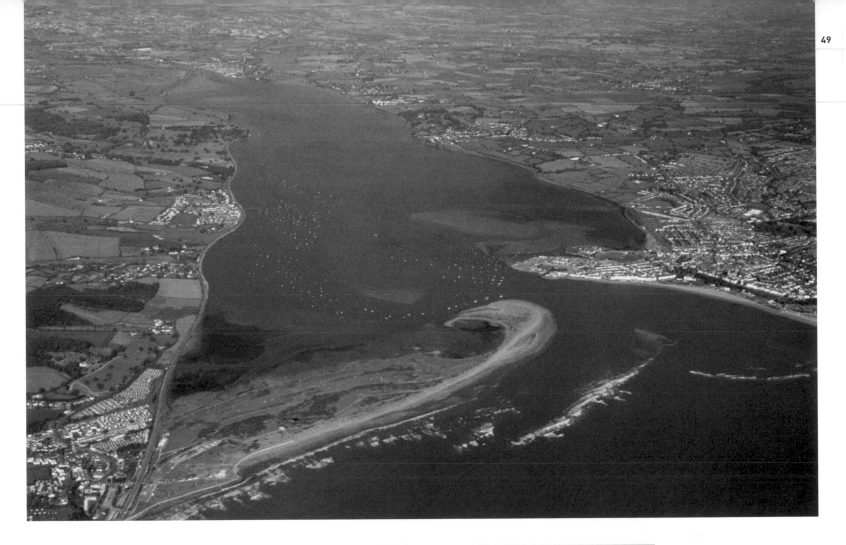

Opposite The Tamar all but makes an island of Cornwall and only a few miles of dry land defy the river in its path. It is crossed here, between Saltash in Cornwall and Plymouth in Devon, by the Tamar Bridge, built in 1961, and the Royal Albert Bridge, built by Isambard Kingdom Brunel in 1859.

Above Restrained by an unusual double spit of sand across its mouth, the River Exe spills gently into the open sea at Dawlish Warren, on Devon's south coast. The estuary extends for six or seven miles south of Exeter itself and is a haven for wintering waders, wildfowl and other wildlife.

Left Like work in progress on a motorway into the sea, Chesil Beach extends 18 miles from Burton Bradstock to Portland. This though is a natural wonder. Millions upon millions of flint and chert pebbles have been arranged in size after endless sorting by the sea – small as peas at the start, big as duck eggs by the end.

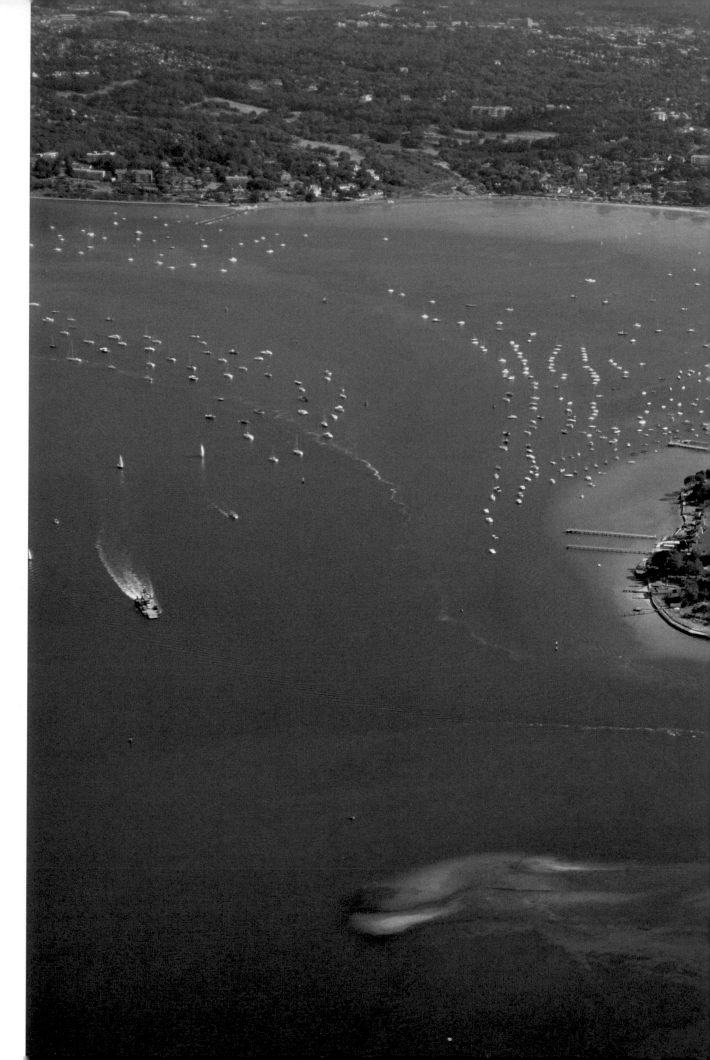

Right After New York, Hong Kong and London, Sandbanks in Poole Harbour, Dorset, is the most expensive place on earth to buy a house. But considering its location beside one of the largest and most beautiful natural harbours in the world, it's not hard to see the appeal.

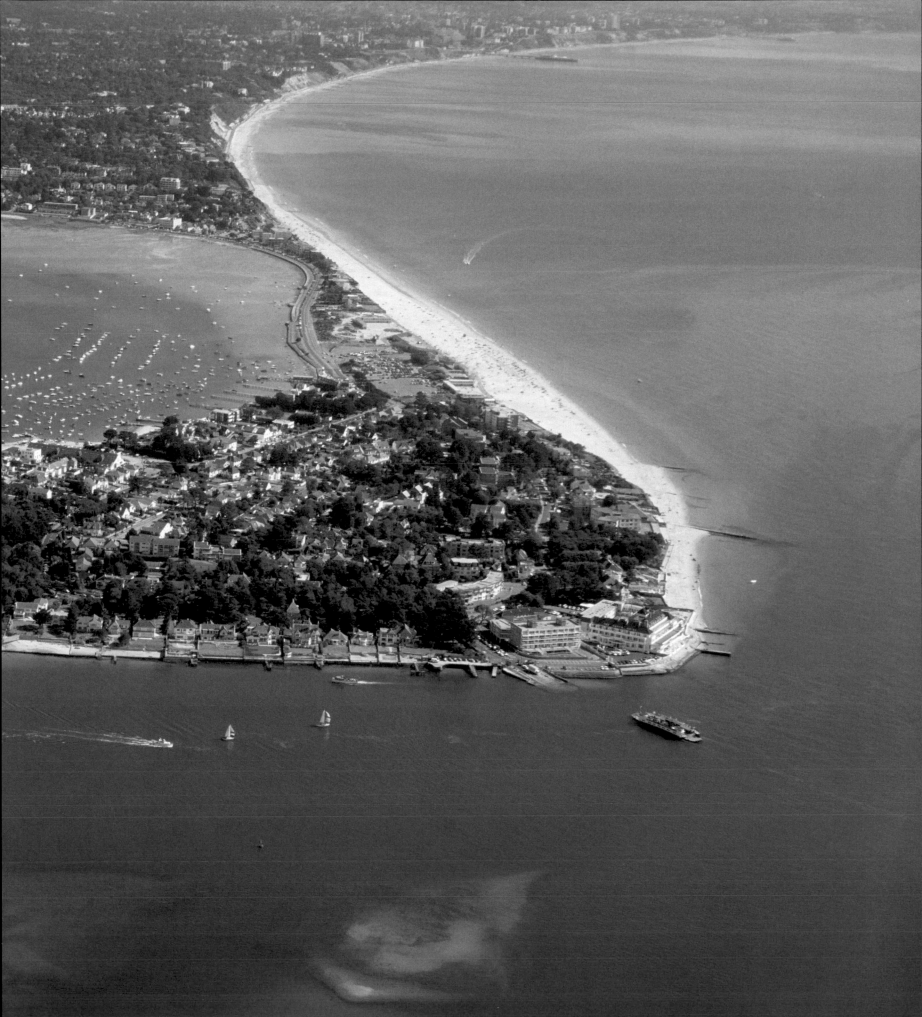

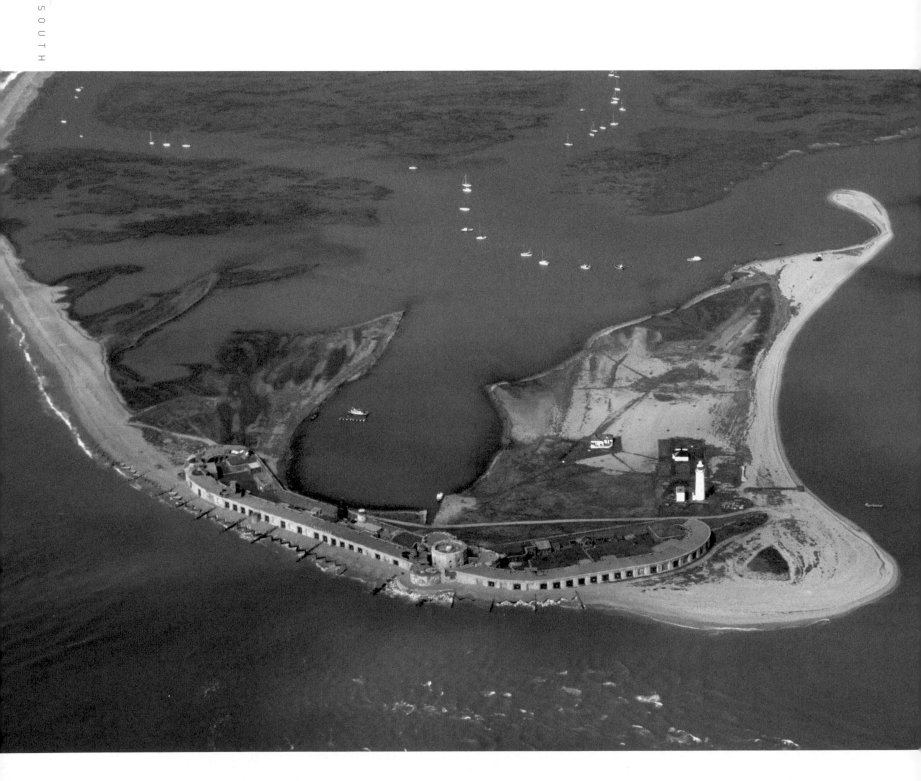

Above Treacherous currents at the narrow western entrance to the Solent provide natural protection to the approach to Portsmouth. It was here, on a shingle spit reaching into this part of the waterway, that Henry VIII ordered the building of Hurst Castle so that any would-be invaders would be at the mercy of man and nature combined.

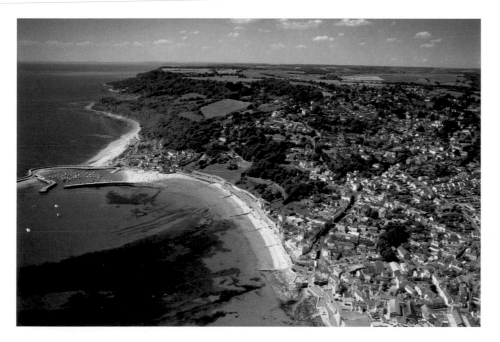

Left Known as 'the Pearl of Dorset', Lyme Regis was one of England's most important ports from the thirteenth century onwards. It was here the Duke of Monmouth, bastard son of Charles II, landed at the start of the Monmouth Rebellion, an ill-fated attempt to oust James II from the throne of England.

Below Near the village of Studland, towards the eastern end of the Jurassic Coast World Heritage Site are the Old Harry Rocks of Handfast Point – islets, arches, stacks and stumps carved out where the chalk meets the sea.

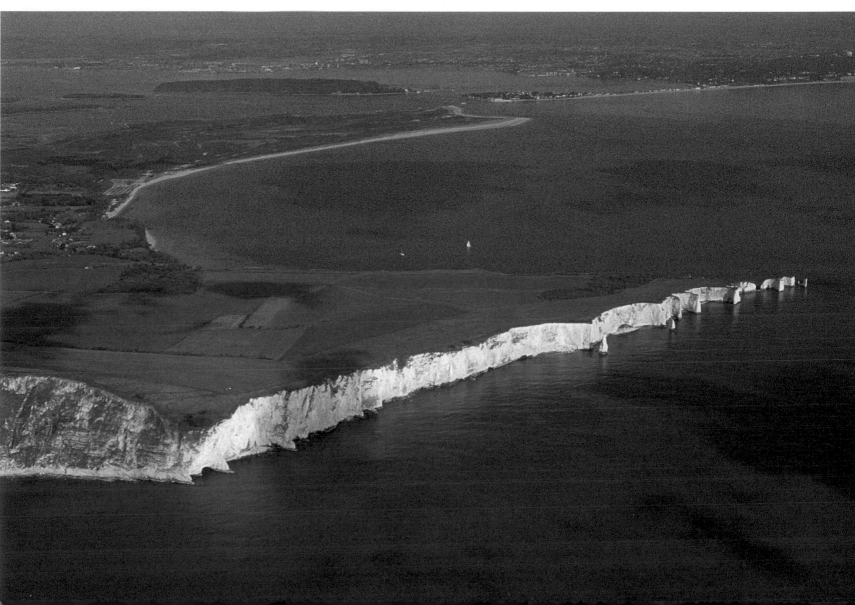

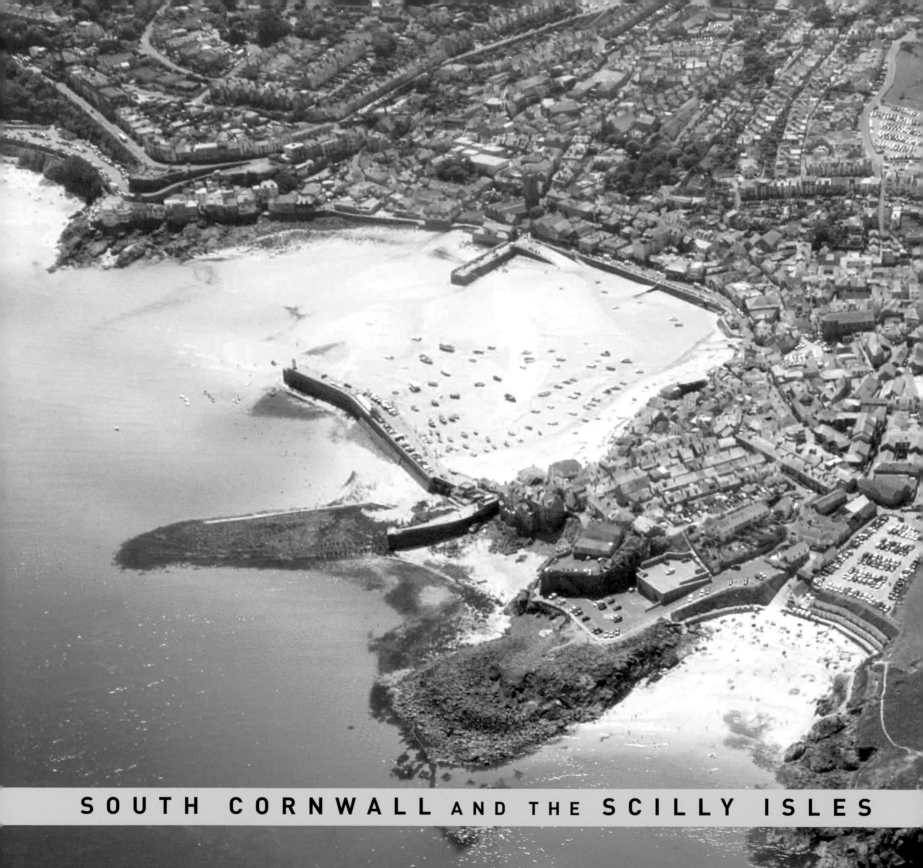

SOUTH CORNWALL AND THE SCILLY ISLES

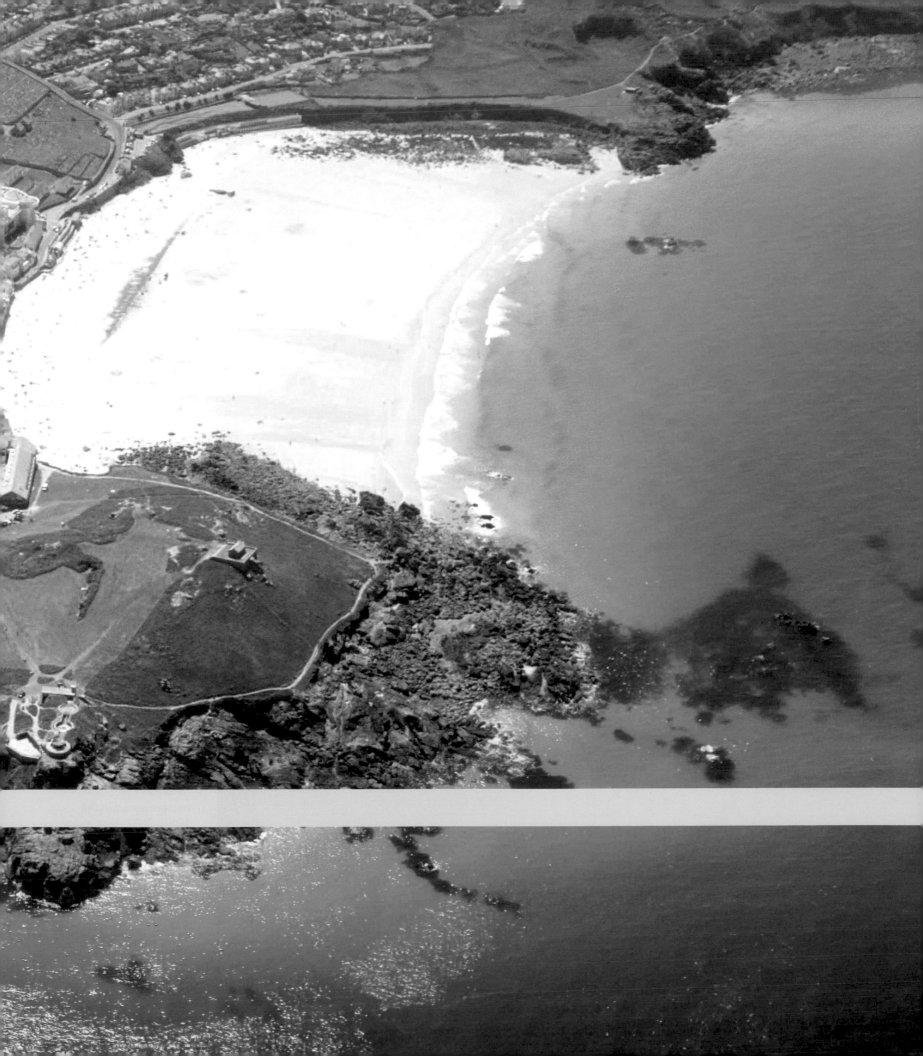

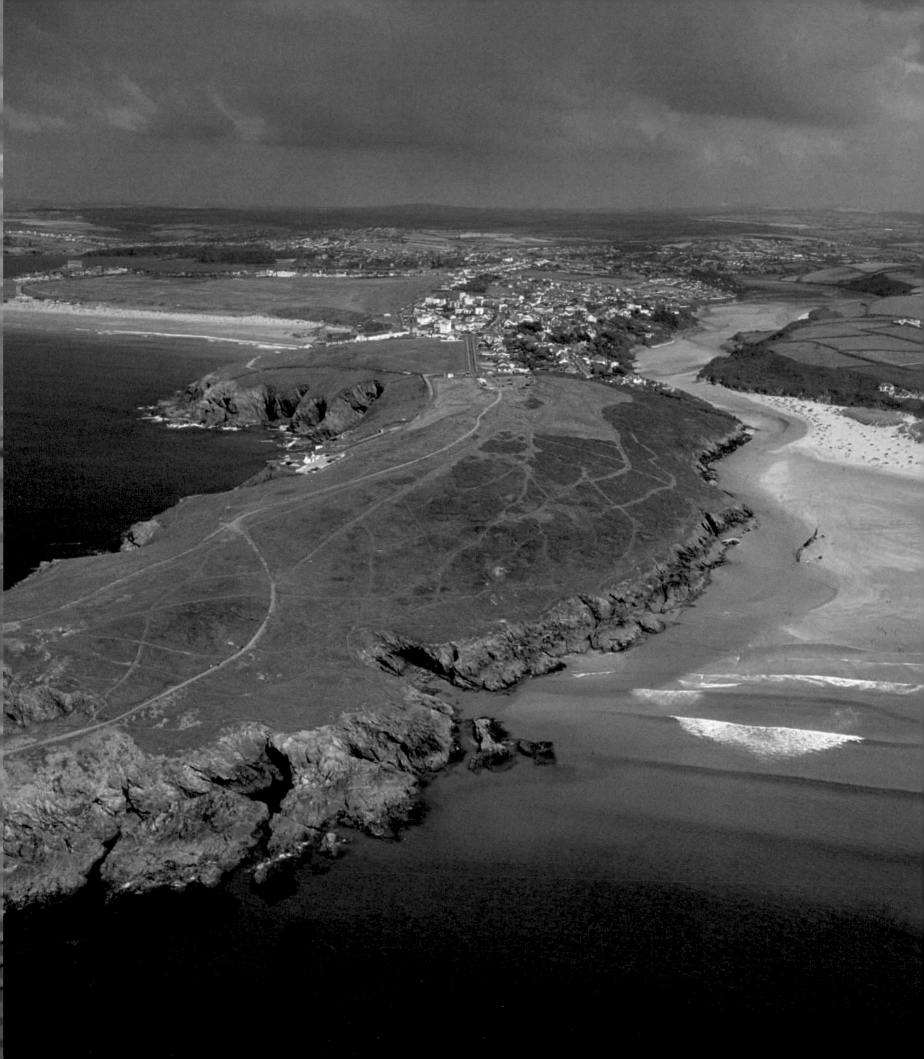

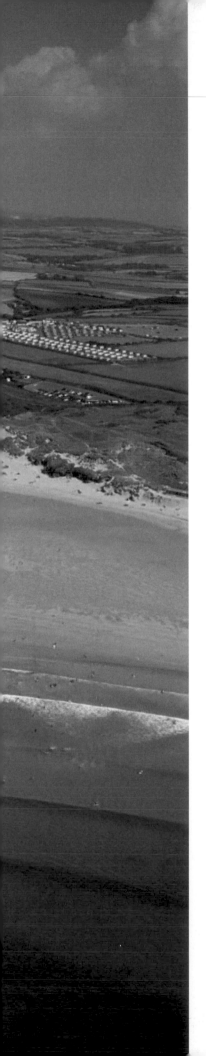

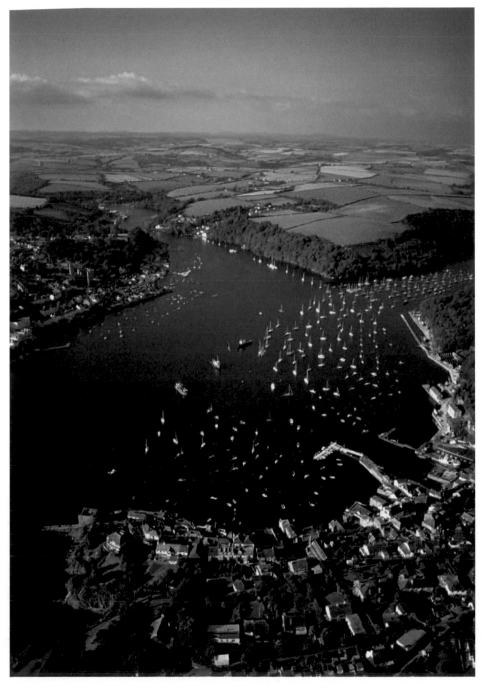

Opposite The promontory of Trevelgue Head strikes out from the coast at Newquay, providing shelter for one of the many sandy beaches accessible from the town. In hindsight, it seems amazing that it's only in recent years that this location has emerged as 'The Surfing Capital of Britain'.

Left By the time the Romans arrived in Britain the deep-water harbour of Fowey was already a working port. The town is situated on Cornwall's south coast halfway between Plymouth and Falmouth and in its day was a point of departure for no lesser maritime figures than Drake, Raleigh and Frobisher.

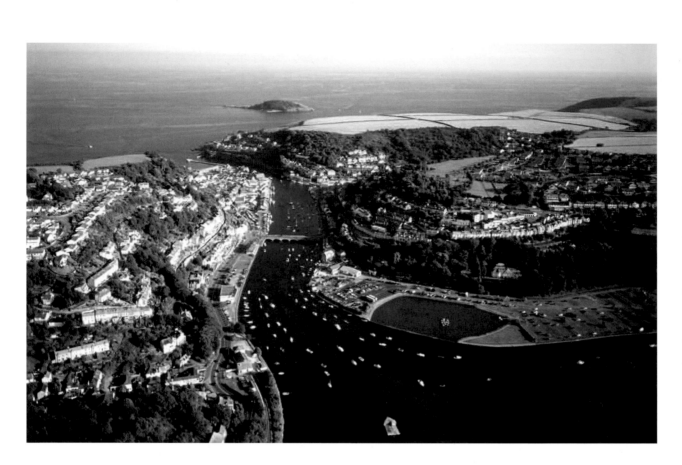

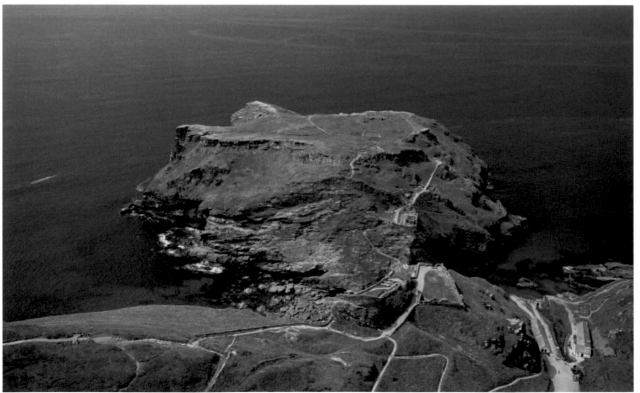

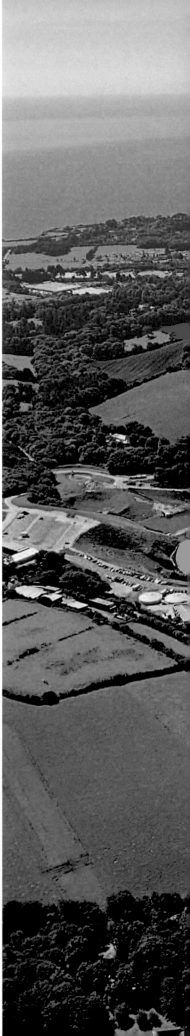

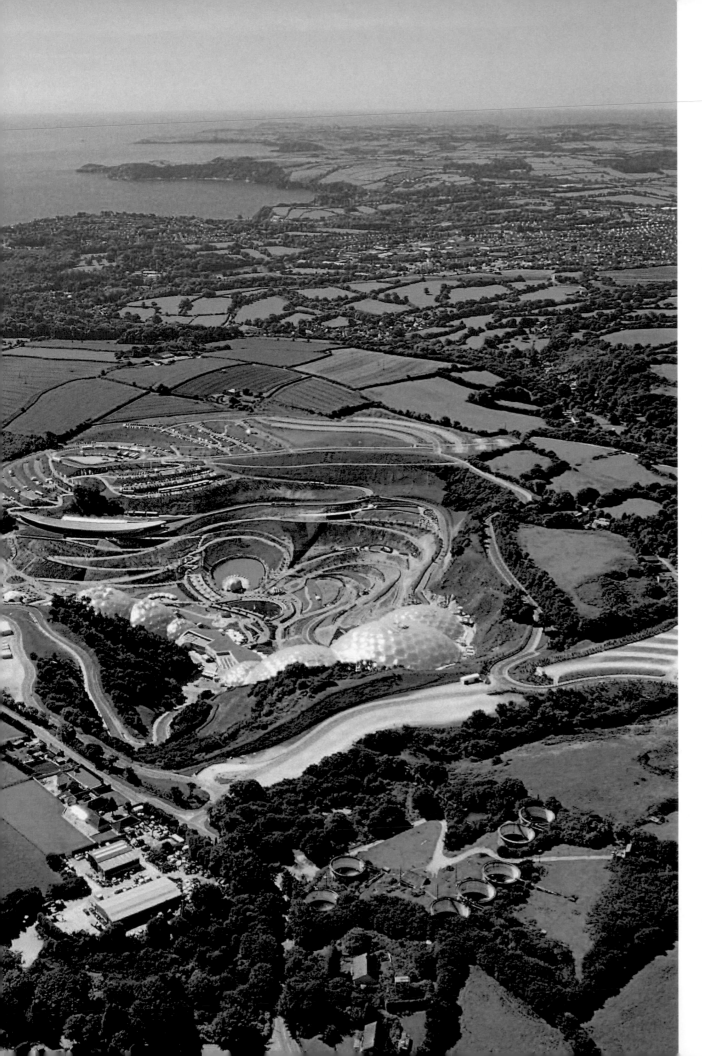

Opposite top Only 'day-boats' operate out of the Cornish port of Looe – meaning the fish landed here have been out of the sea for just a few hours before they're landed and sold. The locals will proudly tell you theirs is therefore the freshest fish available anywhere in the whole country.

Opposite bottom Almost an island, Tintagel is joined to the mainland by just a narrow strip of rock. The place is so steeped in myth and legend it is all but severed from the real world as well. It was in the fortress here that Uther Pendragon fooled Igraine into believing he was her husband – and so King Arthur was conceived.

Left What was once a disused china clay mine near St Austell in Cornwall has, since 2001, been the Eden Project. Beneath the giant domes the climate is carefully modified to create temperate, Mediterranean and tropical zones in which thrive plant species from around the world.

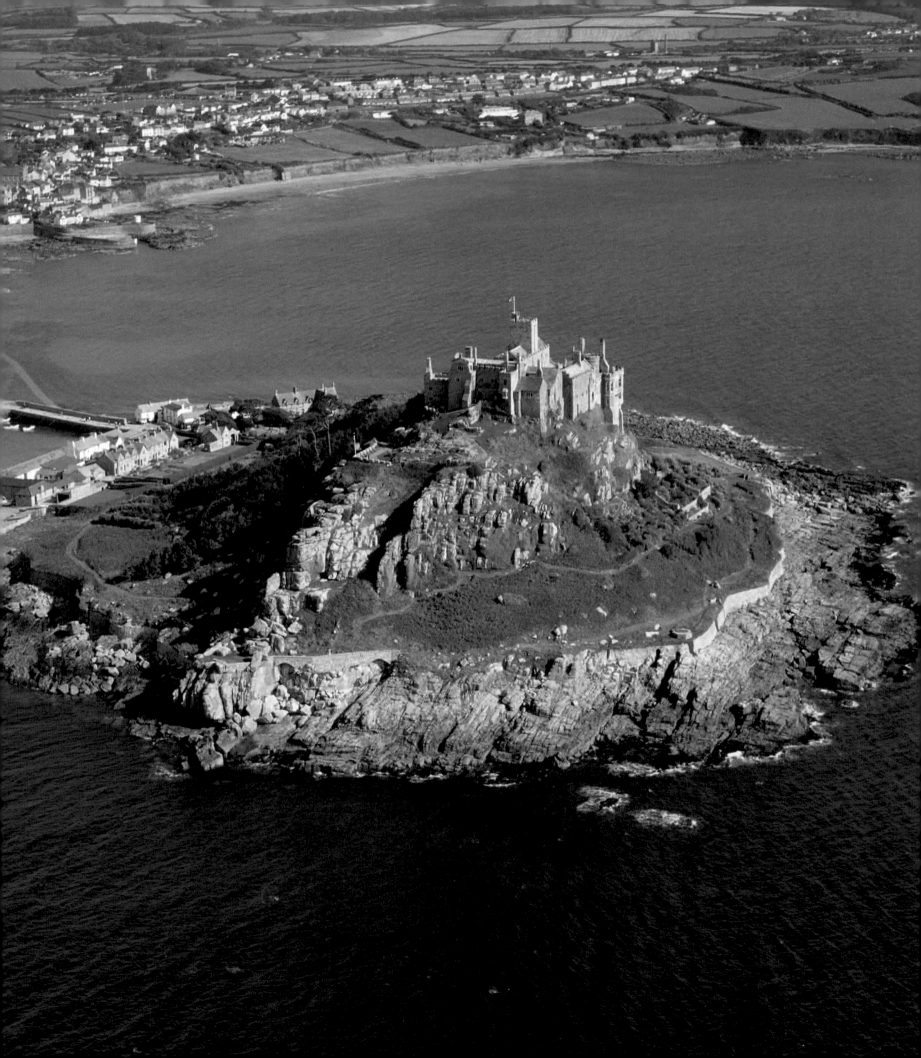

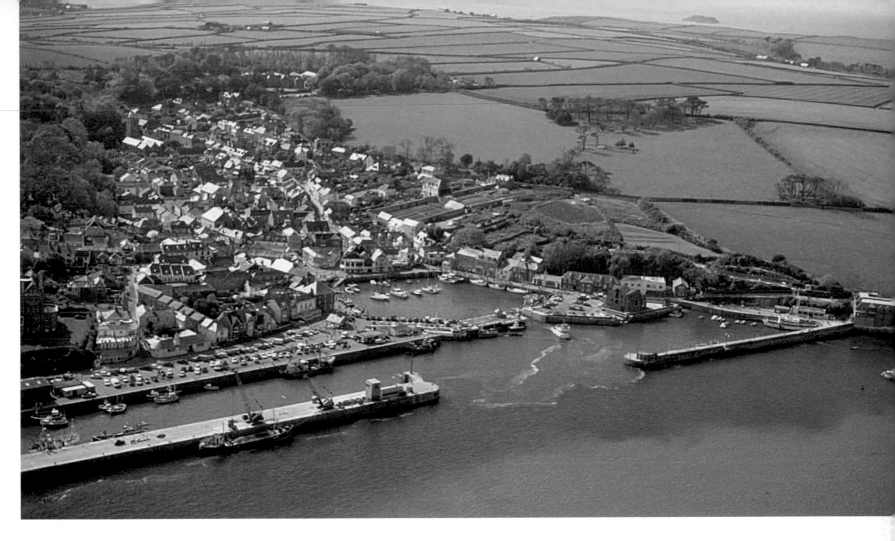

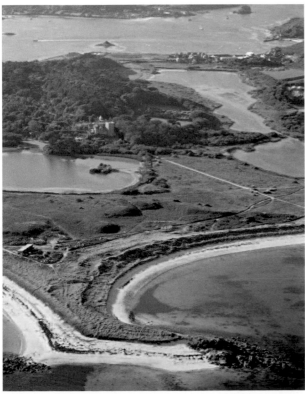

Opposite An island in the time of Phoenician tin-traders nearly 4000 years ago, St Michael's Mount is known in Cornish as 'the old rock in the woods'. How deep within the land are the roots of that tongue if it recalls the mount surrounded not by sea, but by a forest long since lost beneath the waves?

Above Padstow lies on the western side of north Cornwall's Camel Estuary. Before it was famous for fish restaurants – 4000 years before – travellers were passing through. The valleys of the Camel and Fowey rivers offered routes to and from Ireland and the west coast of Britain without having to make the dangerous trip around Land's End.

Left Second largest of the Scilly Isles, Tresco is believed by some to be a remnant of the lost land of Lyonesse – last resting place of King Arthur. Whatever the truth of the legend, with rugged heathland to the north and subtropical beaches to the south, it is anyway a place of startling beauty.

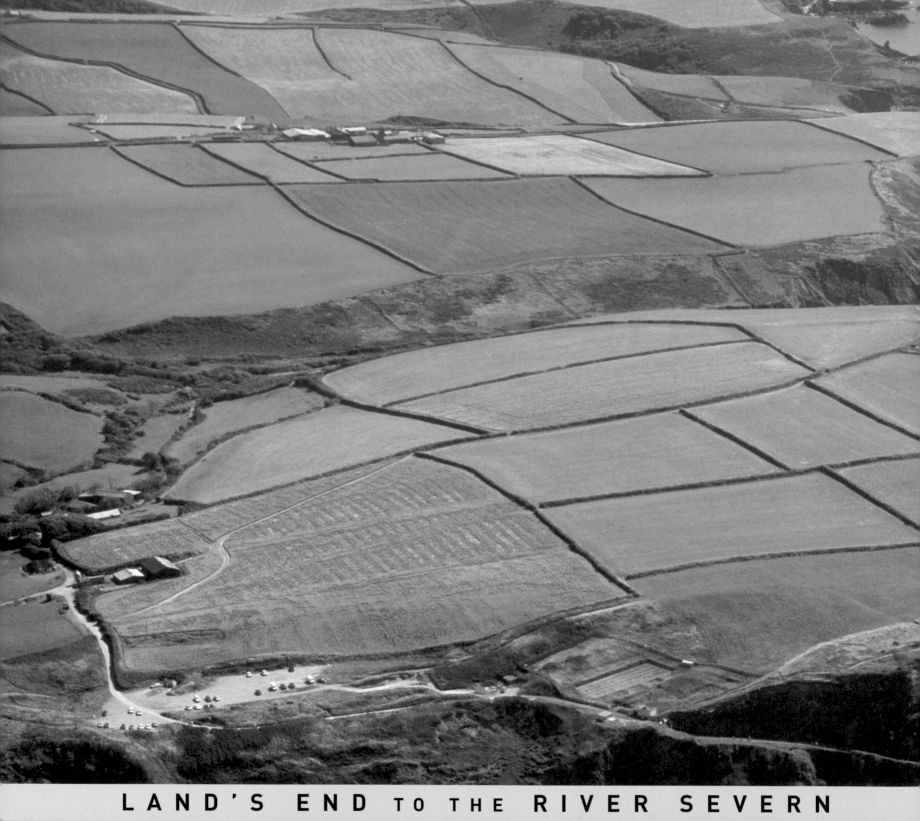

LAND'S END TO THE **RIVER SEVERN**

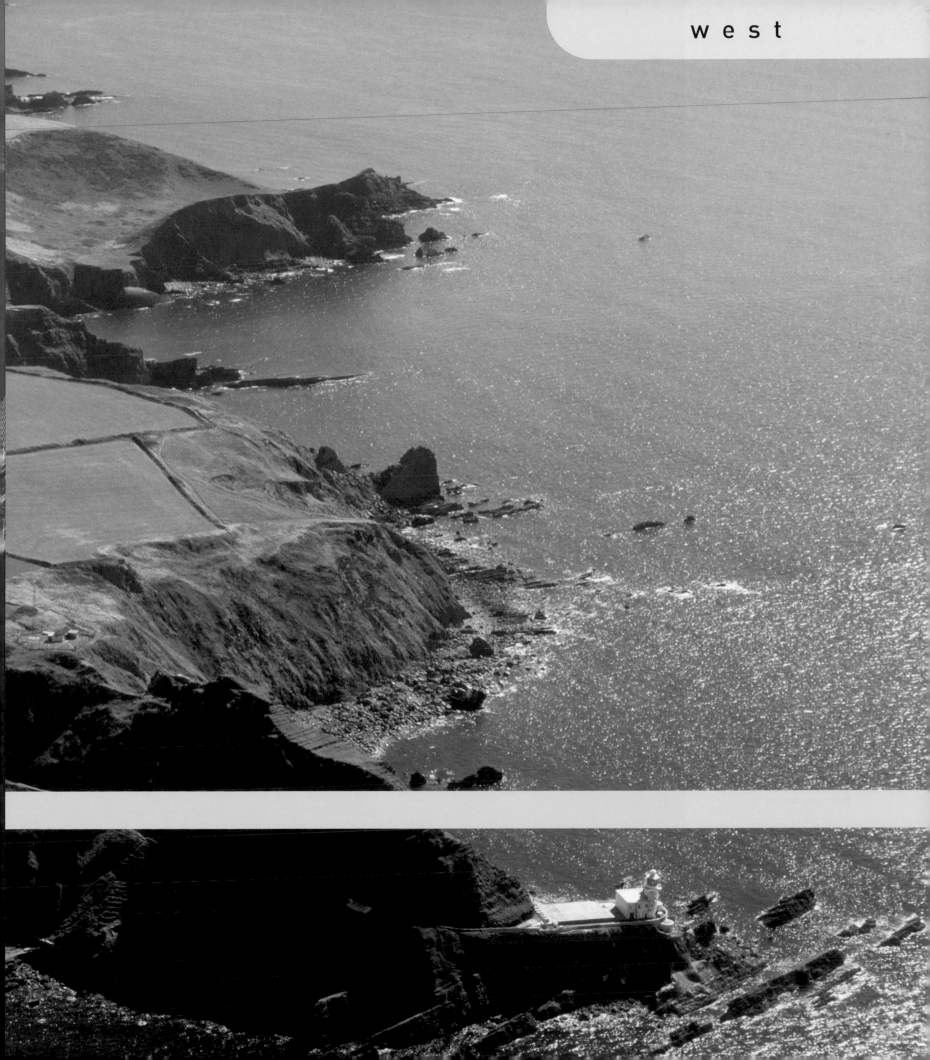

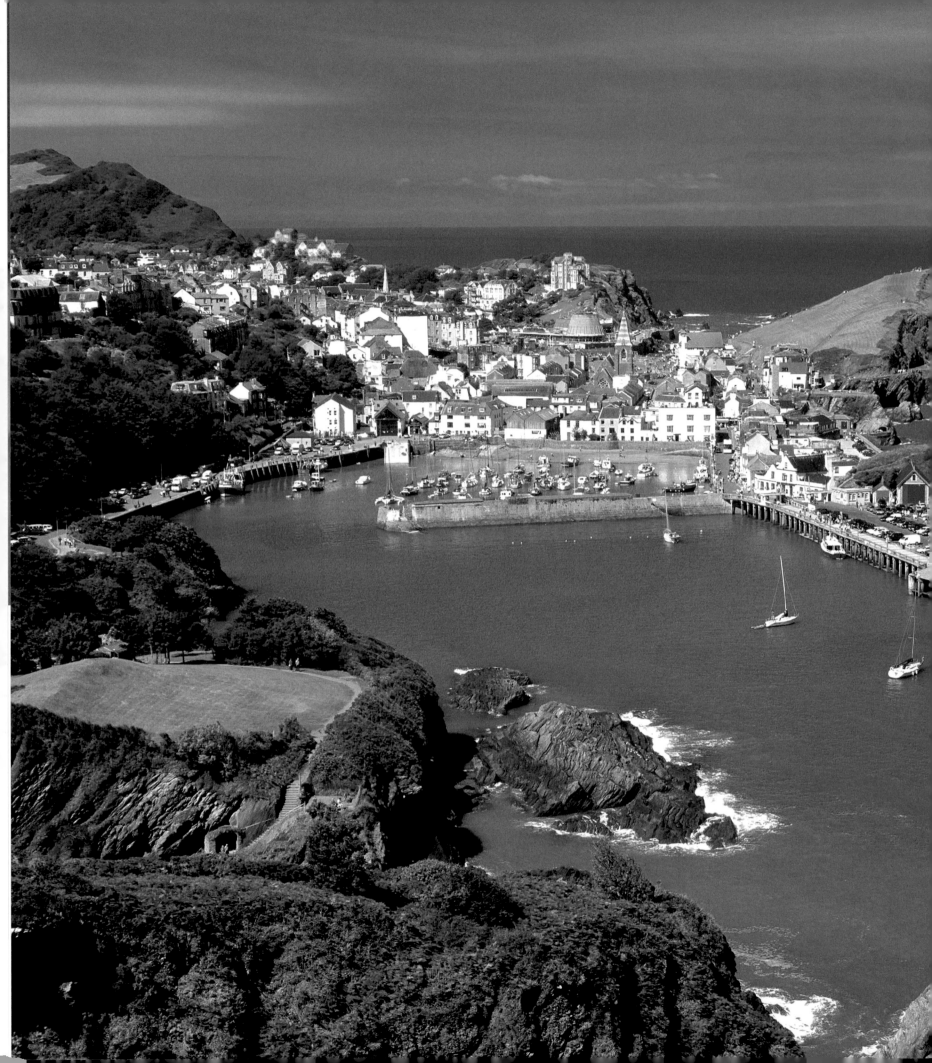

Left The name Ilfracombe is derived from the Saxon 'Aelfreinscwm', meaning 'the valley of the sons of Alfred'. This seaside resort on Devon's north coast is surrounded on all sides by its many hills, notably Hillsborough Hill, which dominates the harbour and is known locally as 'the sleeping elephant'.

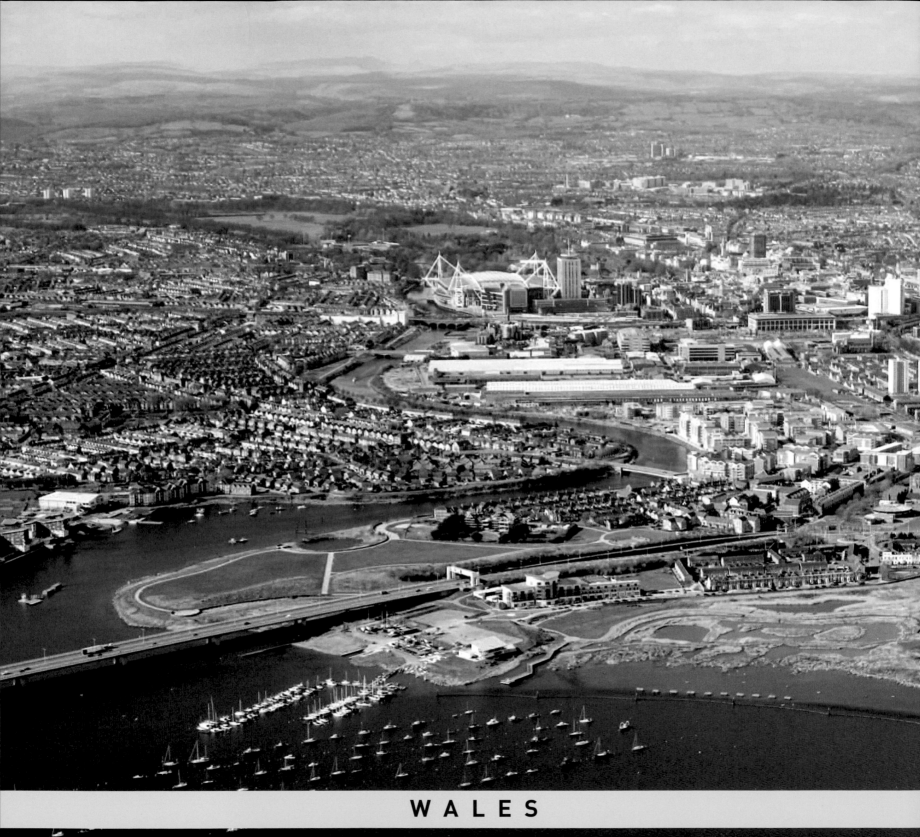

WALES

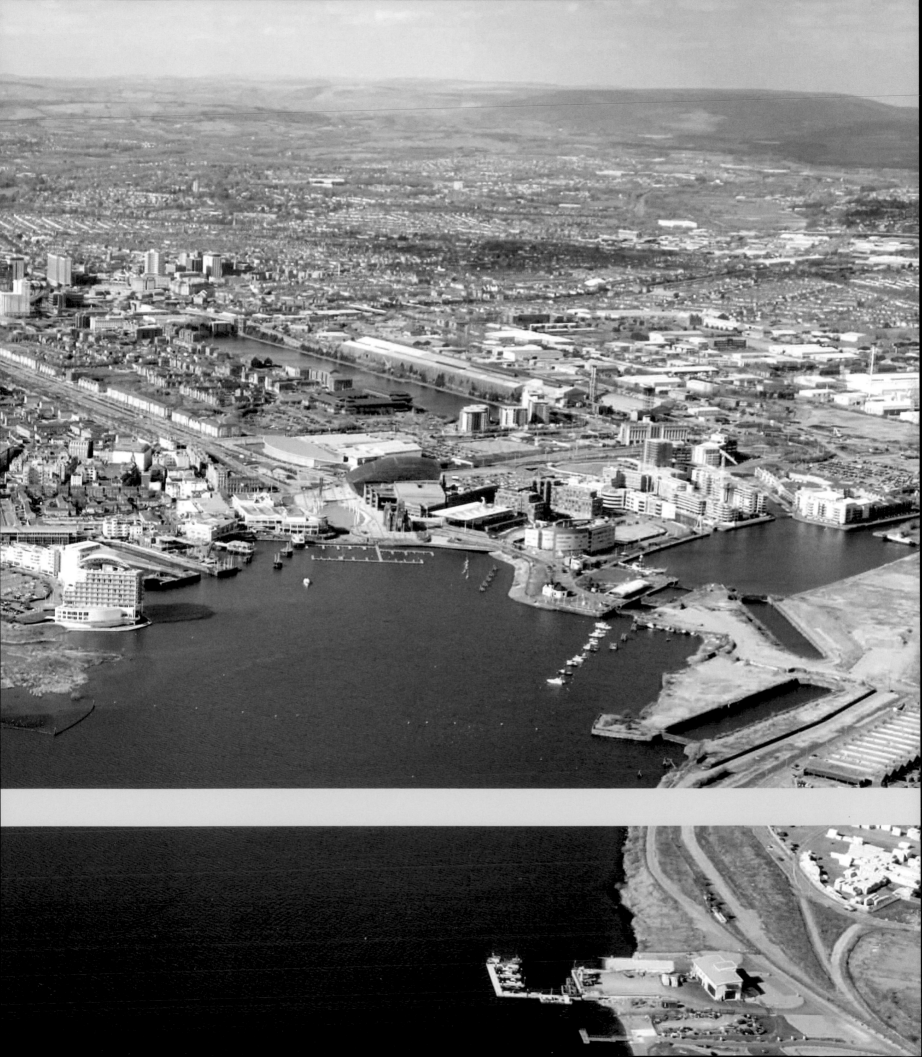

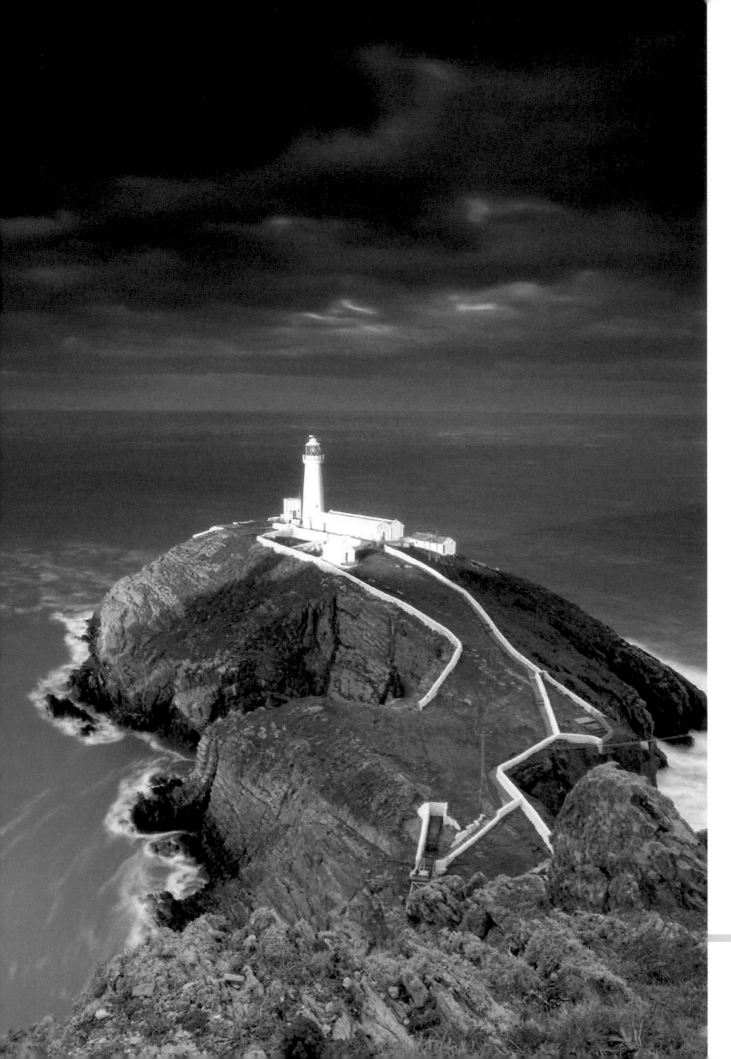

Previous pages The man-made 500-acre freshwater lake of Cardiff Bay provides the perfect setting for a capital city that has toiled long and hard to find a post-industrial identity for itself. The coal ships may be gone but the inhabitants have found a new heart here and it beats strongly.

Left Anyone seeking to visit the spectacular location of South Stack Lighthouse, three miles from Holyhead, must first negotiate a flight of around 400 stone steps down the steep mainland cliffs. The islet itself is reached by crossing a footbridge over a deep-water channel.

From above, the coastline of Wales is no more than a thin fringe skirting the vast mountain range of the interior; a land of mountains, right enough. First Cardiff and then Swansea appear beneath us, clinging like limpets to the low ground. The capital is changing fast. Where before Cardiff Bay was twice a day a dismal swathe of mud, deserted by the tide, now it's a freshwater lake flourishing behind a man-made barrage. This part of town is reinventing itself. Once it was about coal and only coal – the glistening lifeblood of the nation, coursing down the Rhondda on to ships bound for the wide world. Now the bay is about marinas full of leisure craft and luxury flats offering sea views. It's all been tamed. No more Tiger Bay. The coal doesn't flow here any more and neither does the tide.

Past the two principal cities and deeper into the west, we round Pembrokeshire heading for St David's. This is the tiniest of cities but it has at its heart a massive cathedral. The building seems tired, slumping drowsily into its own foundations.

Wales is a place for deep thoughts, old thoughts. Around this coastline it's impossible – at least for me – to resist plunging into myth and legend. Now shallow sea, Cardigan Bay was once dry land, rich and fertile. The story of its sudden inundation by the sea is echoed at points all round our coast – but here there's proof of truth. Low tide at the coastal town of Borth sometimes reveals the stumps of huge and ancient pine trees, relics of a time when what is now a bay was a great forest. Just as the Cornish name for St Michael's Mount recalls a period of our history when the coastline was shaped quite differently from what we know today, the stumps at Borth also deserve our attention. Both are reminders that nothing about our landscape is immune to change.

The Welsh coast offers glimpses of both past and future. My strongest memory of this part of the journey, however, is a bridge between the two. During Victoria's reign there was an 'optical telegraph' between Holyhead and Liverpool. Messages were transmitted between the two points, via movable arms on towering masts, 'faster than the wind'. The telegraph relied on line of sight and the careful attention of human crews, but the driver for it – the urge to communicate over great distances – is the same as the one that compels us to carry mobile phones. As well as everything else, our coast has always borne witness to our innovative spirit.

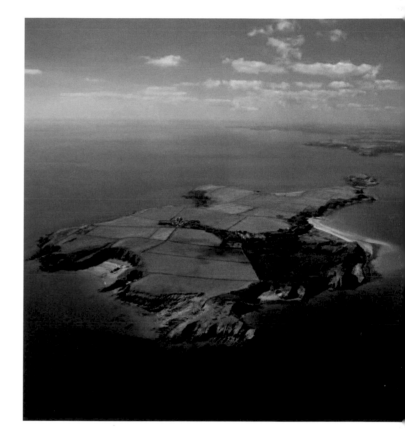

Above Across the Caldey Sound from the seaside resort of Tenby, in Pembrokeshire, lies Caldey Island. It was sought out by religious men in search of isolation as early as the sixth century, and is today home to a community of Reformed Cistercian monks.

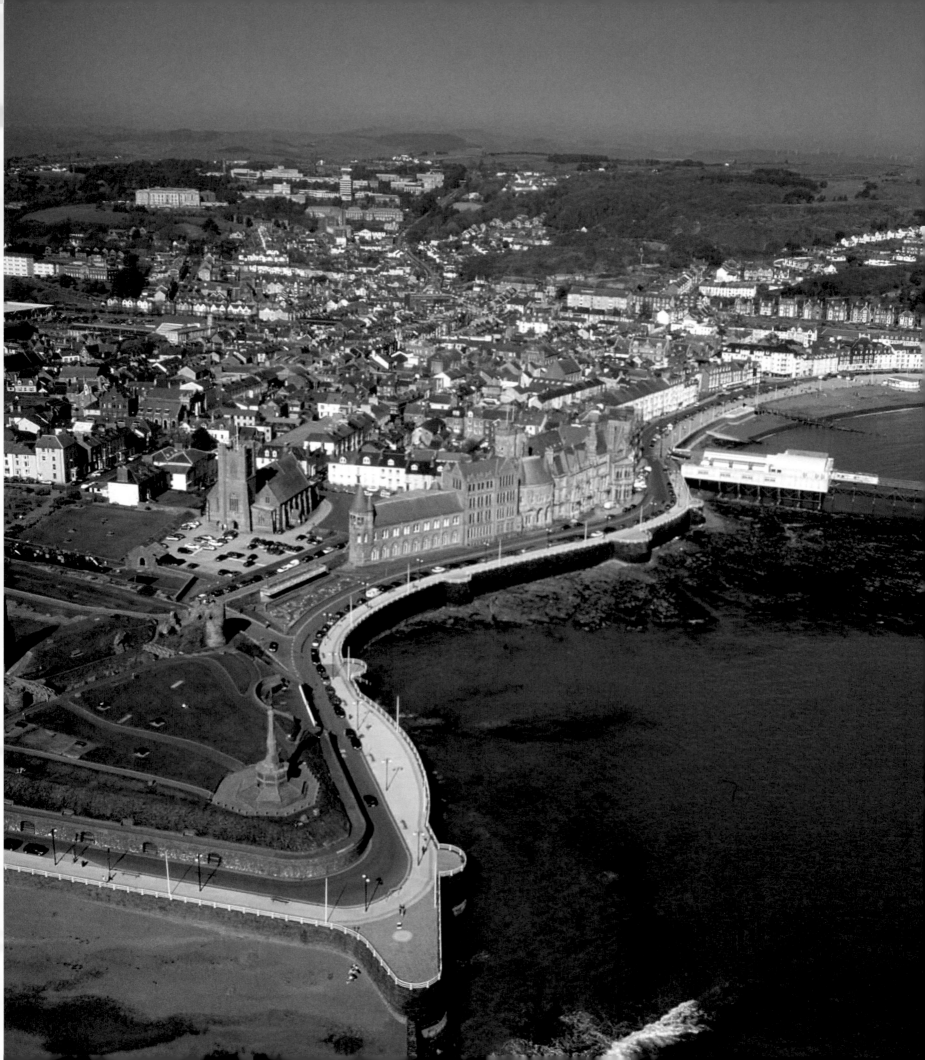

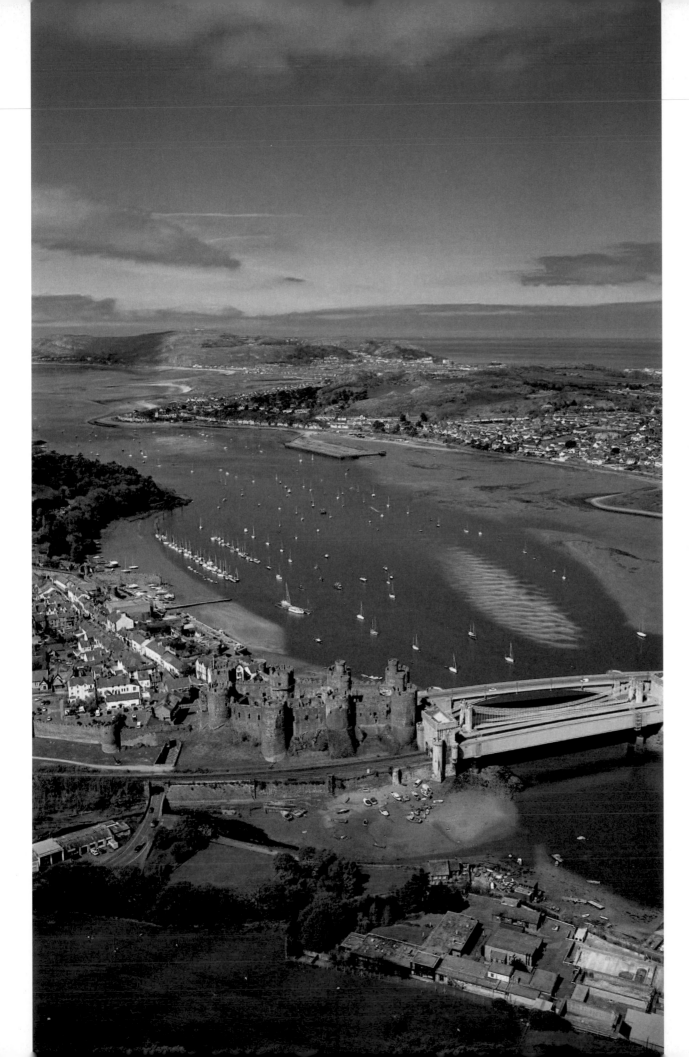

Opposite At the confluence of the Ystwyth and Rheidol rivers, towards the centre of the majestic crescent of Cardigan Bay, sits Aberystwyth. The town originally housed a Norman garrison but has also been a centre for silver and lead mining. Thanks to fishing and the transportation of ore, it was at one stage Wales' second busiest port.

Left The fine medieval walled town of Conwy, in north wales, with Deganwy beyond, on the opposite bank of the River Conwy. This view is dominated by the uncomfortable juxtaposition of the castle, built between 1283 and 1289 by Edward I, and Robert Stephenson's wrought-iron tubular bridge across the river, opened in 1849.

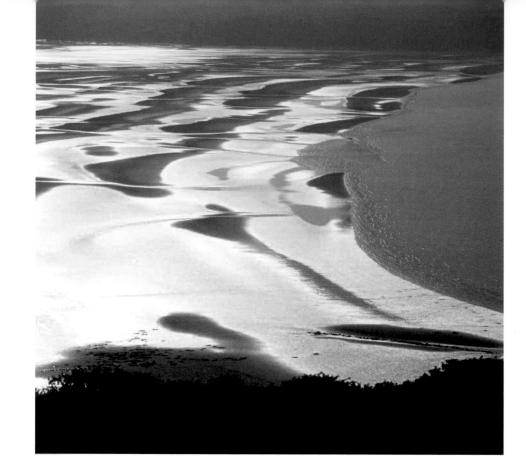

Top right Like beaten gold in the low sunlight, the sands of Red Wharf Bay on the north-east coast of Anglesey. At low tide this shallow bay reveals around 10 square miles of beach, dune and salt marsh and attracts curlew, dunlin, grey plover, oyster catchers, purple sandpipers and shelduck.

Right The elegant sweep of Marloe Sands, part of the Pembrokeshire coastal path, points the way westwards towards the unpopulated Skomer Island, a nature reserve that is home to around half-a-million seabirds, including a large colony of puffins.

Opposite The evidence of ceaseless erosion by the sea, cutting back these cliffs near Bridgend, in Mid Glamorgan, appears on the foreshore like wrinkles on a furrowed brow. Dynamic sites like this remind us our coastline is the most changeable and unpredictable environment we have.

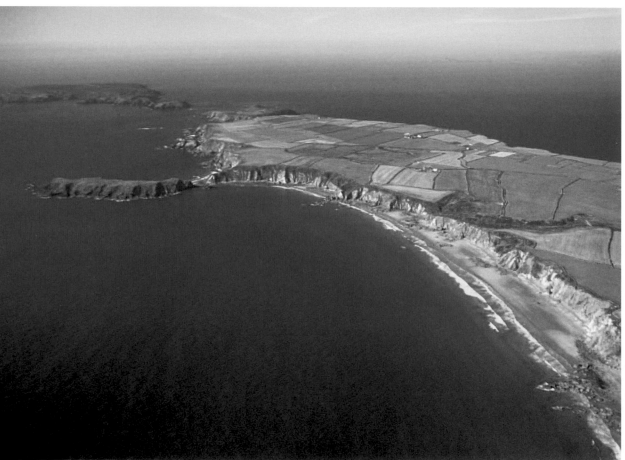

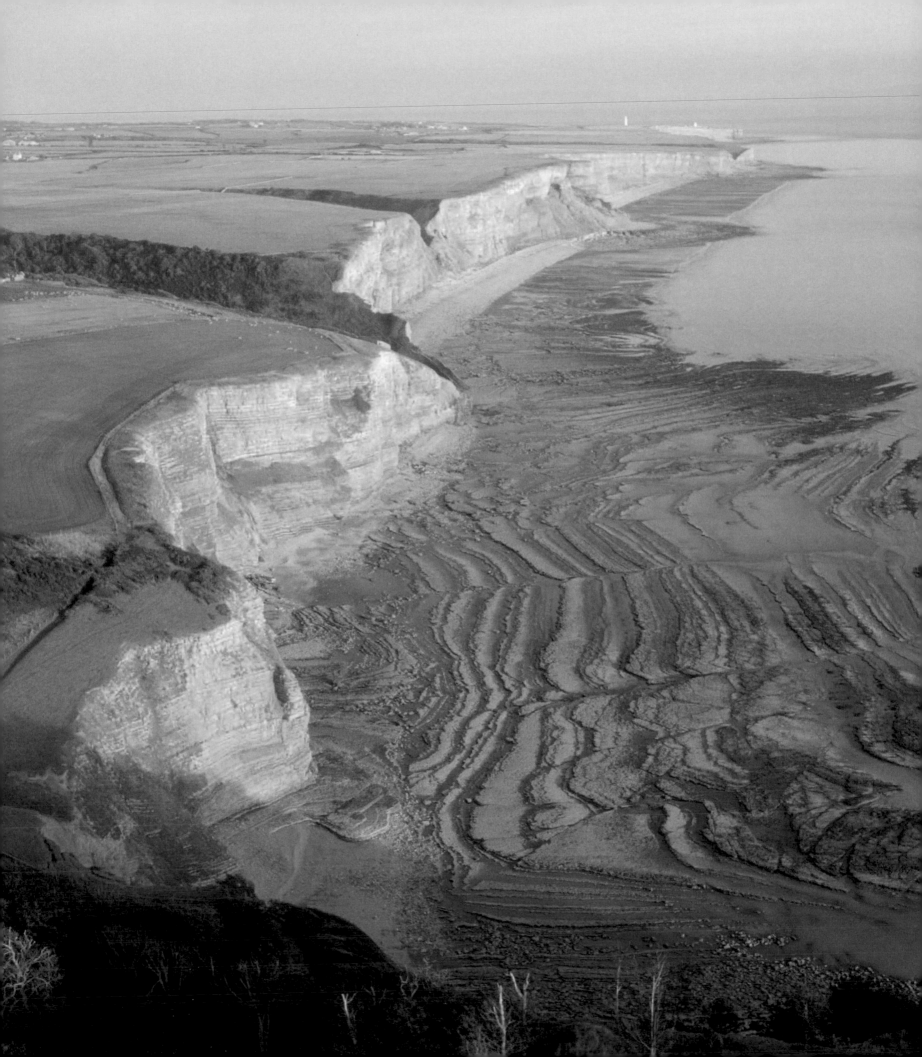

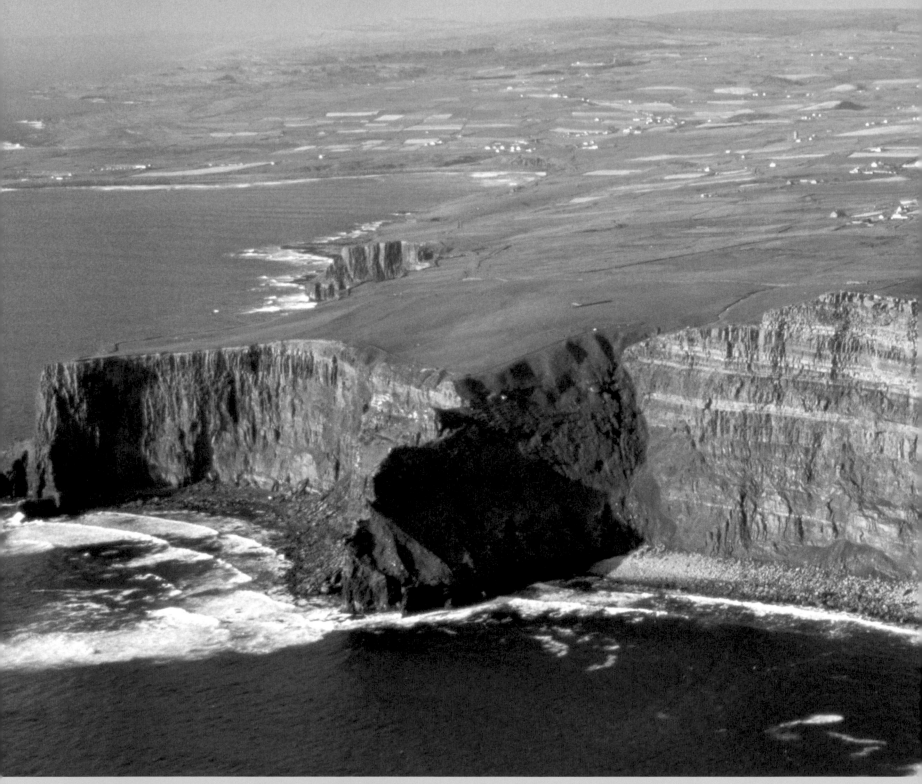

DONEGAL TO WICKLOW

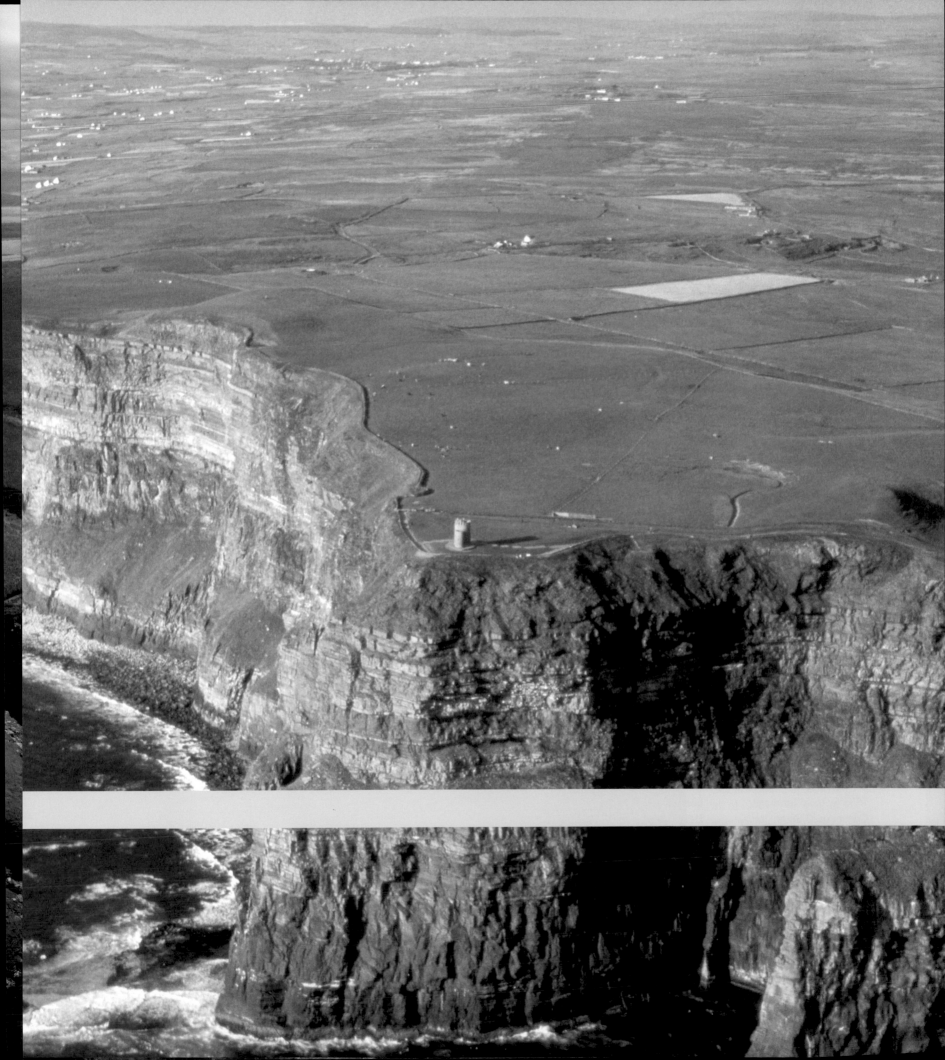

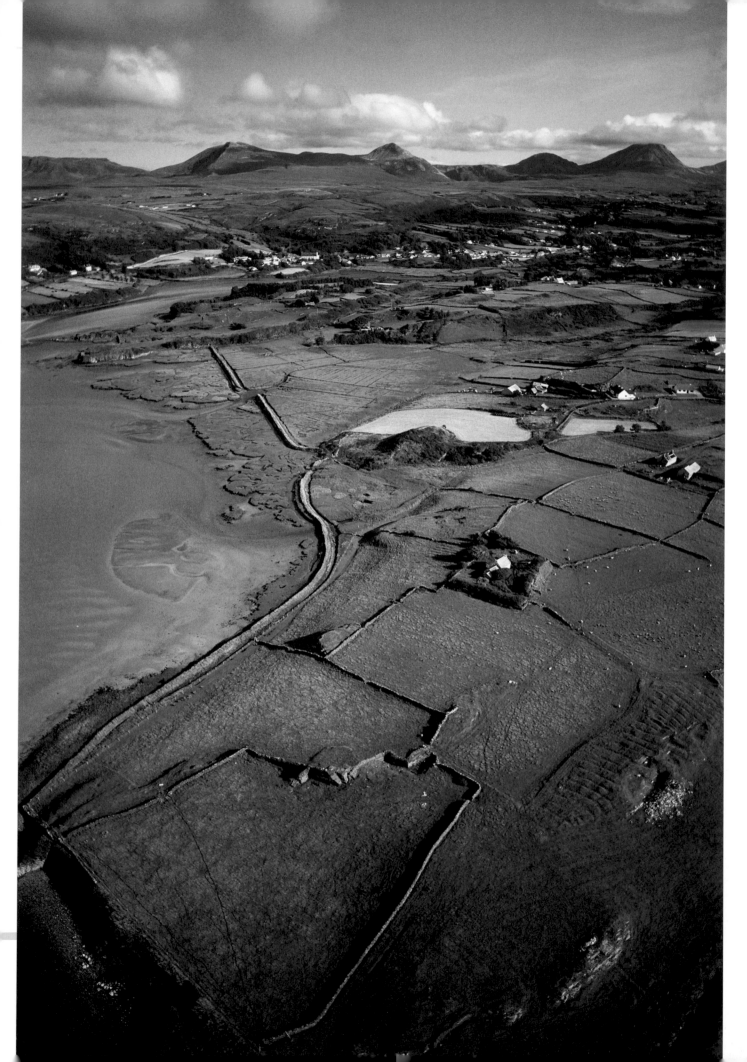

Left The marks of centuries, even millennia, of agriculture mark mile after mile of the coast of County Donegal. On the far horizon are the Derryveagh Mountains, the principal mountain range of this part of the Republic of Ireland.

Opposite top Tory Island off the coast of County Donegal seems toughened and hardened by harsh treatment meted out by the sea. The great angular promontory in the foreground is named Balor's Fort, after the one-eyed king of a race of giants who once made the place his home.

Opposite bottom All straight edges – an Irish jigsaw puzzle on Inis Mor, largest of the three Aran Islands in Galway Bay. Close by are Inis Meain, 'middle island', and Inis Oirr, 'eastern island'. Even today the settlements huddle on the eastern shores of the islands in hope of shelter from Atlantic storms.

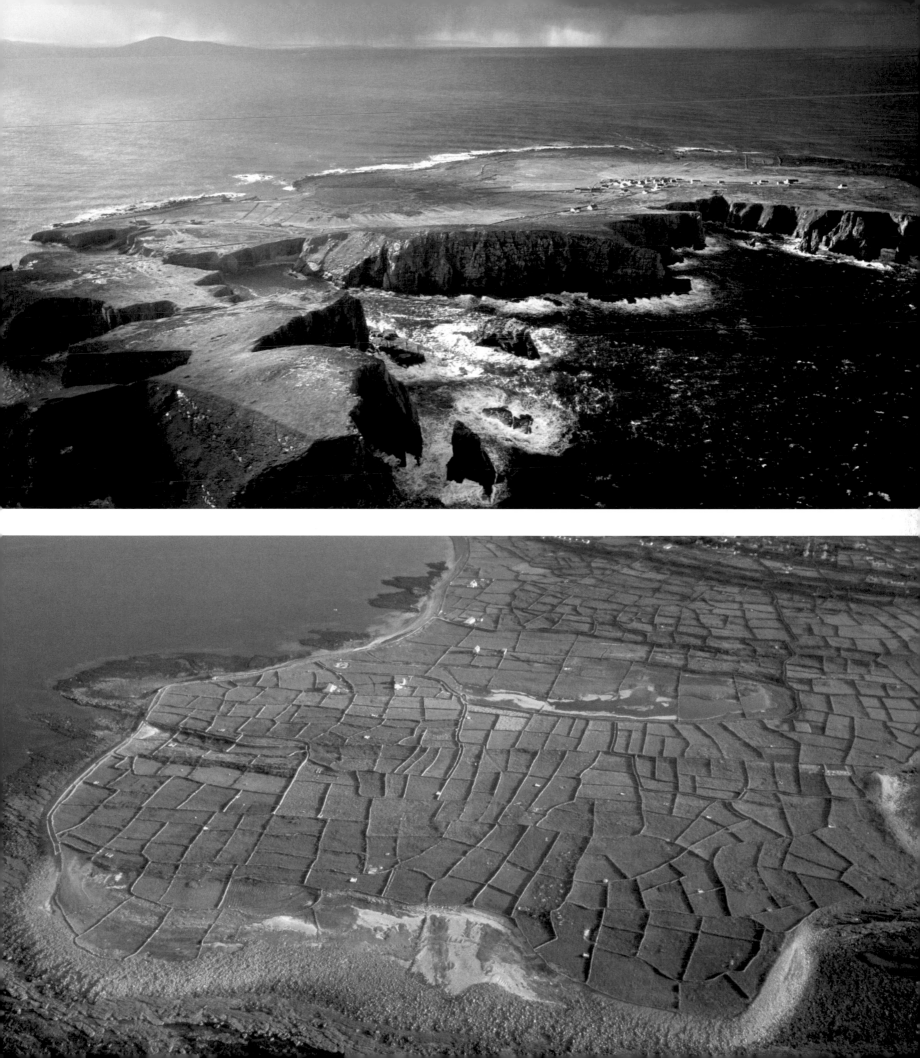

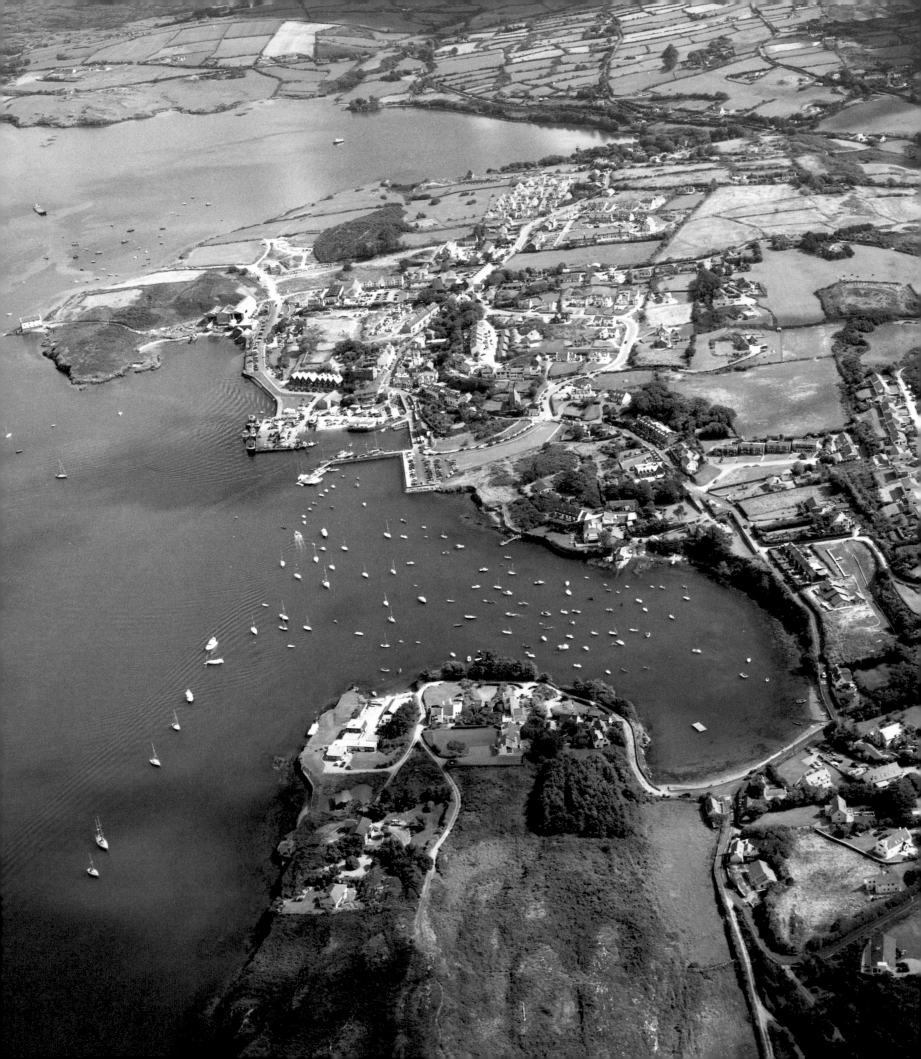

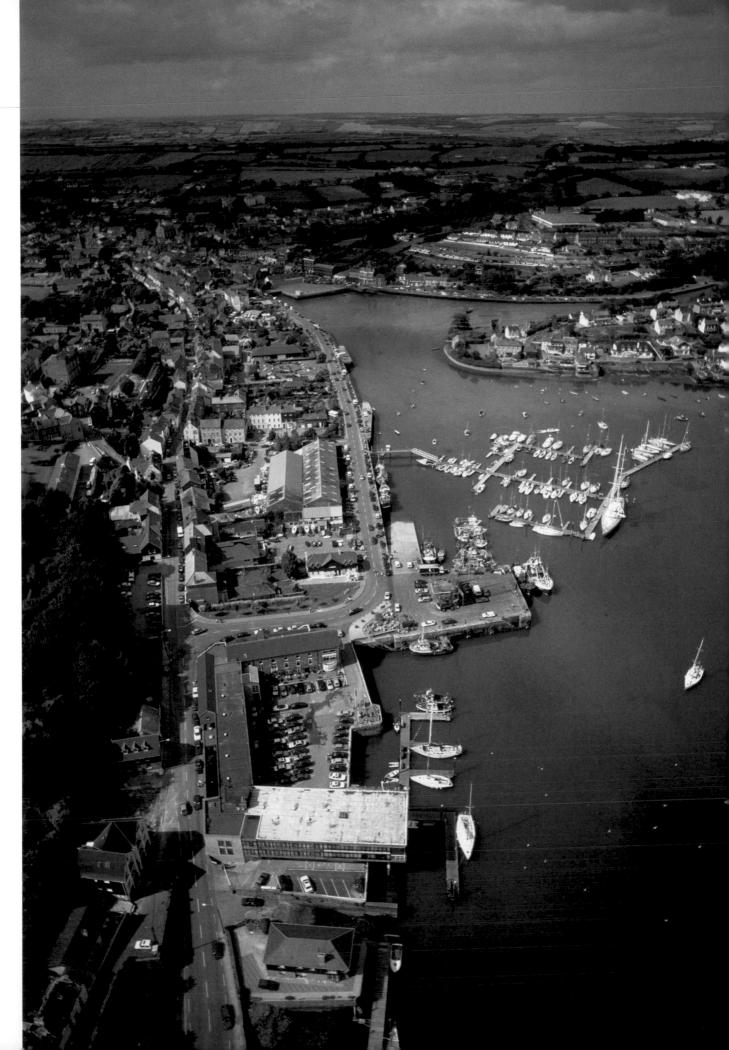

Opposite In 1631 almost the entire population of Baltimore in the west of County Cork was taken by Algerian pirates and sold as slaves in North Africa. In the year of the 200th anniversary of the abolition of the slave trade throughout the British Empire, it's worth remembering that this scourge of mankind has affected all races.

Right At the mouth of the River Bandon sits the village of Kinsale, quietly remembering a history that connects it to Spain, France and even the Americas. It was off the coast of Kinsale that the great steamship the RMS *Lusitania* was torpedoed and sunk by a German U-boat, on 7 May 1915, with the loss of 1198 lives.

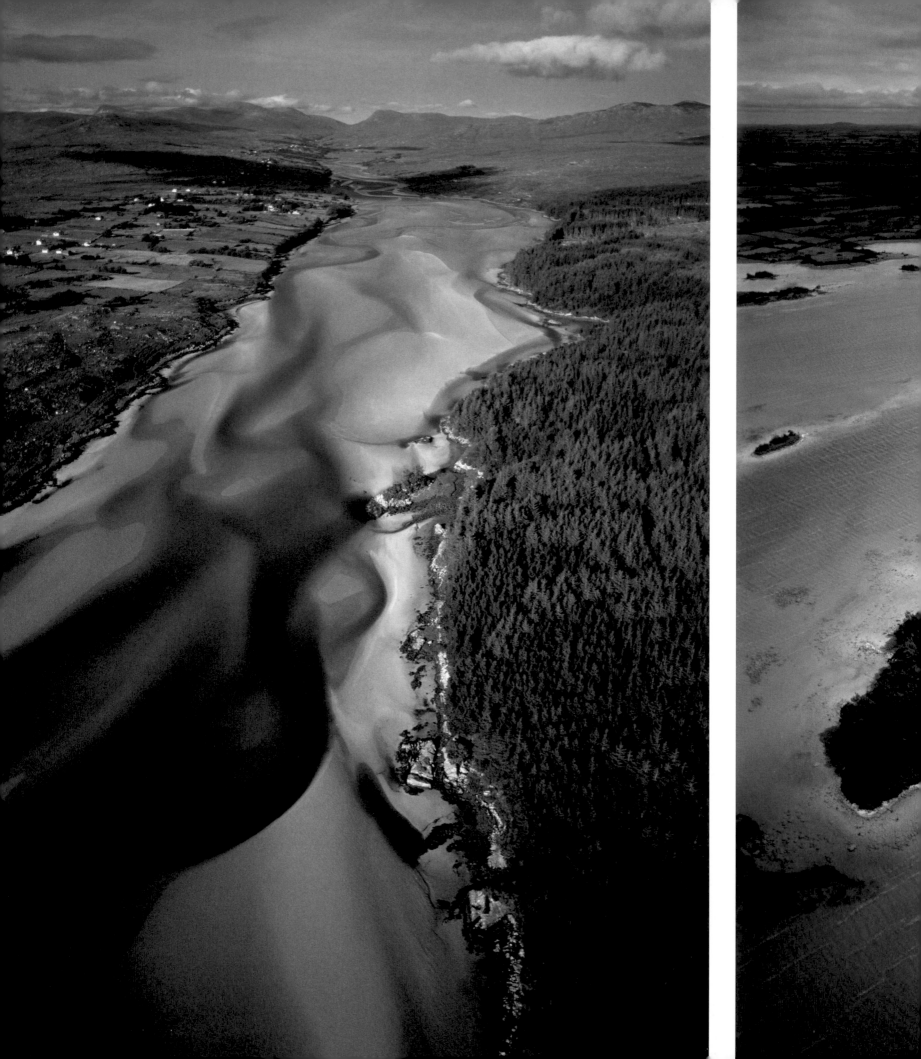

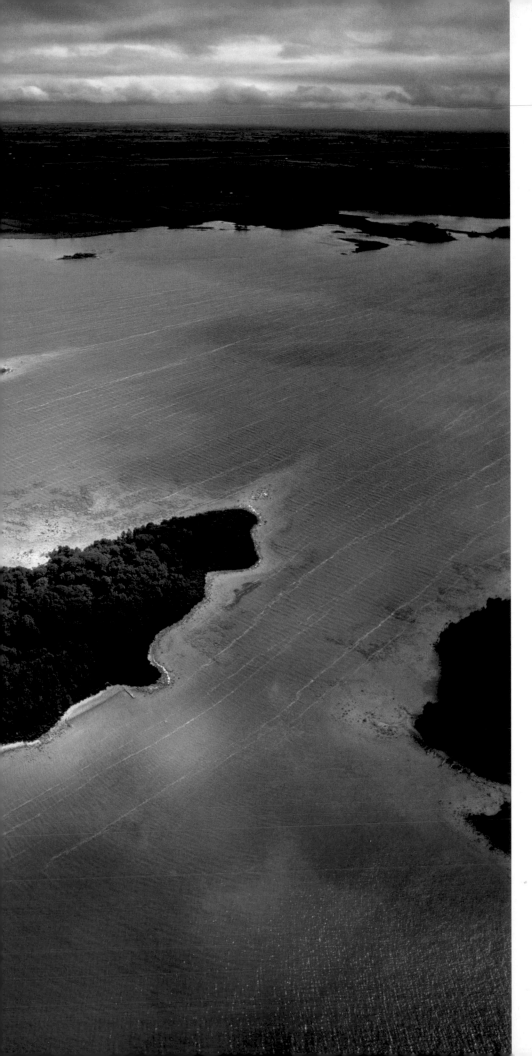

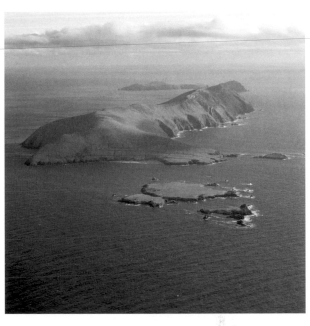

Opposite Dreamily, lazily the waters of Gweebarra Bay Estuary in County Donegal take the time to reflect all the colours of earth and sky as they wend their way across the sands and silts towards the sea.

Left Not a paradise holiday destination in the Caribbean, but a densely forested island in the clear shallow waters of Lough Carra in County Mayo. Popular with trout fishermen, this spring-fed lake is around six miles long and covers an area of approximately 4000 acres.

Above Beyond Slea Head, at the end of the Dingle Peninsula, lies Great Blasket Island – four miles long by half a mile wide and rising out of the sea like the spine of a monster. It was in the waters here that several ships of the ill-fated Spanish Armada met their doom.

DUBLIN to DERRY

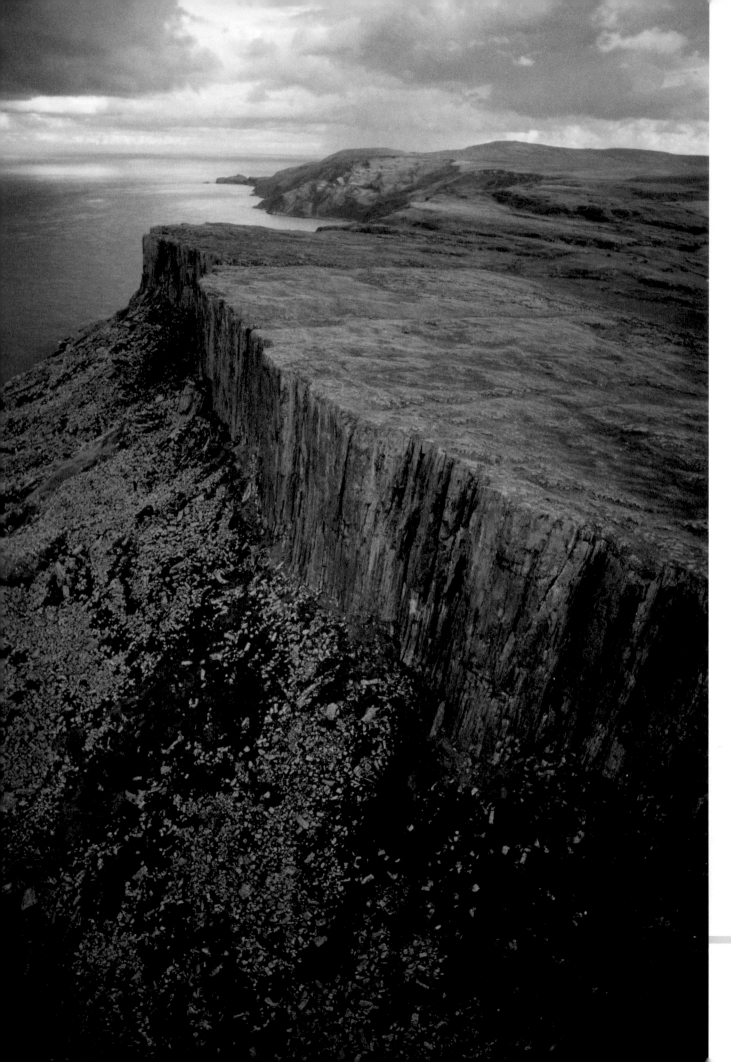

Previous pages Near Ballycastle towards the north of the Antrim Coast, land and sea fight it out – a moment of battle in the endless war of erosion.

Left Rising nearly 650 feet above the sea, Fair Head Cliffs in County Antrim are the tallest in Northern Ireland and the Republic. Climbers are drawn to the spot from all over the world to tackle the biggest expanse of scaleable rock anywhere in the British Isles.

Dublin is a coastal city that seems to have its back turned to the sea. People seldom talk about coming to it for walks along the beach, after all. Perhaps it faces inland because it's been an invaders' city – first the Vikings, later the British. When the incomers arrived they were finished with the sea and looked instead to the emerald-green interior for their future prosperity.

North from the capital of the republic and the journey carries us over a coastal landscape that has been a revelation me. The border that separates south from north is invisible from above, and imperceptible nowadays on the ground. Britain's sole land frontier with a foreign power, the only evidence of its existence is the switch from kilometres to miles on the roadside speed signs in Northern Ireland.

If Dublin is a city turned away from the sea, Belfast floats stubbornly above it. Sitting as it does on countless steel and timber stilts screwed and driven deep into the grey, clayey mud they call sleach, it should hardly be here at all. But here it is, in defiance of the sea and also closely wedded to it.

Heading north again and the Antrim Coast is revealed as a string of green, blue and silver jewels, with Scotland's Mull of Kintyre reaching out as if to clutch it. Over the toy building blocks of the Giant's Causeway then, past the Skerries and on to Derry. Or is that Londonderry, or London/Derry, or 'Stroke' City? No one is quite sure what name to give it any more.

From above Derry, the eye is drawn away from the town and out towards Loch Foyle, the dominant feature in the landscape here. This corner of Ireland, on the Atlantic frontier, was witness to the surrender of the German U-boats at the end of the Second World War. The wolf packs had so harried the Atlantic convoys upon which Britain depended that for a while it looked as though we might be starved out of the conflict. I stood on the edge of the loch next to the only woman to witness that surrender and she told me she could still see the U-boats clear as day.

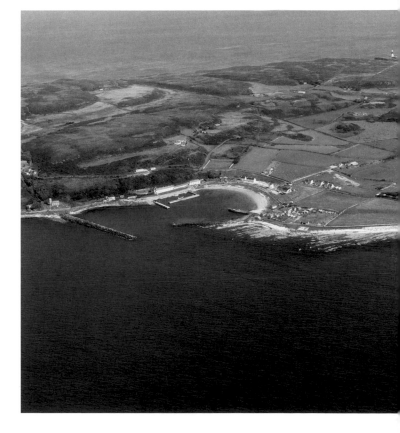

Above Church Bay on Rathlin, Northern Ireland's only inhabited island, six miles off the Antrim coast between Ballycastle and the Mull of Kintyre in Scotland. Shaped like a clumsy boomerang it has been inhabited since at least the Mesolithic period, around 8000 years ago.

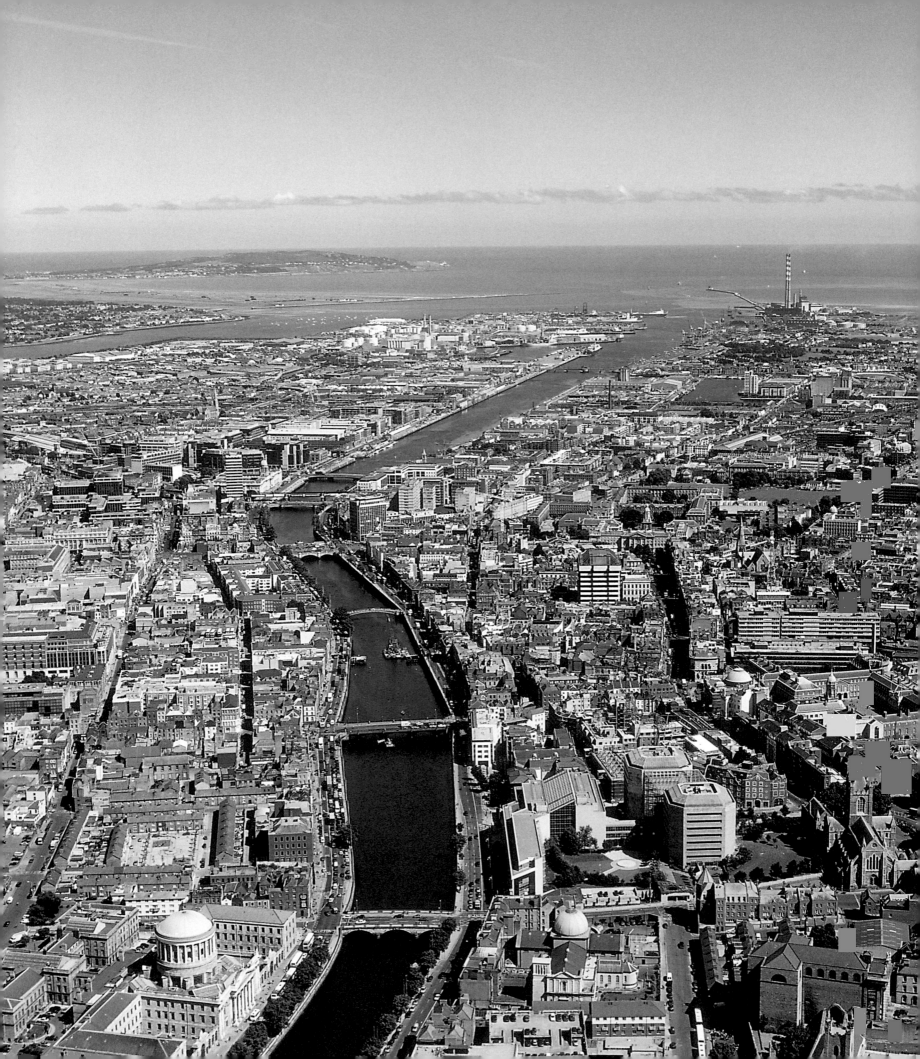

Opposite Founded by Viking invaders in the ninth century, Dublin is the capital of, and the largest city in, Ireland. The name is derived from 'dubh linn' – 'black pool' in the Irish Gaelic – and the life-blood of the place is provided by the River Liffey that cuts it neatly in half.

Below Belfast has always depended upon the River Lagan and the access it provides to the sea and the wider world. RMS *Titanic* was built on slipway number three at the Harland and Wolff shipyard here, ready for its launch into history in 1912.

Overleaf Dwarfed and sheltered by the cliffs of Whitepark Bay in County Antrim is the tiny fishing village of Portbraddon. The half-moon-shaped beach has always thrown up fossils of ancient animals and flint tools crafted by humans here at least as early as the Neolithic Age.

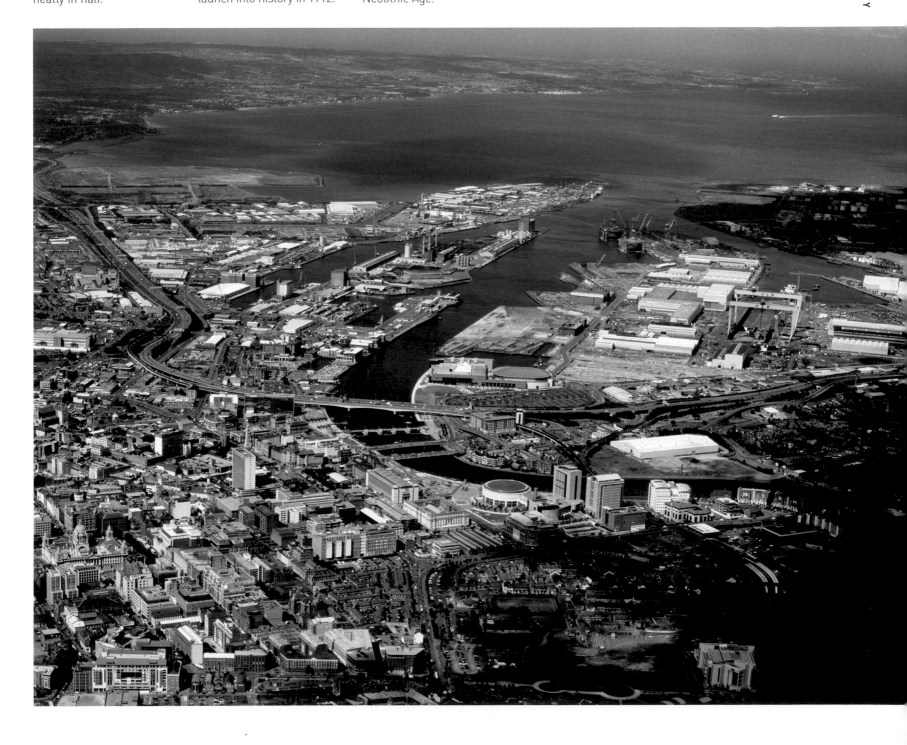

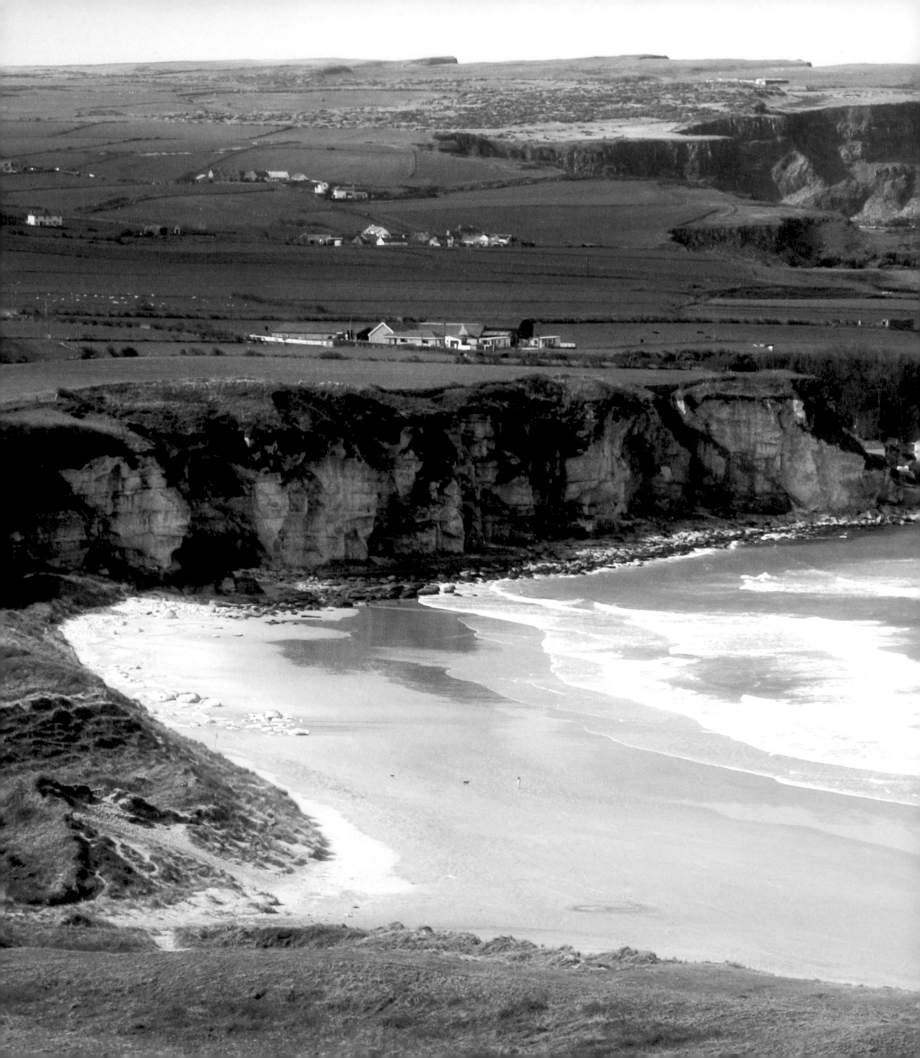

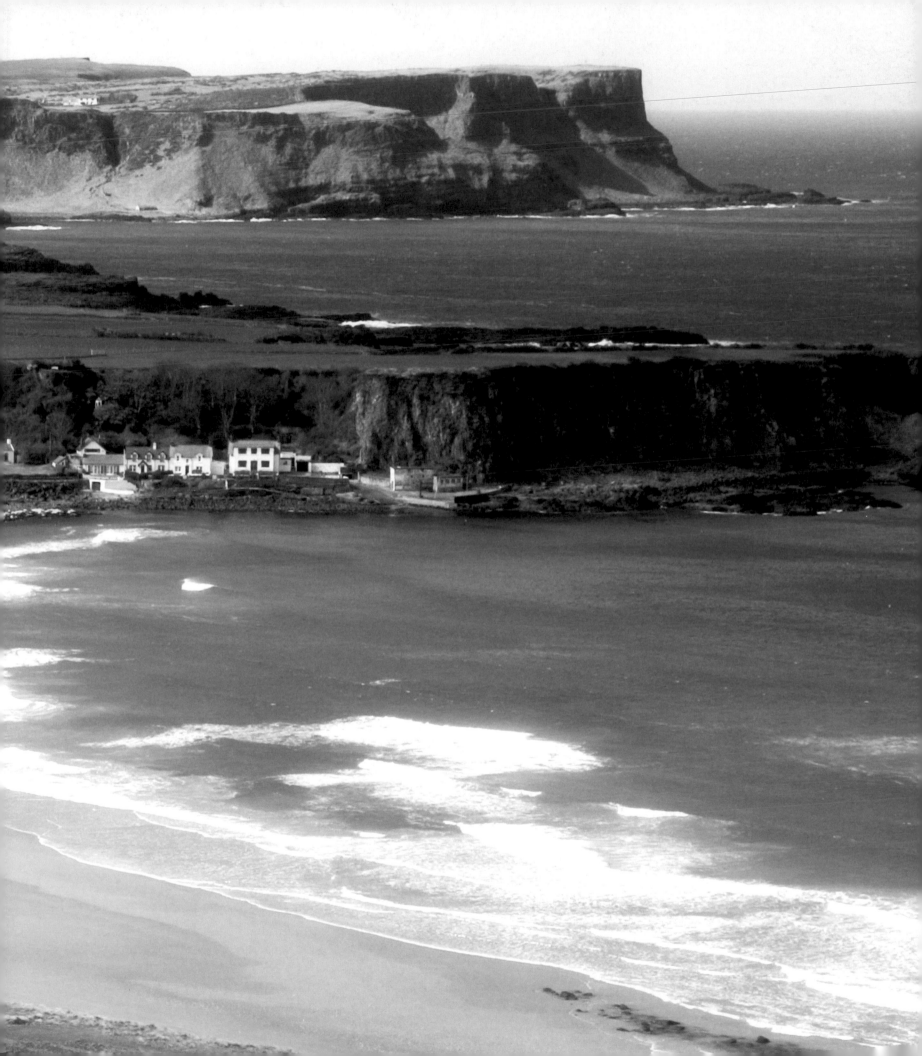

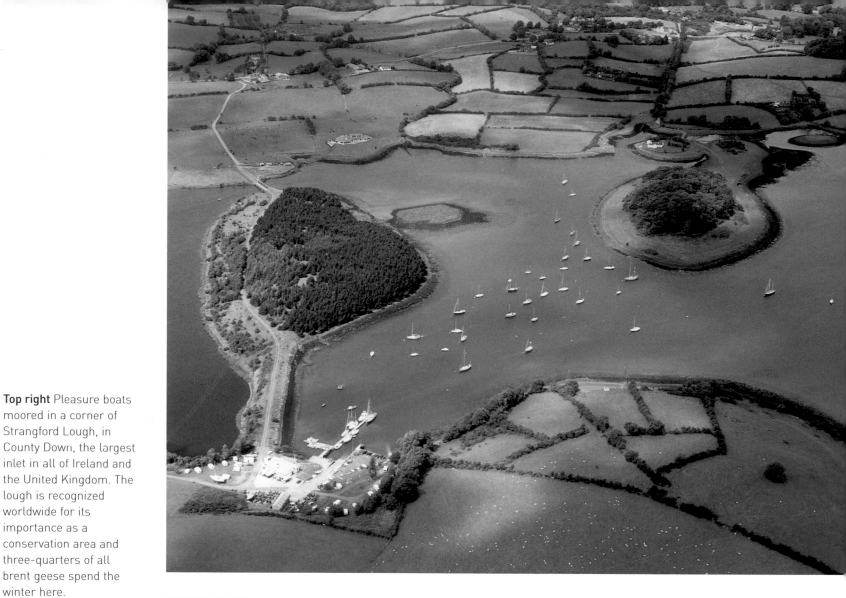

Top right Pleasure boats moored in a corner of Strangford Lough, in County Down, the largest inlet in all of Ireland and the United Kingdom. The lough is recognized worldwide for its importance as a conservation area and three-quarters of all brent geese spend the winter here.

Right Consider the location of Royal County Down Golf Club, with views towards the Mountains of Mourne, and ask yourself if Mark Twain was right to describe the game as, '... a good walk spoiled."

Opposite The high lonesome terrain of the Silent Valley in the Mountains of Mourne with a view over Lough Shannagh – created by melted ice left behind in a corrie at the foot of Carn Mountain – towards the sea.

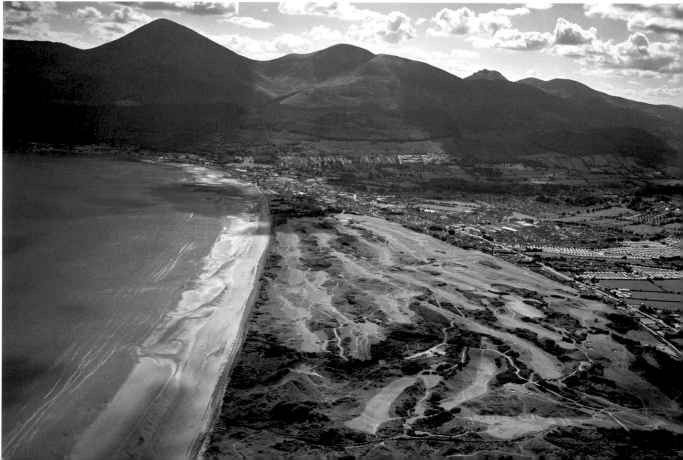

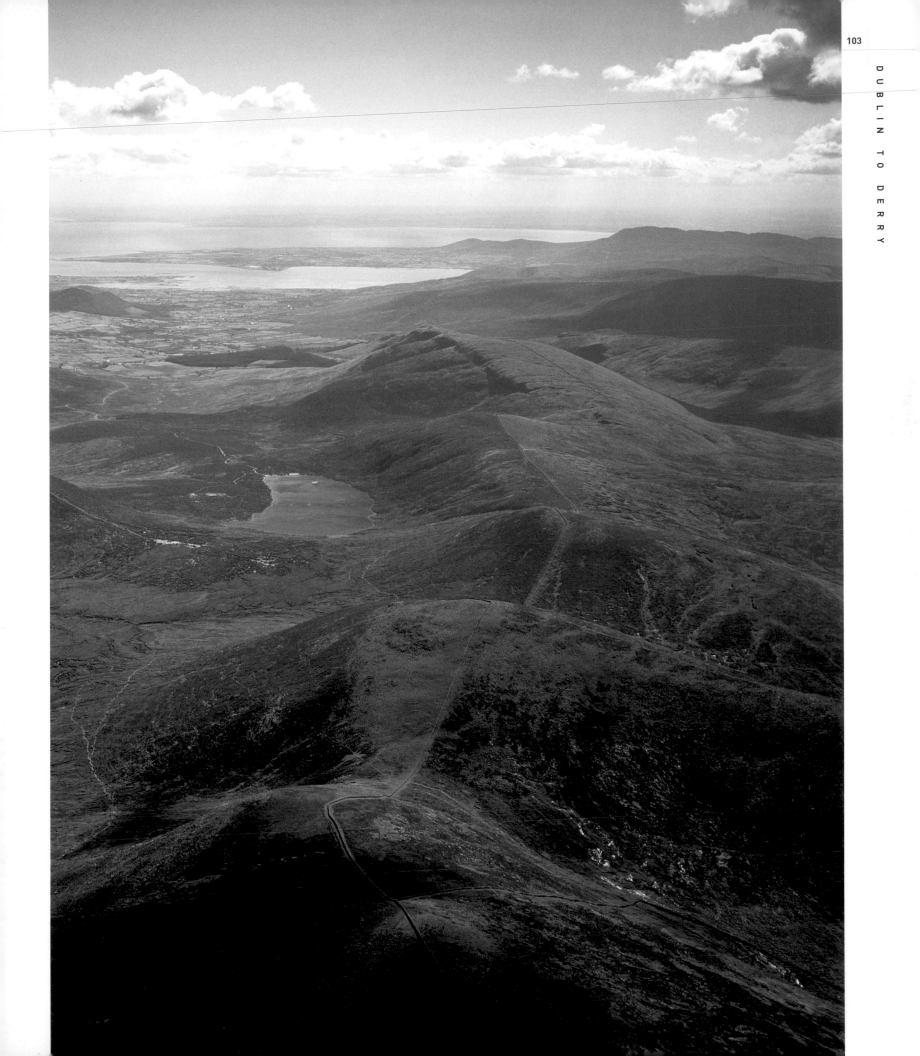

LIVERPOOL TO THE **MULL OF GALLOWAY**

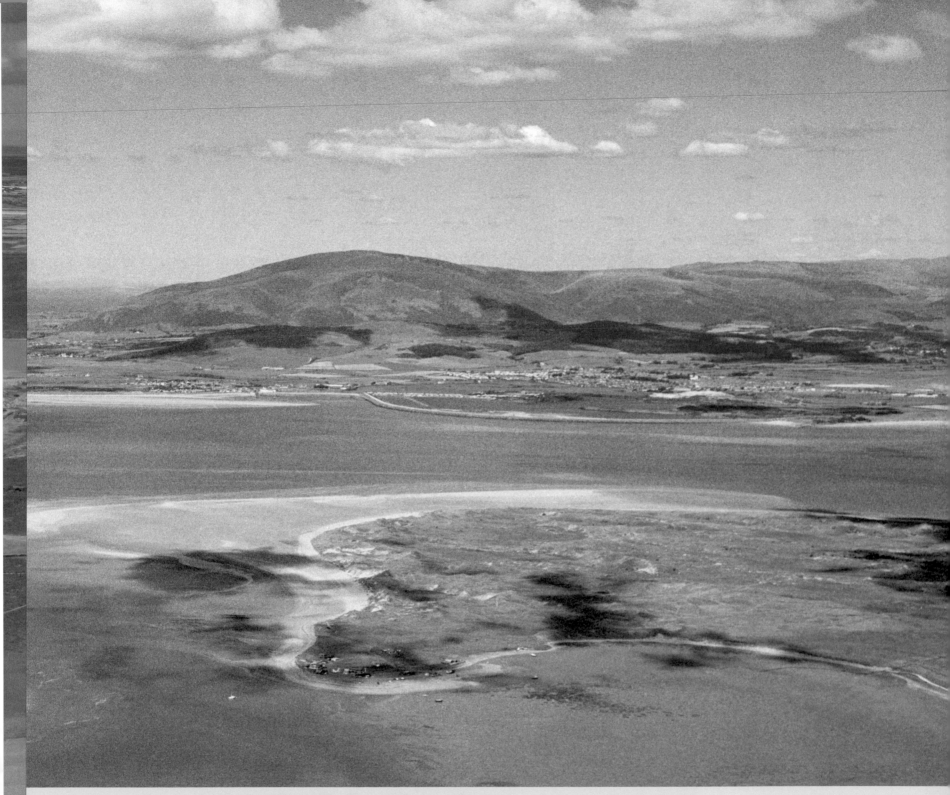

AND THE **ISLE OF MAN**

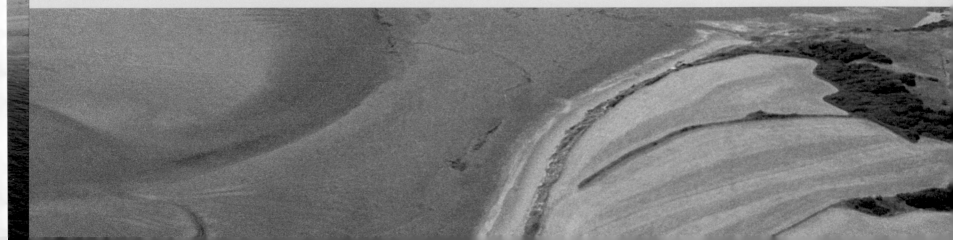

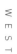

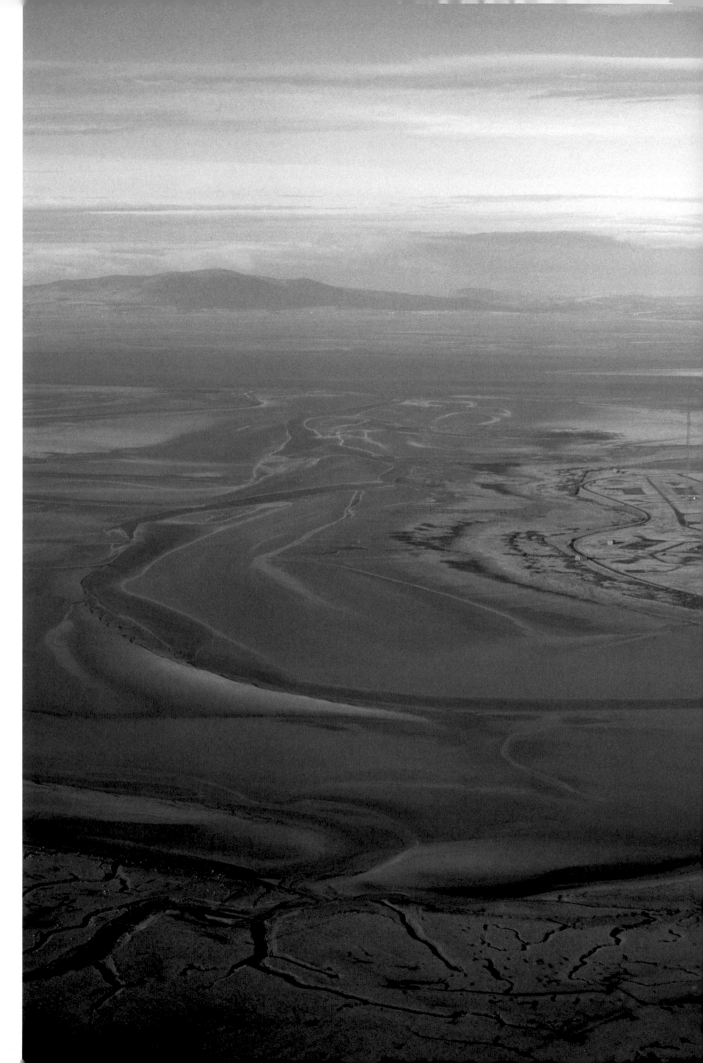

Right Forming a natural part of the border between Scotland and England, the Solway Firth stretches from the Mull of Galloway in the north to St Bees Head in Cumbria in the south. Though it appears tranquil, the swift tides and treacherous quicksands can make it a dangerous place for the unwary.

Opposite One of the oldest towns in the British Isles, Castletown was the capital of the Isle of Man for centuries and home to the Tynwald, the island's parliament. The Isle of Man is not strictly part of the United Kingdom, but stands apart as a crown dependency.

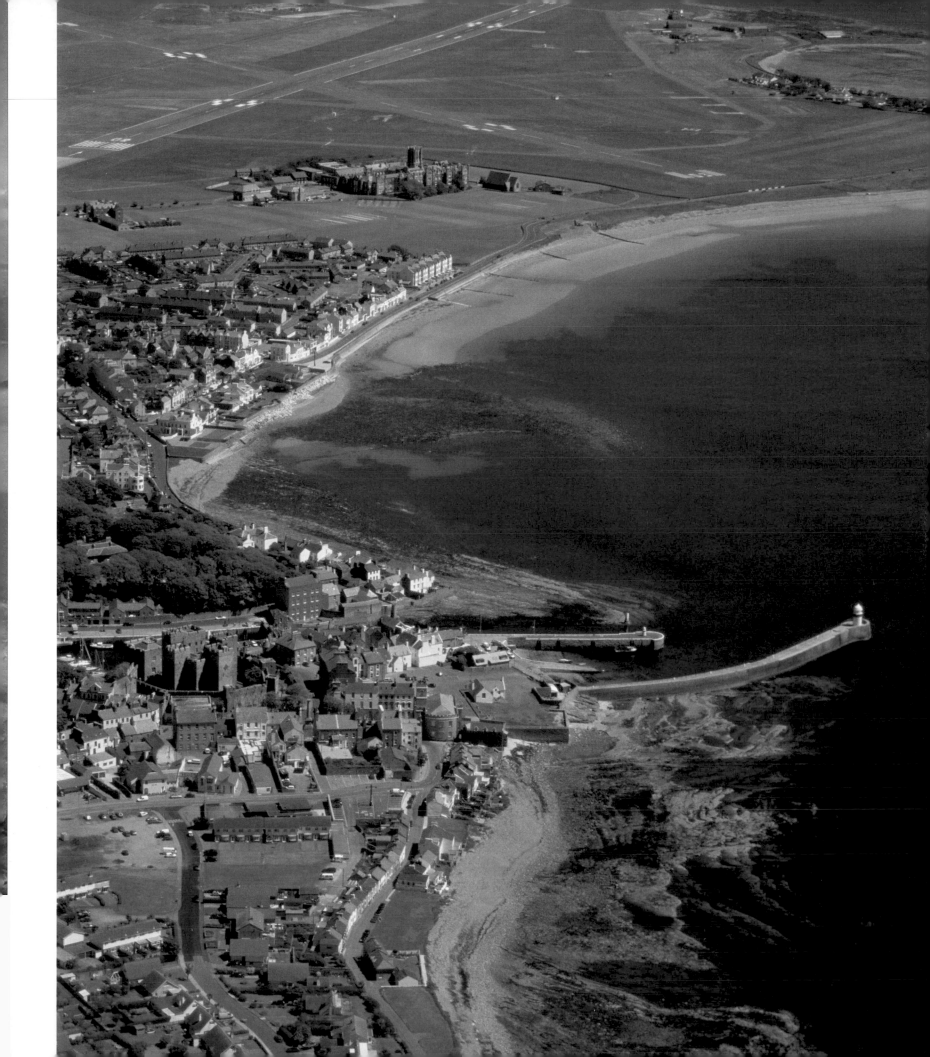

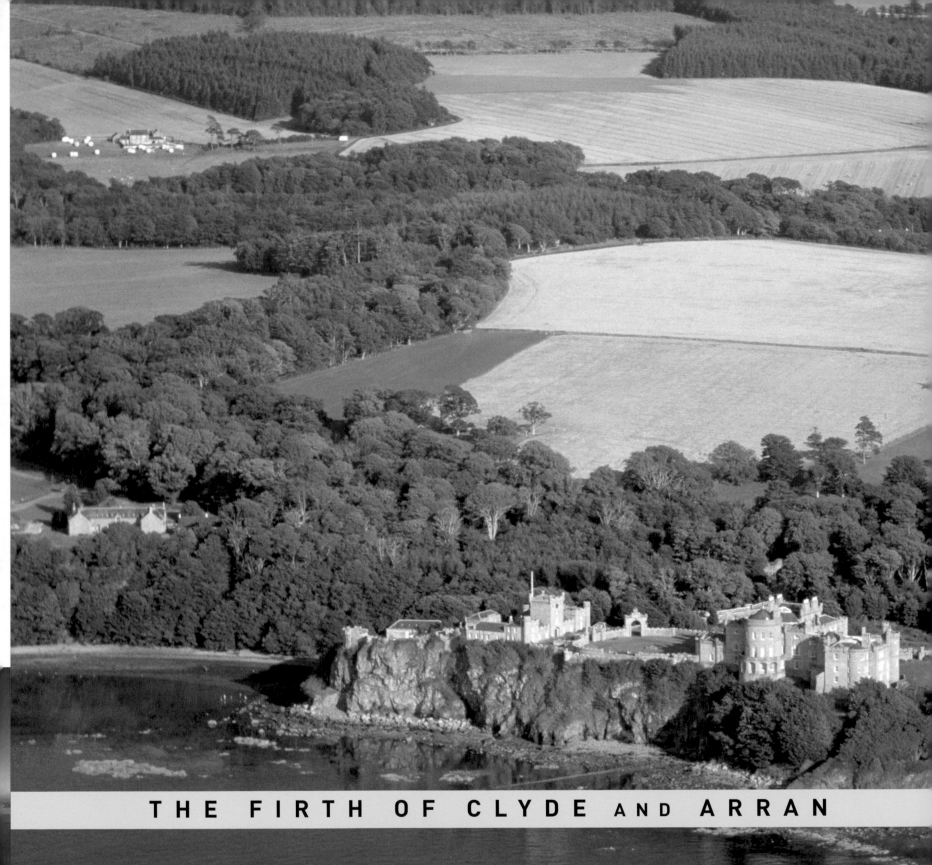

THE FIRTH OF CLYDE AND ARRAN

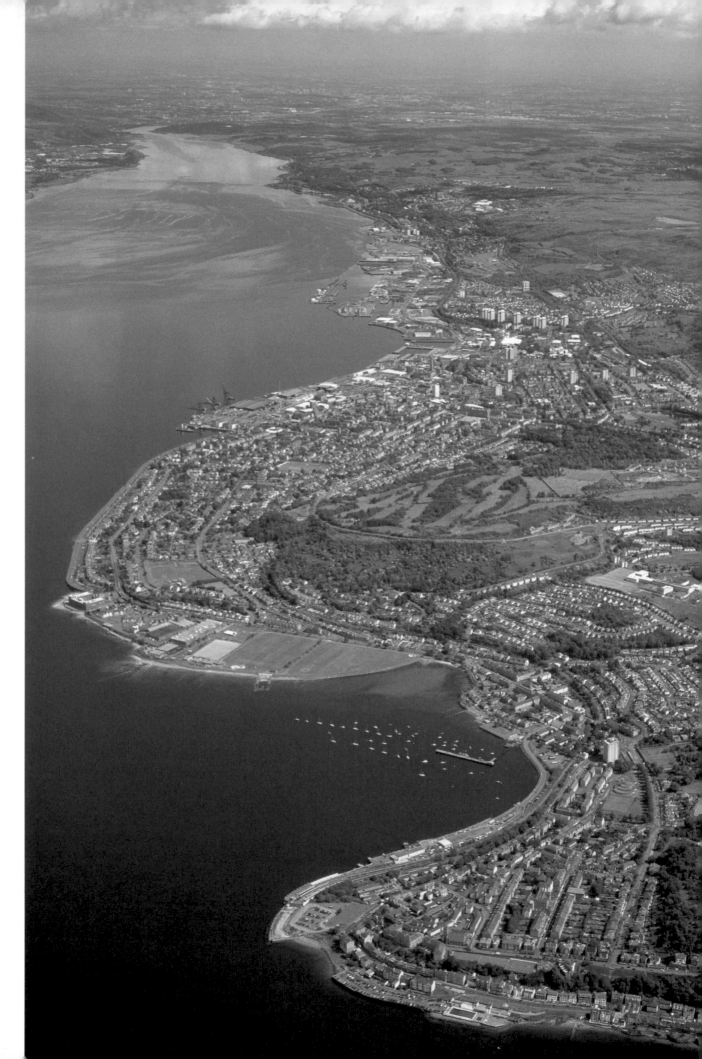

Right The growth of ship building on the River Clyde was made possible only by the work of nineteenth-century engineers who dredged and deepened what had until then been a very shallow waterway. As the saying goes, 'Glasgow made the Clyde and the Clyde made Glasgow'.

Opposite The main town on the Cowal Peninsula of the Firth of Clyde, Dunoon became a prime holiday destination during the nineteenth century. The Cowal Highland Gathering is the largest Highland games in the world and attracts thousands of spectators and competitors from as far afield as Canada, the USA, Australia, New Zealand and South Africa.

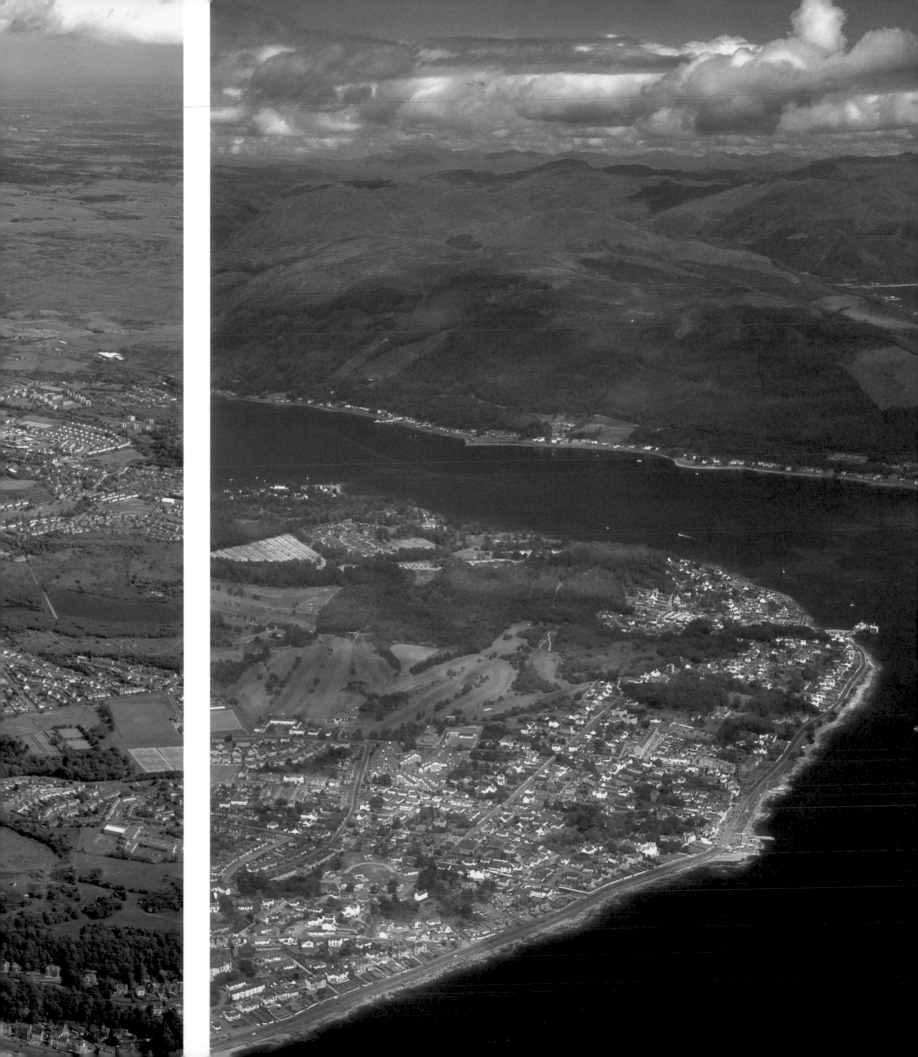

Below Like its near neighbour Arran, the Isle of Bute in the lower Firth of Clyde has been a traditional holiday destination for west coast Scots since Victorian times. The paddle steamer *Waverley* is still a regular visitor, calling in at the port of Rothesay, at the end of the traditional day trip 'doon the watter'.

Opposite Tiny Pladda, less than two-thirds of a mile in length, hangs like a teardrop of land off the southernmost tip of Arran. It has its own source of fresh water – unusual for such a small scrap of an island – and its lighthouse, dating from the late eighteenth century, was designed by Thomas Smith.

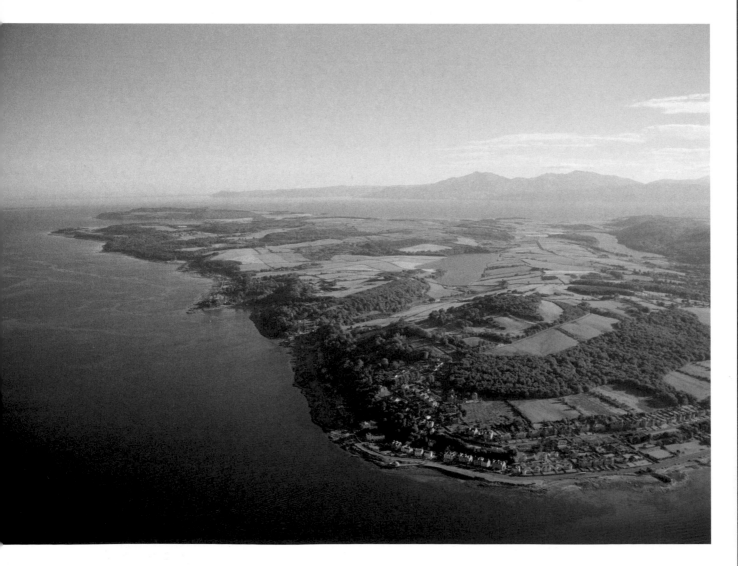

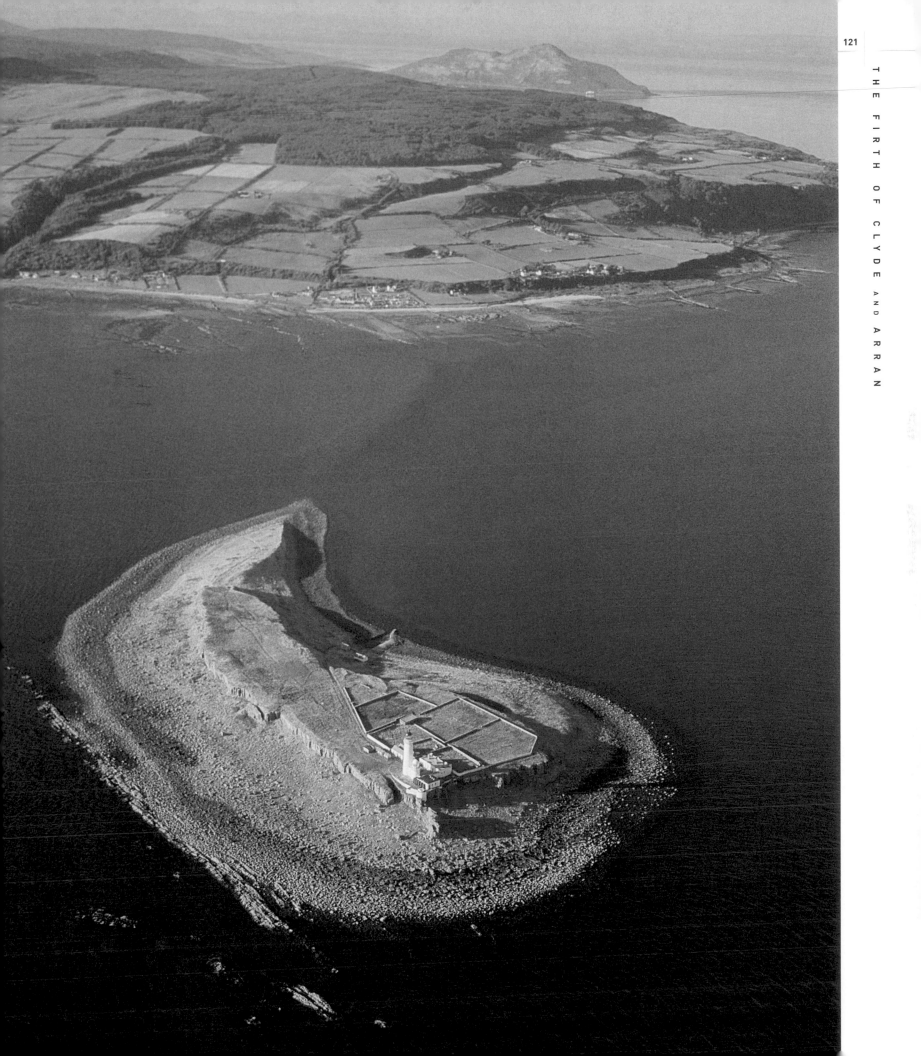

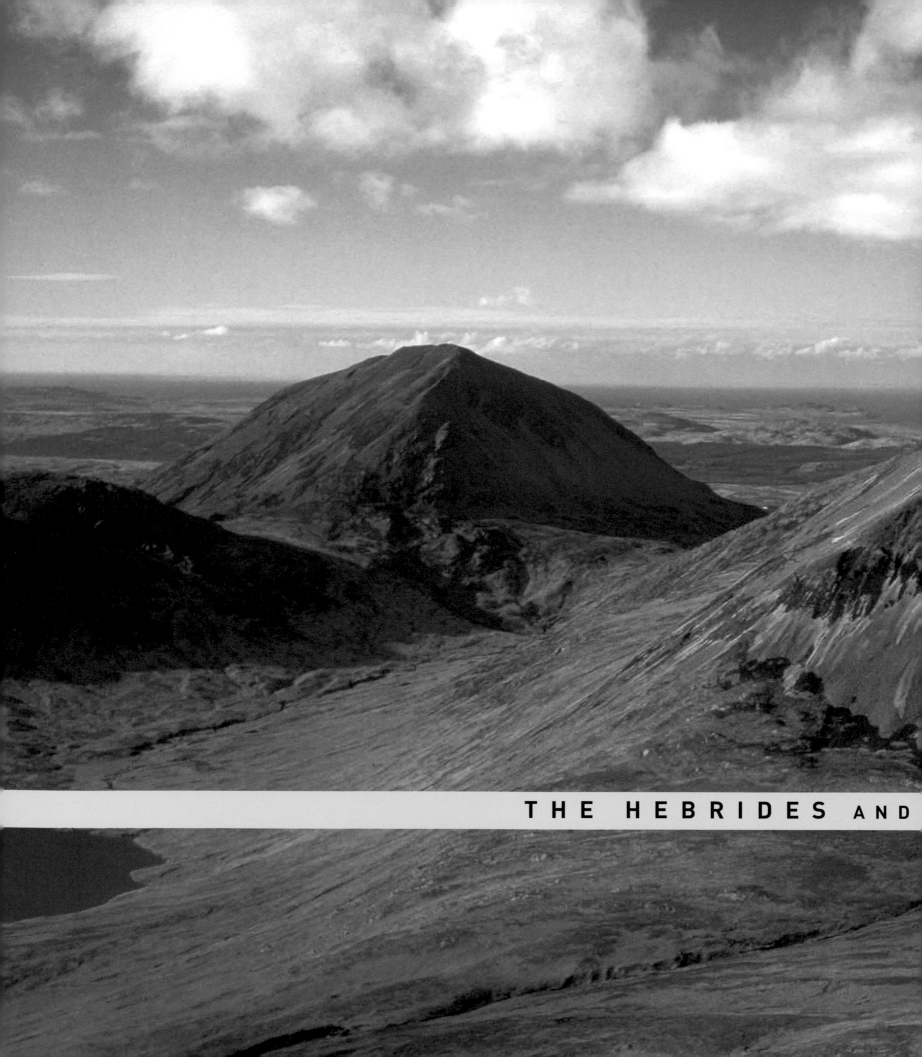

THE HEBRIDES AND

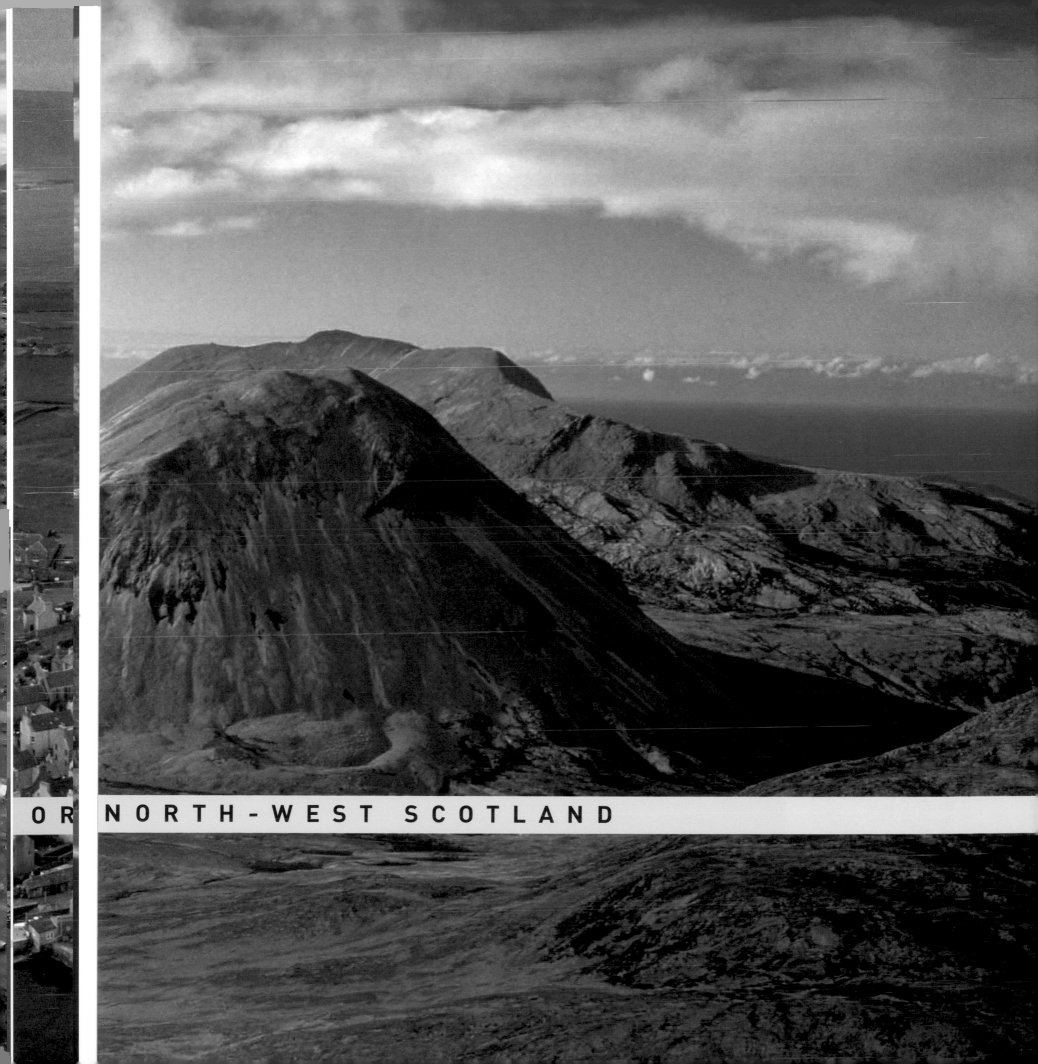

OF NORTH-WEST SCOTLAND

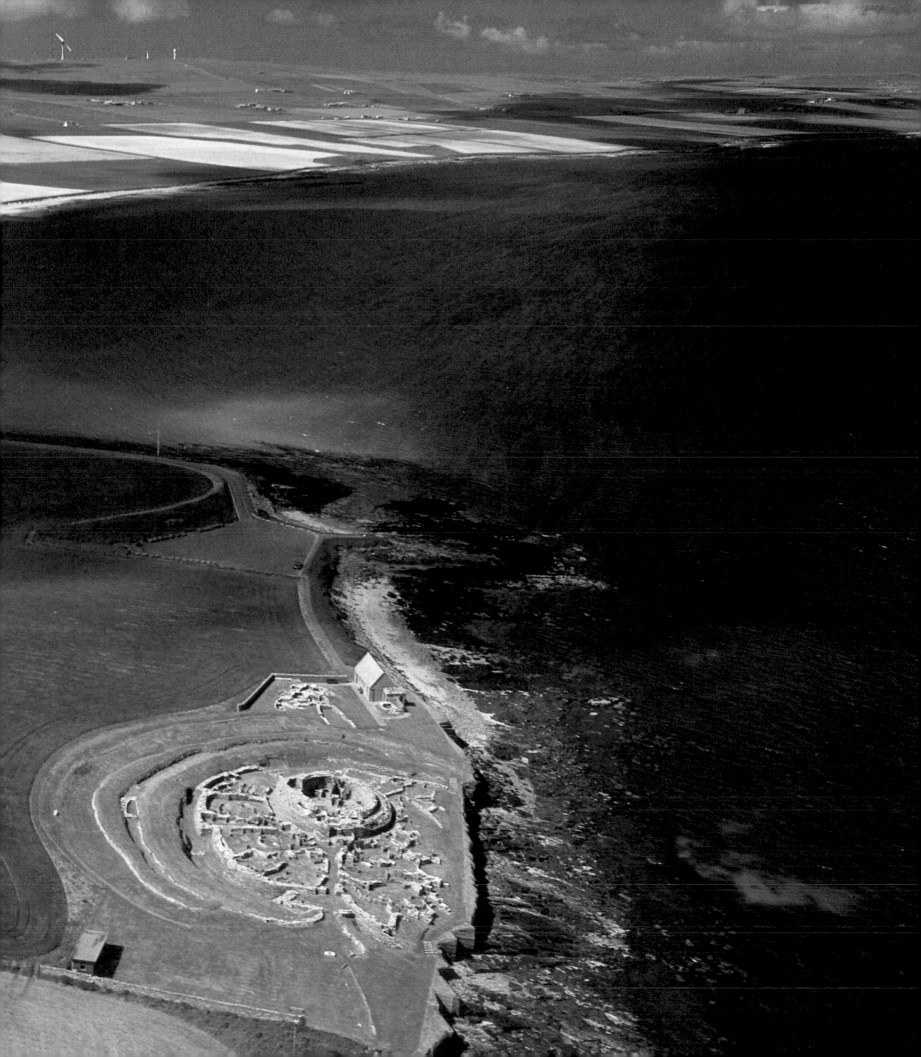

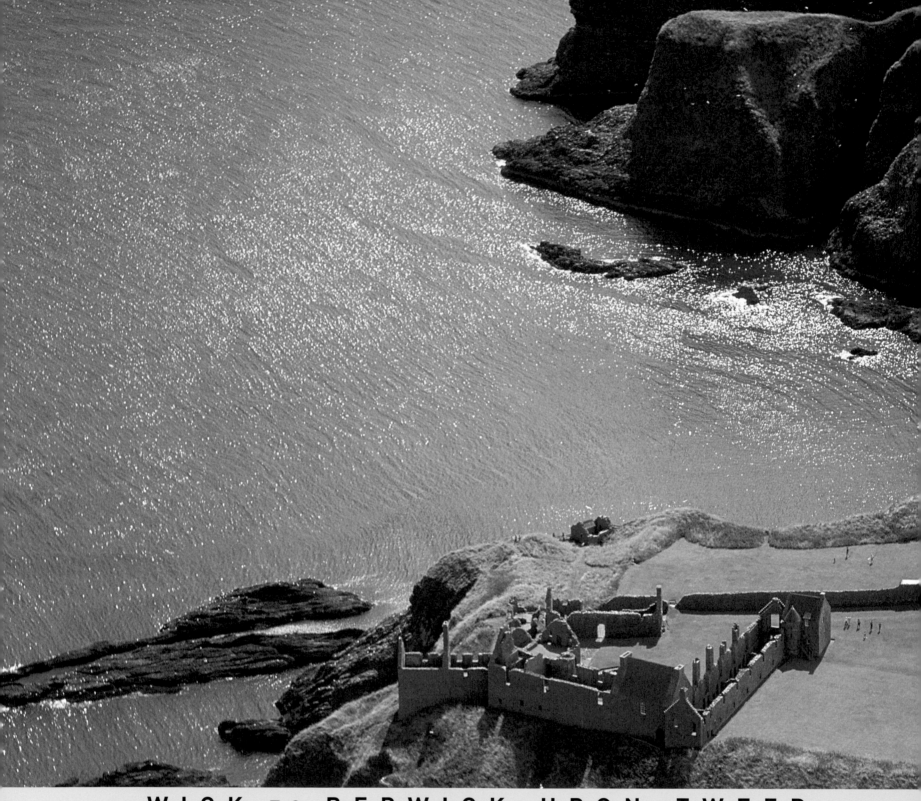

WICK to BERWICK-UPON-TWEED

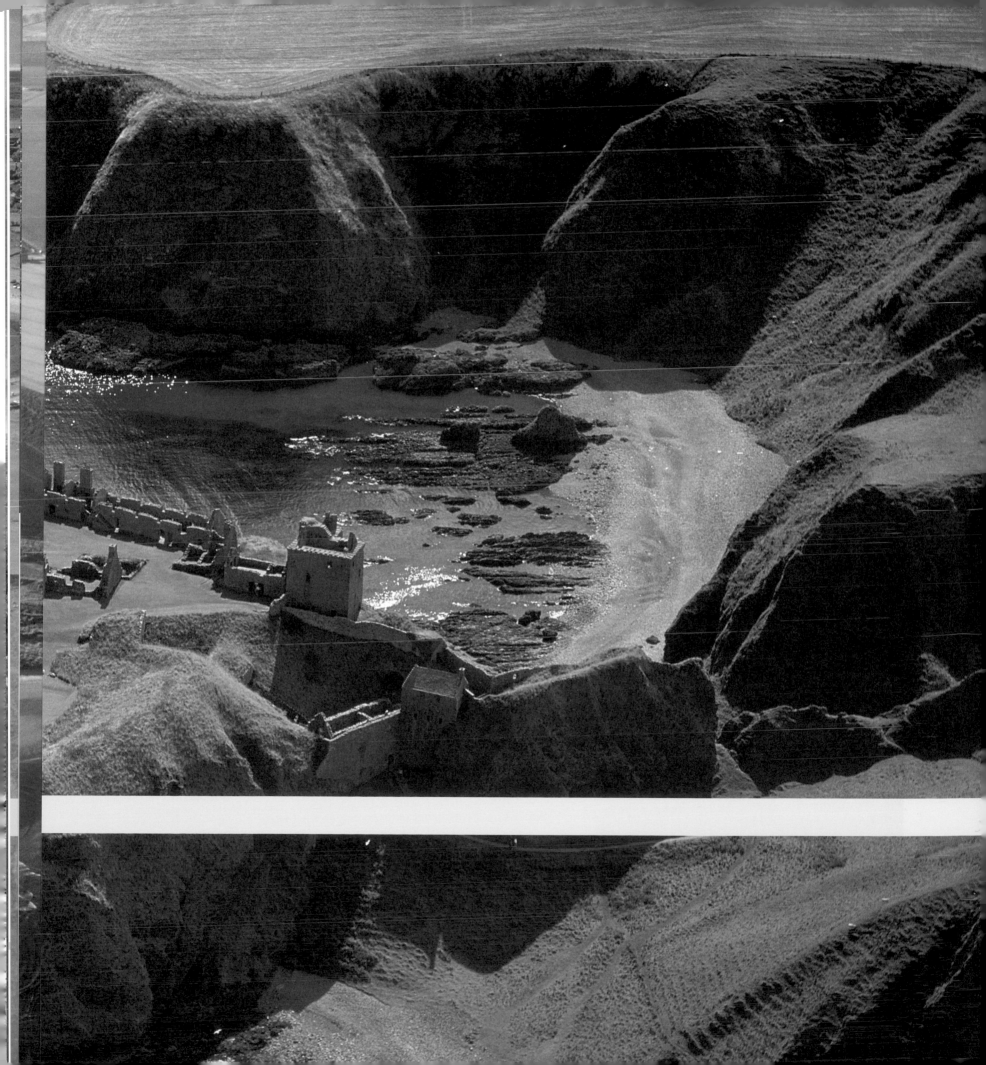

YORKSHIRE, HUMBERSIDE AND

LINCOLNSHIRE

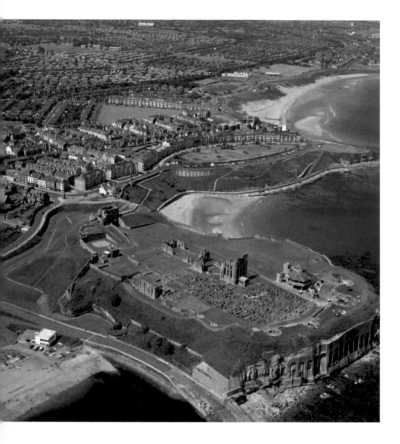

Previous pages Leisurely curves and planes of natural coastline juxtapose with harsh right angles of field boundaries and canalized waterways beside the Wash.

Above The easily defended headland of Tynemouth was used for settlement and fortification from as early as the Iron Age and is the site of a medieval castle and abbey. Only six miles from the centre of the City of Newcastle, the beaches here are popular for water sports including surfing.

Seen from above, the North York Moors are like a humpback, or a hunched shoulder raised in defence against whatever might be delivered next by the North Sea. It was at Whitby, in the abbey, that we received the vampire Count Dracula, or at least the legend. Sinister foreigner from the east, face hidden in the hood of his cloak; perhaps he symbolizes what the nation has always feared and fears still – invasion by dark forces. And so we've always kept a watch on our coast and the horizon beyond – the better to be forewarned of new arrivals, friend or foe.

That same horizon also draws us towards it. For as long as we've been an island we've been sailors, and Britain's maritime history is richer than that of any other nation on earth. Whitby was also home for nine years to James Cook, later Captain Cook, while he learnt some of the craft of navigation and cartography. In 1768 he was sent by the Royal Society to Tahiti, aboard the *Endeavour*, to track the path of the planet Venus across the sun and to search for *Terra Australis*, a southern continent then only presumed to exist. By the time he returned to England in 1771 he had charted New Zealand and the eastern coast of Australia.

England's north-east coast was where the seaside holiday was invented, at Scarborough, and other towns here, like Robin Hood's Bay and Filey cling to the tradition yet. Some seaside towns, like Skegness further south in Lincolnshire, traded on excitement and razzmatazz, showing too much thigh and caring not a jot what others thought. Scarborough was always more demure. With her cliff-top crown of shining white terraces and crescents, she still has an air of elegance, even if it sometimes feels like elegant decline.

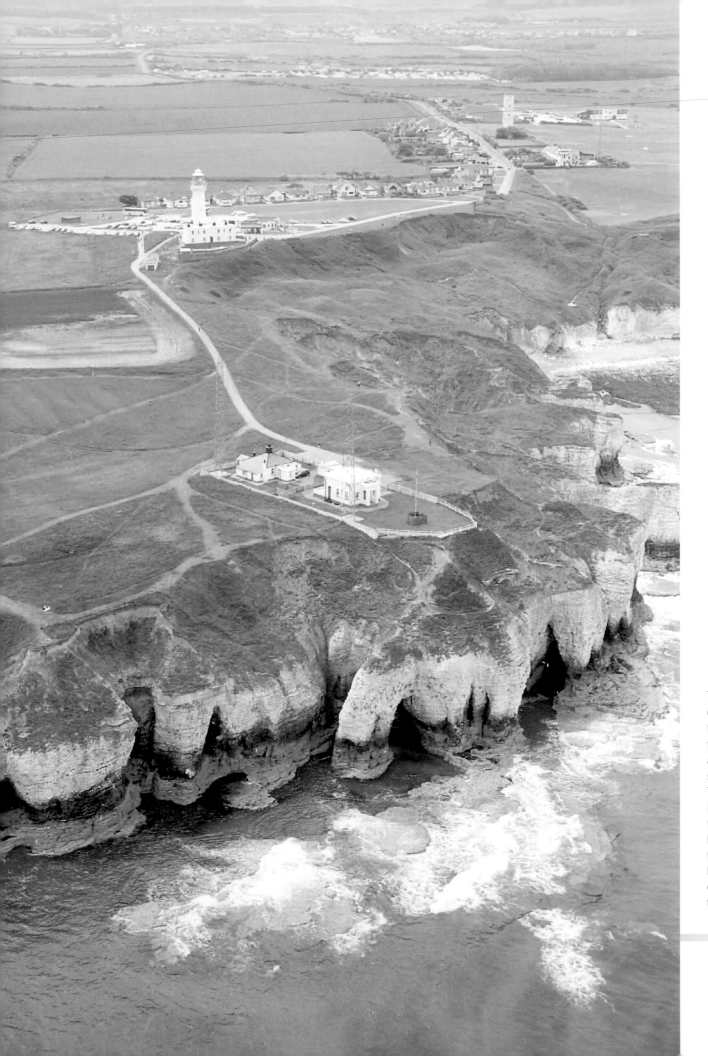

The white chalk cliffs of Flamborough Head, towering 400 feet above the Yorkshire coast, are among the most spectacular in Britain. The village of Flamborough sits towards the centre of the headland and the older of the two lighthouses – the beacon tower – is the only one of its kind in the country.

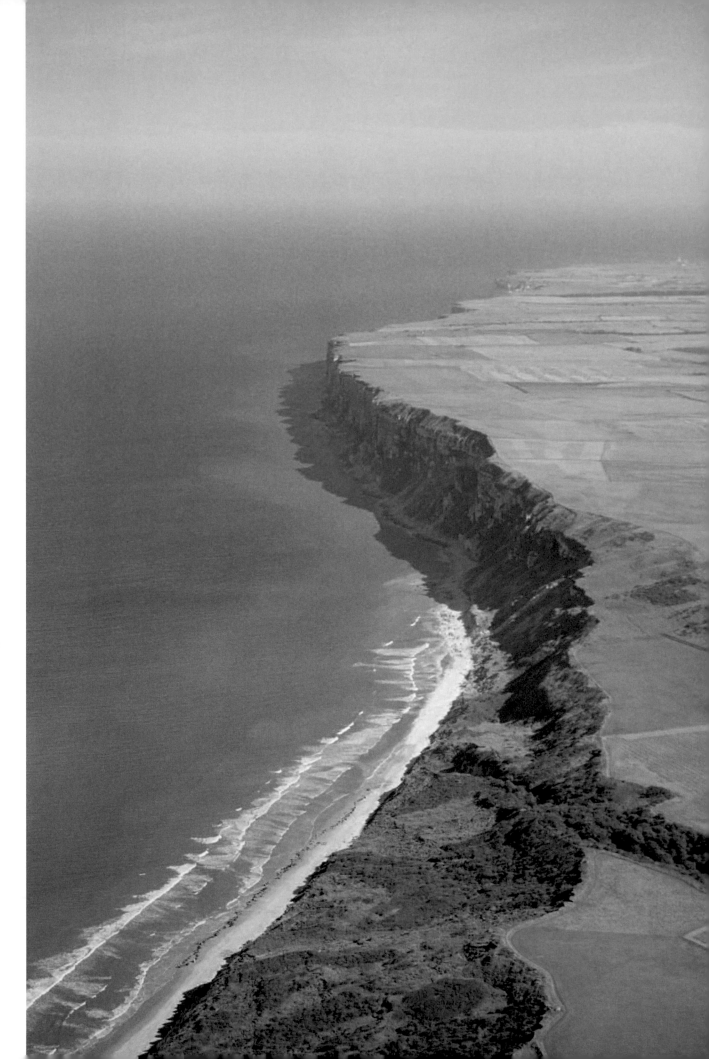

Right A colourful patchwork of farmers' fields edged with sheer sea cliffs near Flamborough on the coastline of the East Riding of Yorkshire.

Opposite top Enfolded and concealed by steep cliffs, the town of Robin Hood's Bay was once a smugglers' den – its jumble of narrow, winding streets providing plenty of getaways for illicit bounty landed on the shore here.

Opposite bottom Chosen by novelist Bram Stoker as the scene of Count Dracula's arrival in England, in real life Whitby is a quiet seaside town in North Yorkshire. Whitby jet, famous around the world and a favourite of Victorians, is the compressed and fossilized remains of ancient monkey puzzle trees.

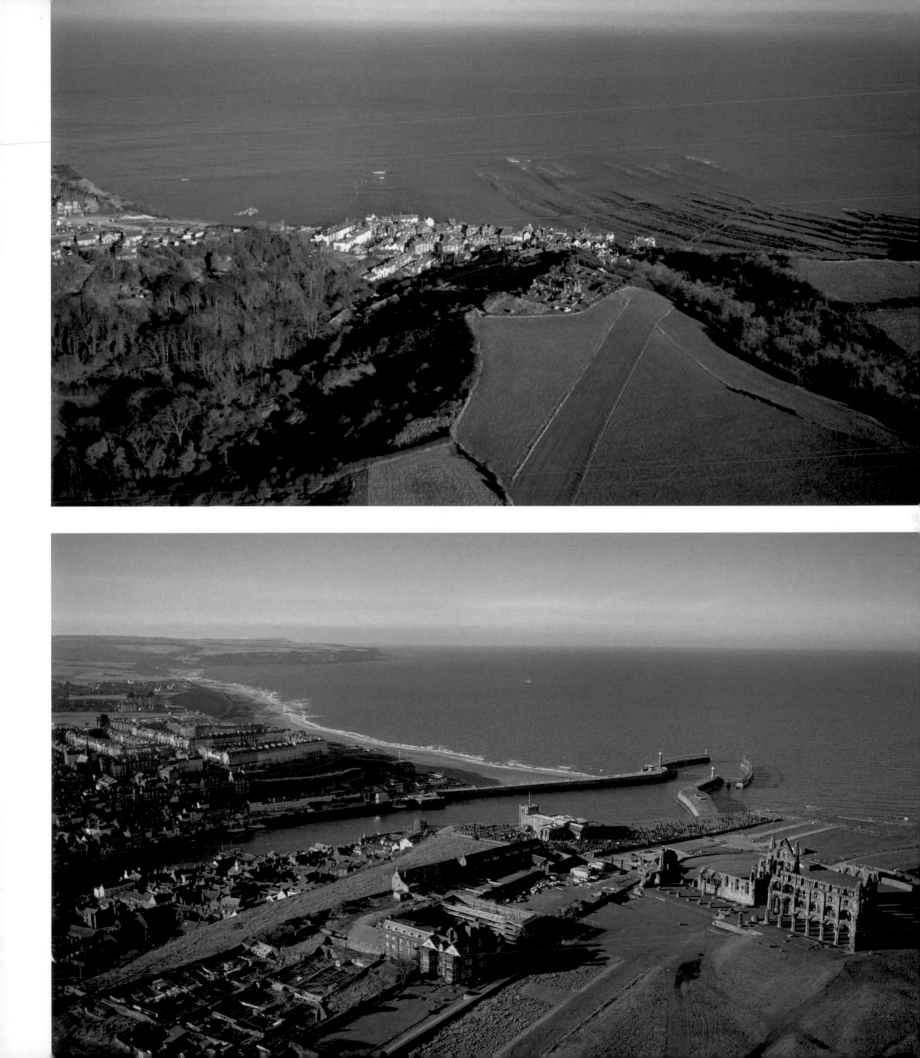

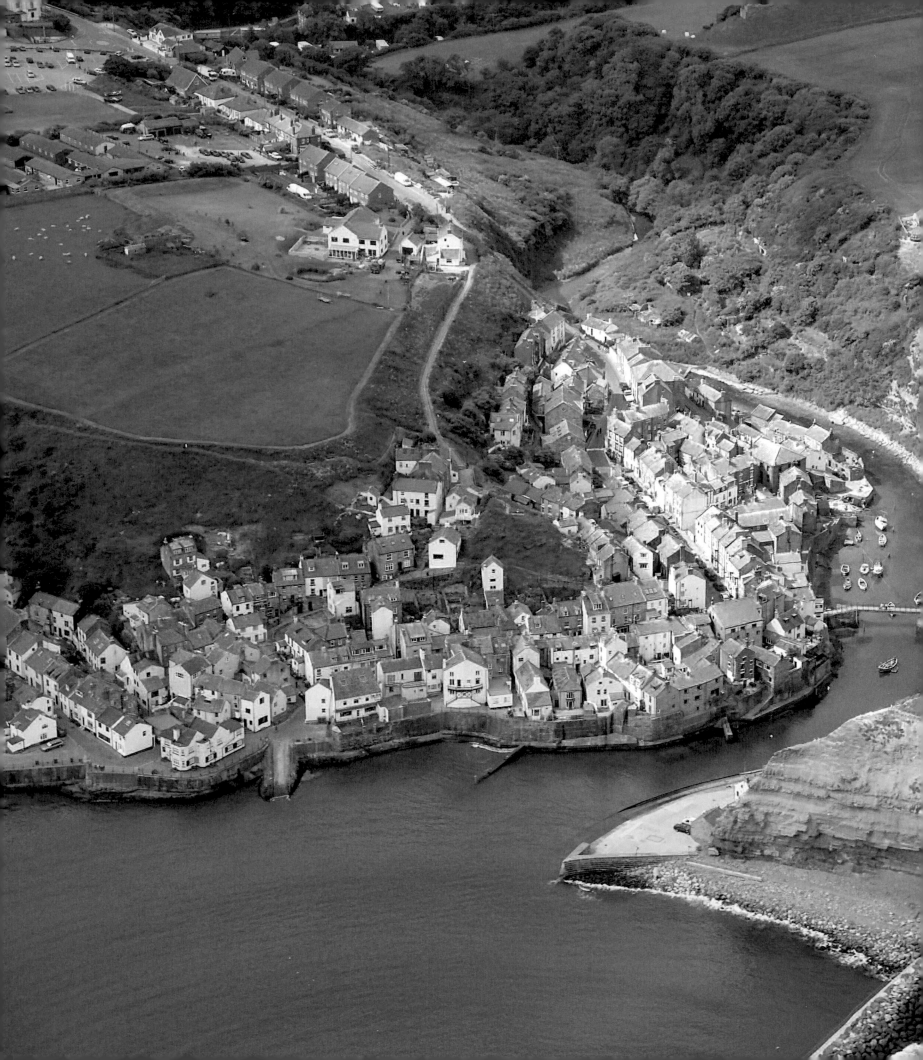

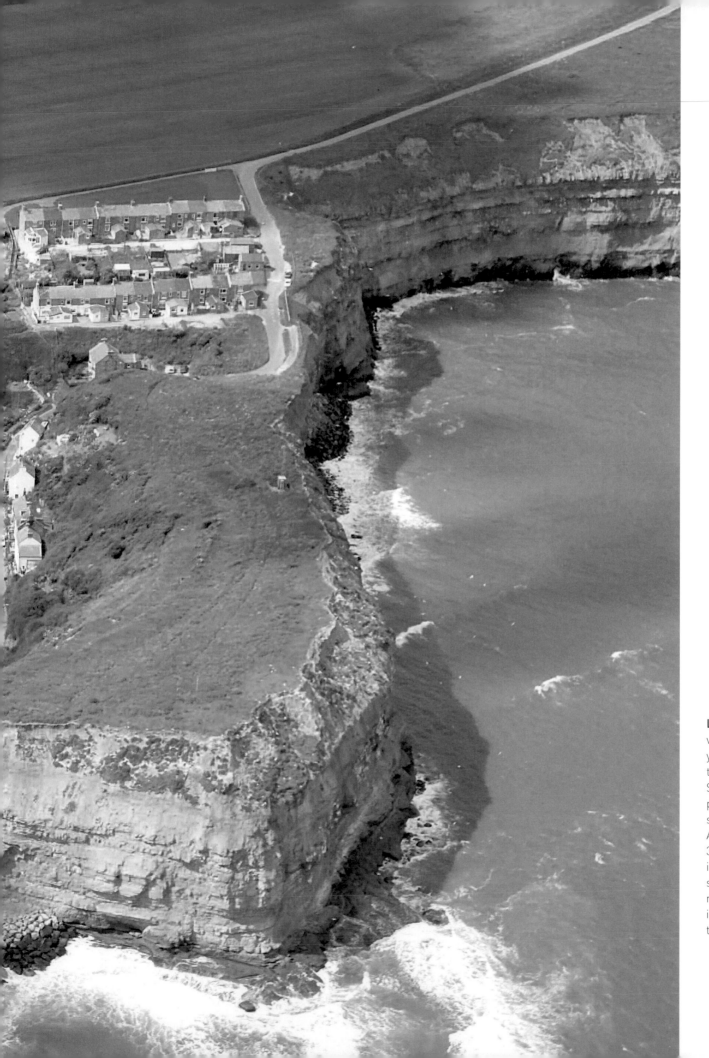

Left More like a Cornish village than anything you'd expect to find on the coastline of Yorkshire, Staithes is a tiny fishing port tucked into a narrow, steep-sided river valley. A community of around 30 artists of the impressionist movement settled here in the nineteenth century, inspired by the sea and the light.

Above Scarborough Castle overlooking North Bay from its lofty, triangular headland some 300 feet above the sea. There is evidence of continuous settlement and fortification from the Iron Age onwards and the remains of a Roman signal station have been excavated here.

Right Traditional English seaside resorts don't come any more authentic than Cleethorpes, on the Lincolnshire coast, with its sandy beaches, promenade gardens and donkey rides. The town is physically linked to neighbouring Grimsby, which was, until relatively recently, an important fishing port.

Opposite Stretching for three and a half miles across the Humber Estuary, Spurn Point is one of the most striking – and fragile – natural features on the coastline of England. The spit of sand and gravel is only 165 feet wide in places and constantly at risk of erosion. It is also the permanent home of Britain's only full-time lifeboat crew.

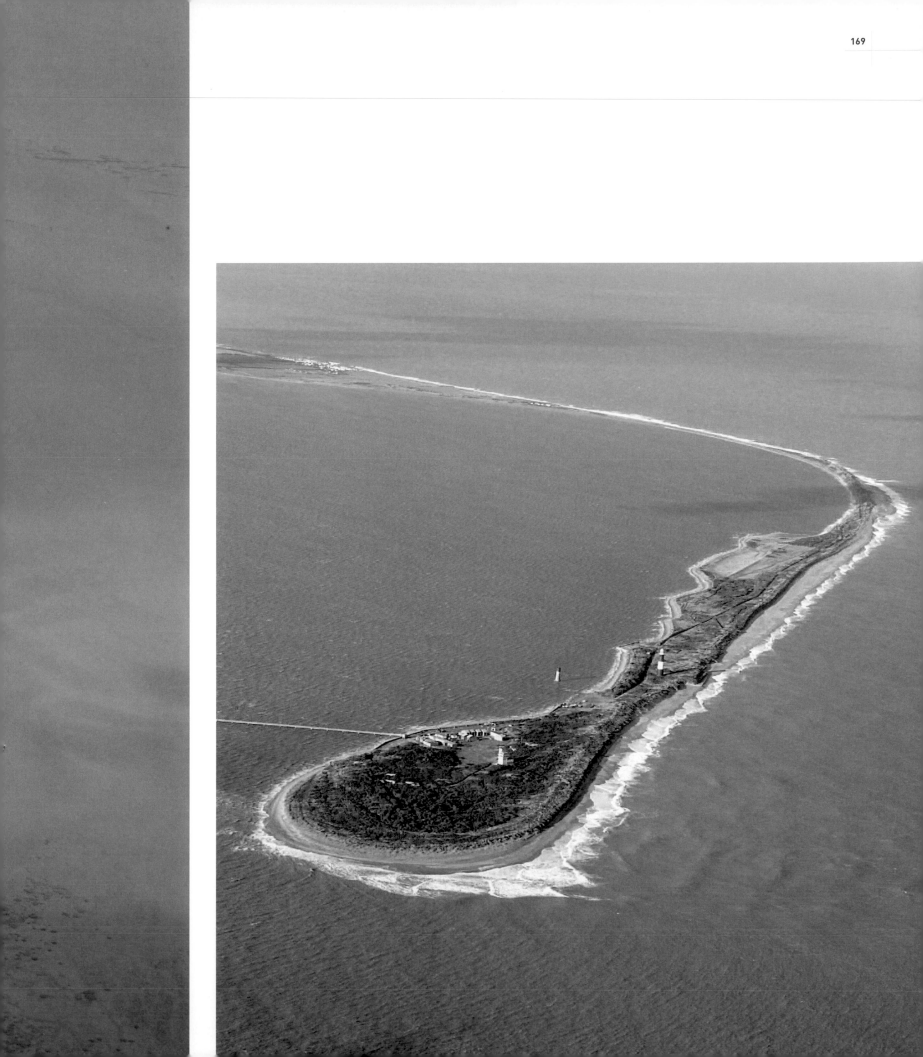

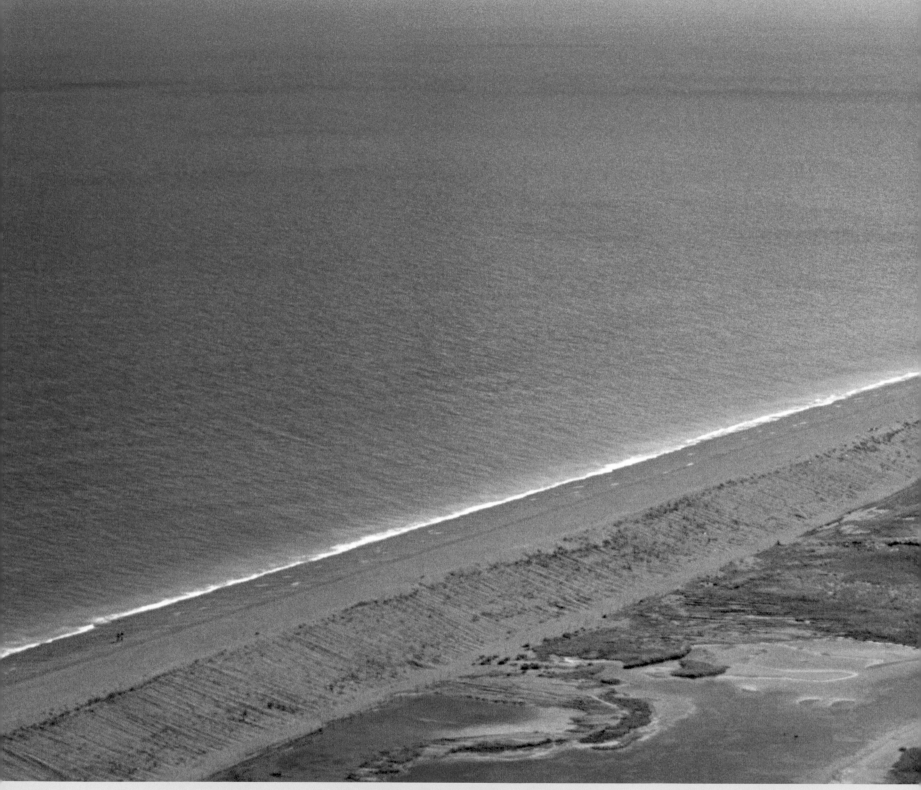

EAST ANGLIA

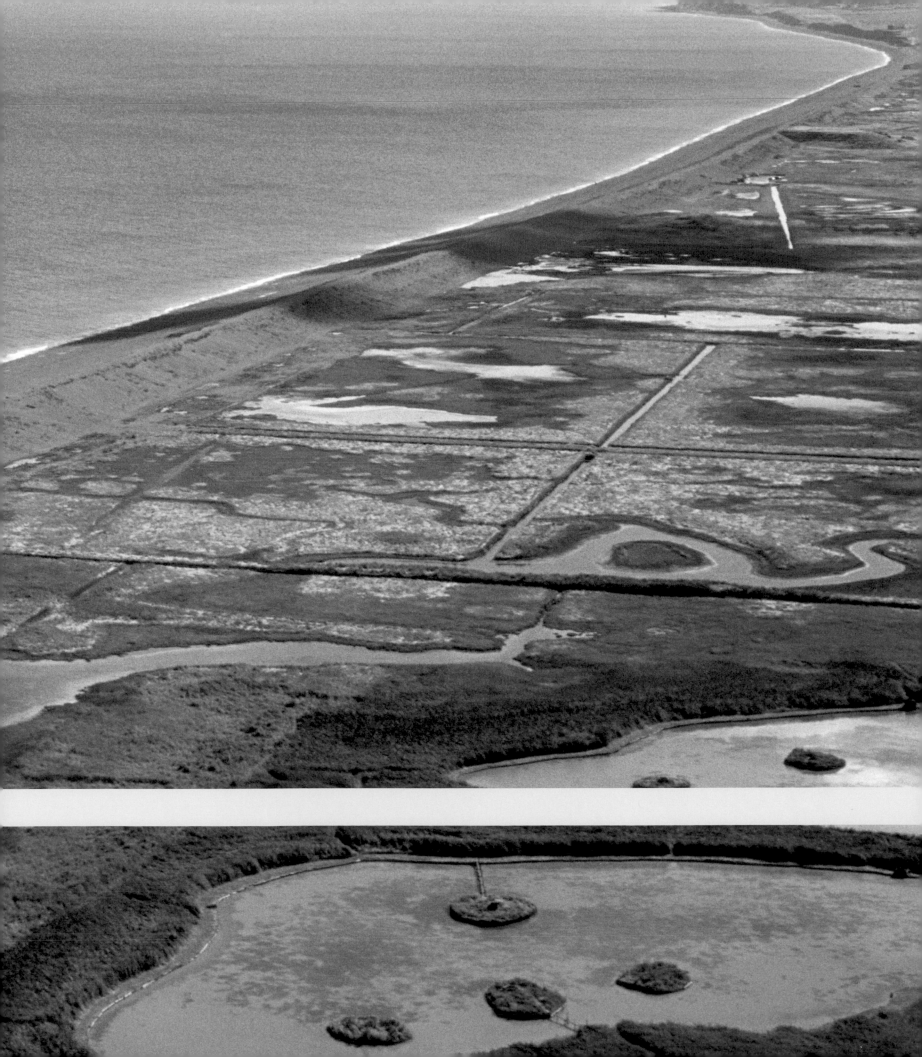

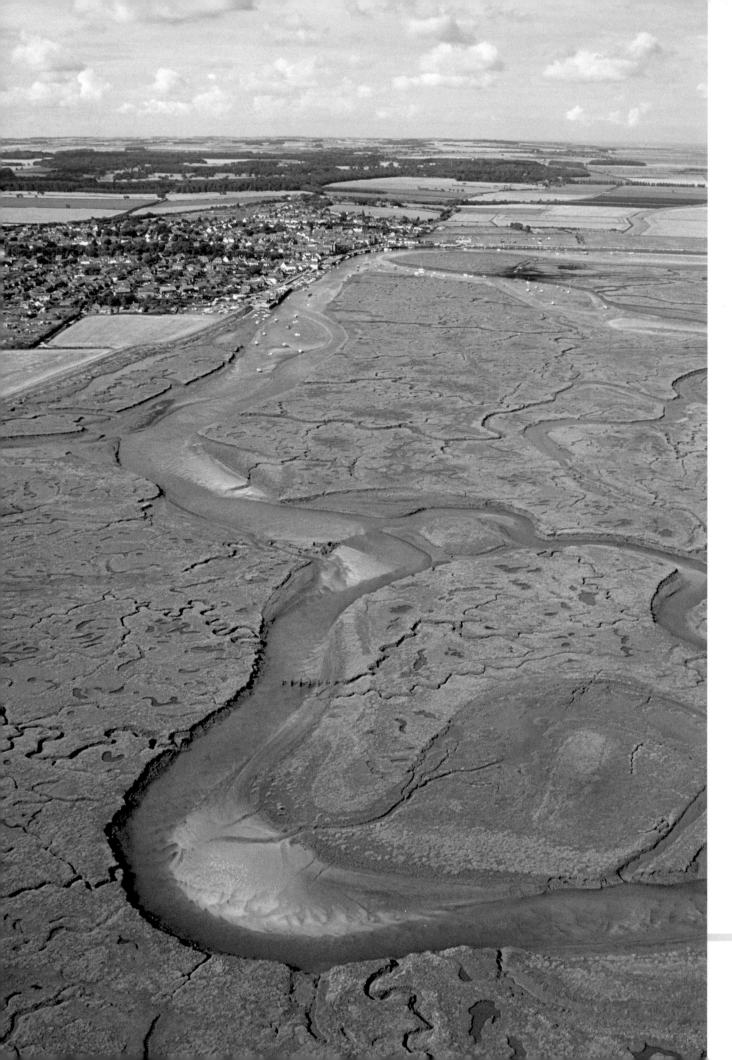

Previous pages A sodden landscape of salt marsh and reed beds near the village of Cley-next-the-Sea, on the North Norfolk Coast between Blakeney and Salthouse. Despite the name, Cley has not been next to the sea since the seventeenth century. The inexorable withdrawal of the waves has allowed instead the development of a habitat that attracts bittern and avocet.

Left For 600 years Wells-next-the-Sea on the Norfolk coast was a safe haven for boats and ships. Nowadays the town is around a mile from the sea – due to the silting of the harbour – but the beach is famous for its unique and idiosyncratic beach huts.

Westward now across the Wash, and the vulnerable flatness of East Anglia is laid out before us. The town of King's Lynn marks the start and, though it's a quiet backwater nowadays, in the fourteenth century it was a thriving port for trade with Europe. The Hanseatic League, a trade monopoly controlled by towns in northern Germany, saw to it that King's Lynn was key to its operations on England's east coast.

This low-lying waterland is cut and scored with streams and rivers, ditches and canals, as if whole swathes of East Anglia can't decide whether it's best to be wet or dry. Much of life here is played out against the background beat of pumps keeping the seemingly inevitable flood at bay. In some parts of this territory the rivers run not towards the sea but backwards, into the land. It's this section of the east coast that will see the greatest changes if sea levels keep rising as predicted.

The coast here has a feeling of remoteness accompanied by the sense that it belongs equally to earth and sea. A debatable land. Approaching from north, south or west it often seems to take for ever to reach destinations on the Norfolk and Suffolk coast. But it's worth the effort. Without hills or other high ground to lift it, the great sky seems closer, all-encompassing in a way not experienced elsewhere. The sea, too, exerts an insistent presence, any boundary with the land seeming hazy and inconsequential.

The ominous rumble and roar of sea-beaten shingle even insinuated its way into the music of Sir Benjamin Britten, one of our greatest composers. His *Peter Grimes* fictionalized lives and loves in the seaside town of Aldeburgh. He spent some of his younger life on this coast and it is the rhythm of the North Sea that suffuses the opera like the breathing of a living thing.

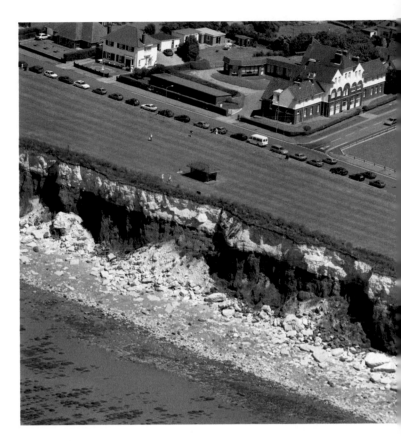

Above The 'candy cliffs' of Hunstanton – a world-famous geological feature created by a layer of white chalk sitting like icing on top of a red variety of carrstone known locally as gingerbread. Estimates vary but some observers say sections of the coastline here have been eroded by as much as 98 feet in the last century.

Below Between Aldeburgh and Southwold is the RSPB nature reserve of Minsmere. Behind the beach and dunes is a protected habitat attracting avocets, bitterns, common and little terns, marsh harriers and nightjars. Bewick's swans and black-tailed godwits can be seen in the winter months, and Cetti's warblers and nightingales in the summer.

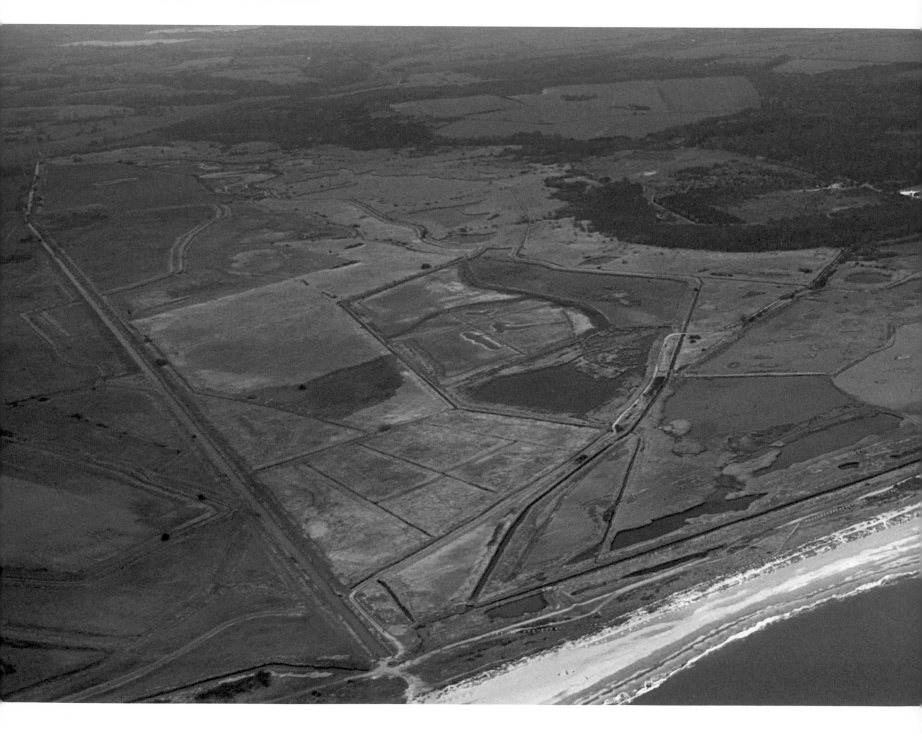

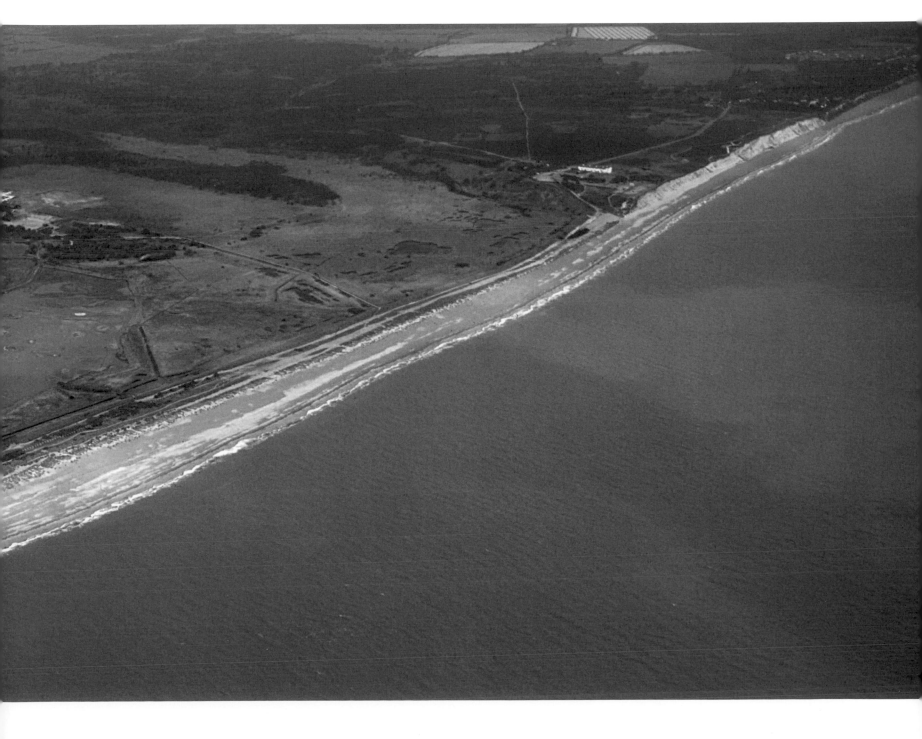

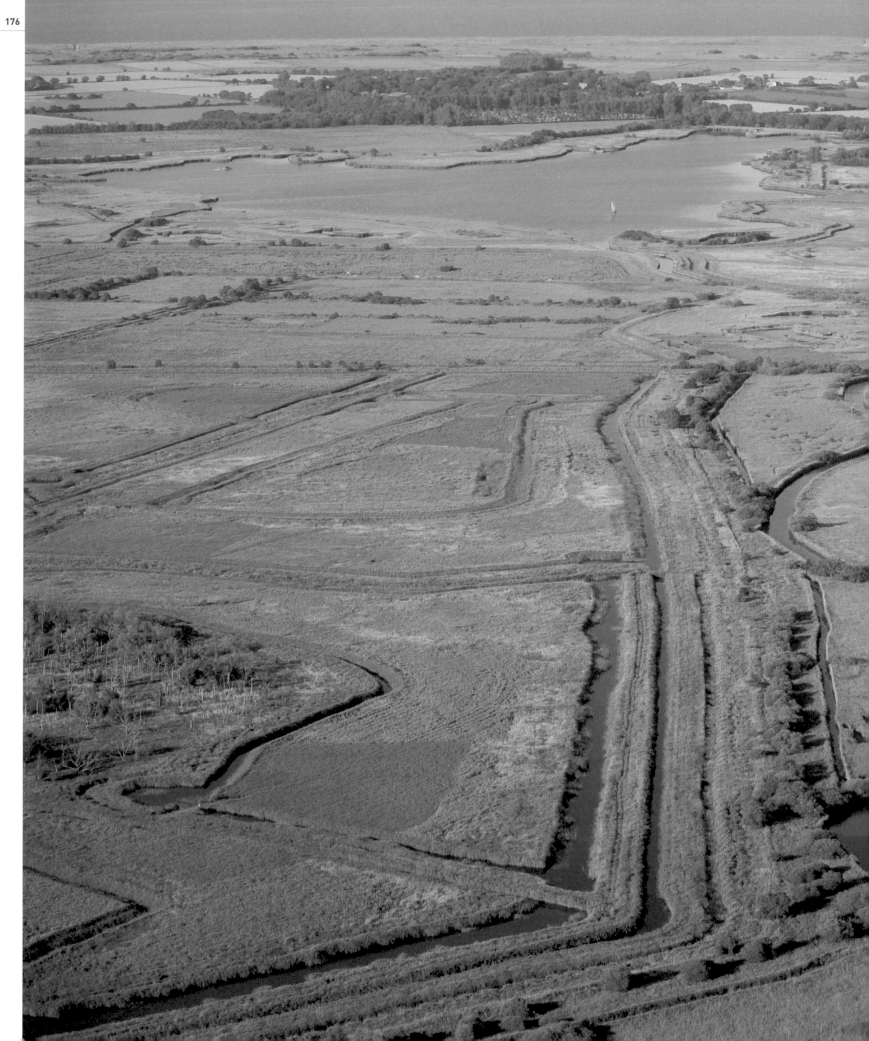

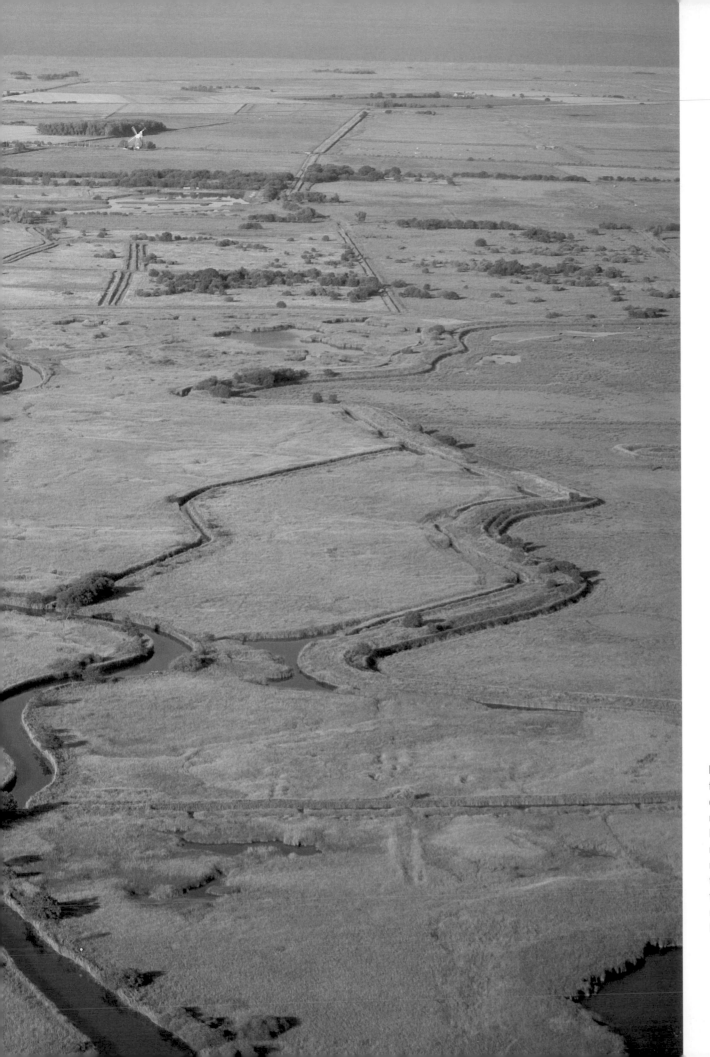

Left Created by the steady
flooding of peat cuttings
dating to at least the
medieval period, the
Norfolk Broads are a
network of waterways
meandering peaceably
through low-lying land
that seems ready at any
moment to be reclaimed
by the nearby sea.

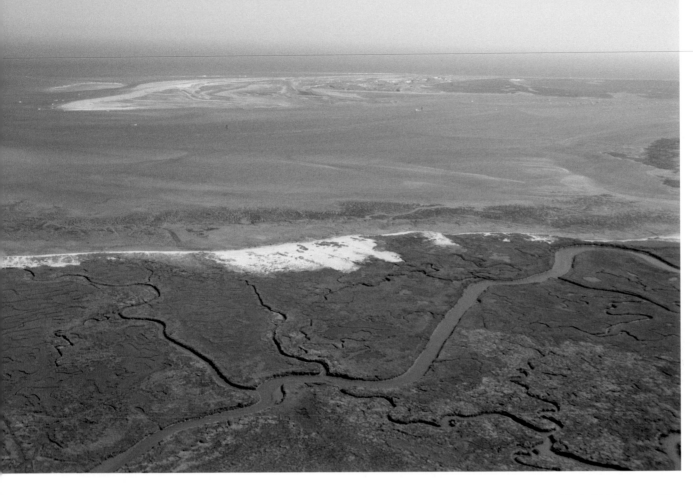

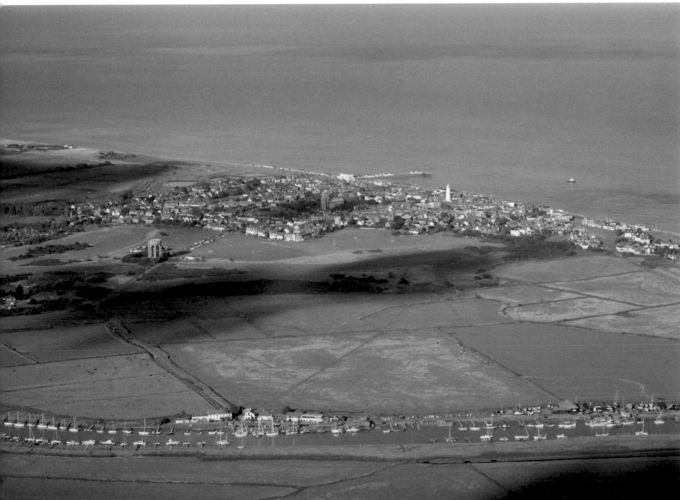

Opposite Happisburgh village on the fast eroding north-east Norfolk coast, 20 March 1995 – some of the houses in the lower left have since been washed away.

Top left The nature reserve on the three-and-a-half mile-long sand and shingle spit of Blakeney Point covers over 2700 acres. Breeding terns and other migratory birds find sanctuary here, alongside colonies of both common and grey seals.

Left All but surrounded by sea, river and creek, Southwold could be mistaken for an island off the Suffolk coast. The sea has taken its toll here in the past – five people drowned in the great flood of 1953 – and nowadays erosion is a steadily worsening threat.

ESSEX AND KENT

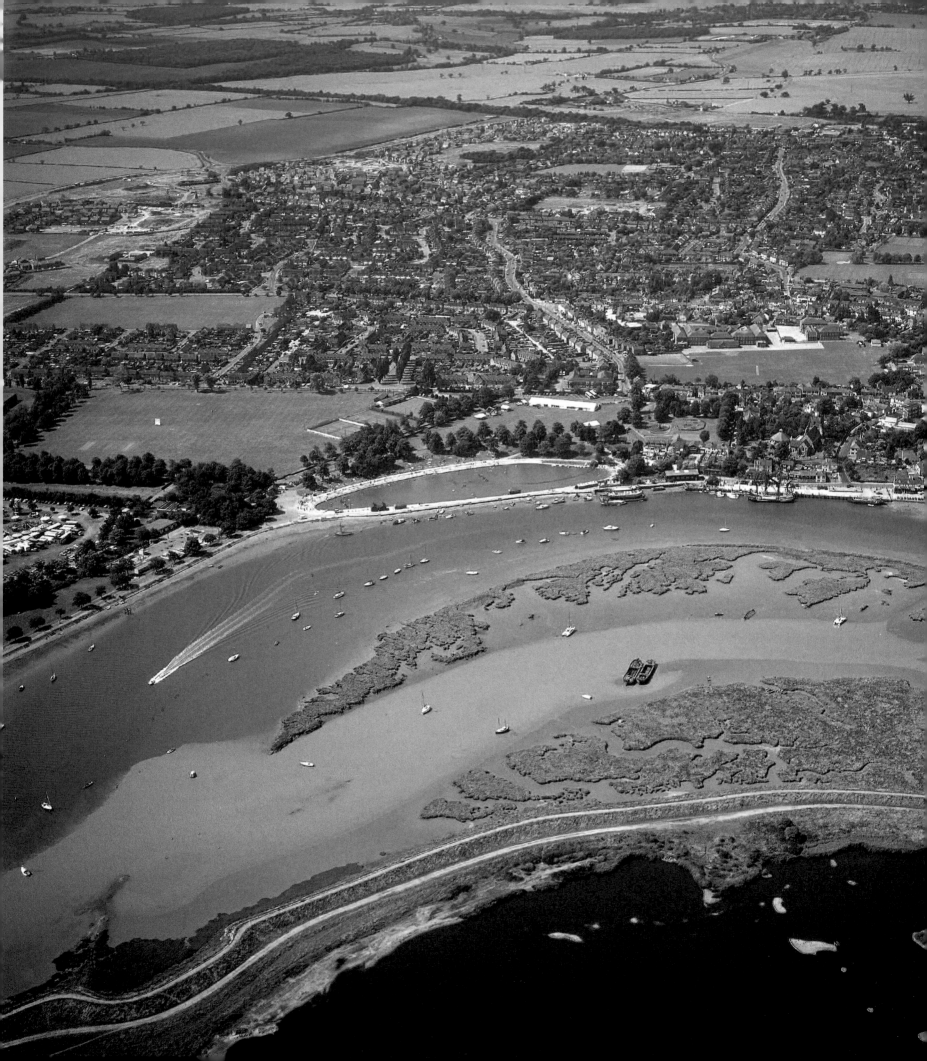

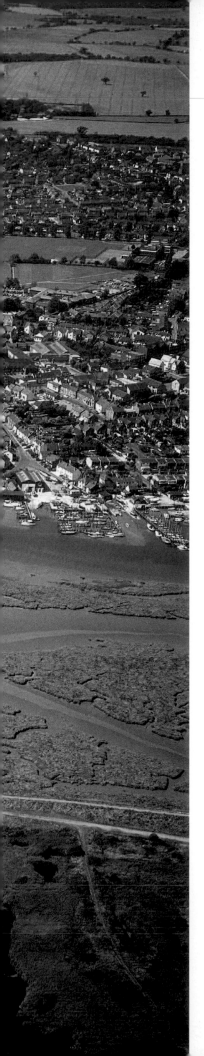

Left At the head of the Blackwater Estuary in Essex sits the hill town of Maldon, settled by Saxons around 1500 years ago. The area has been famous for centuries for its sea salt, collected from the Blackwater River.

Below The unique quality of light to be found on the East Kent Coast inspired much of the work of the artist J.M.W. Turner and he is known to have visited the town of Margate as a child and on many occasions throughout the 1820s and '30s.

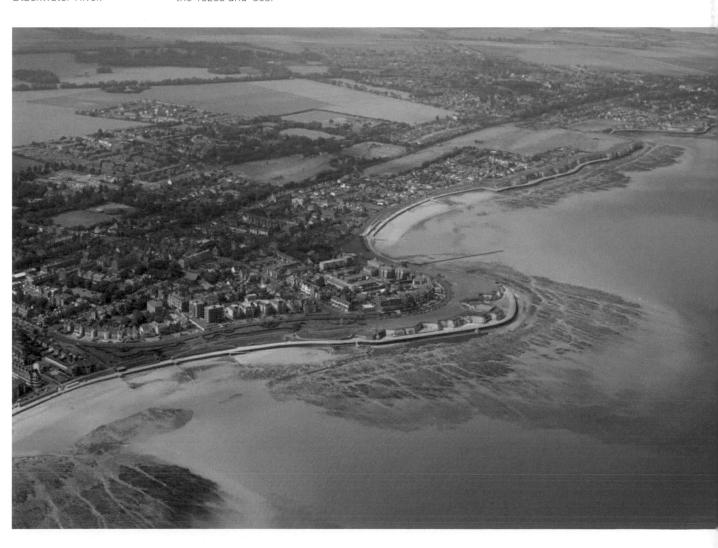

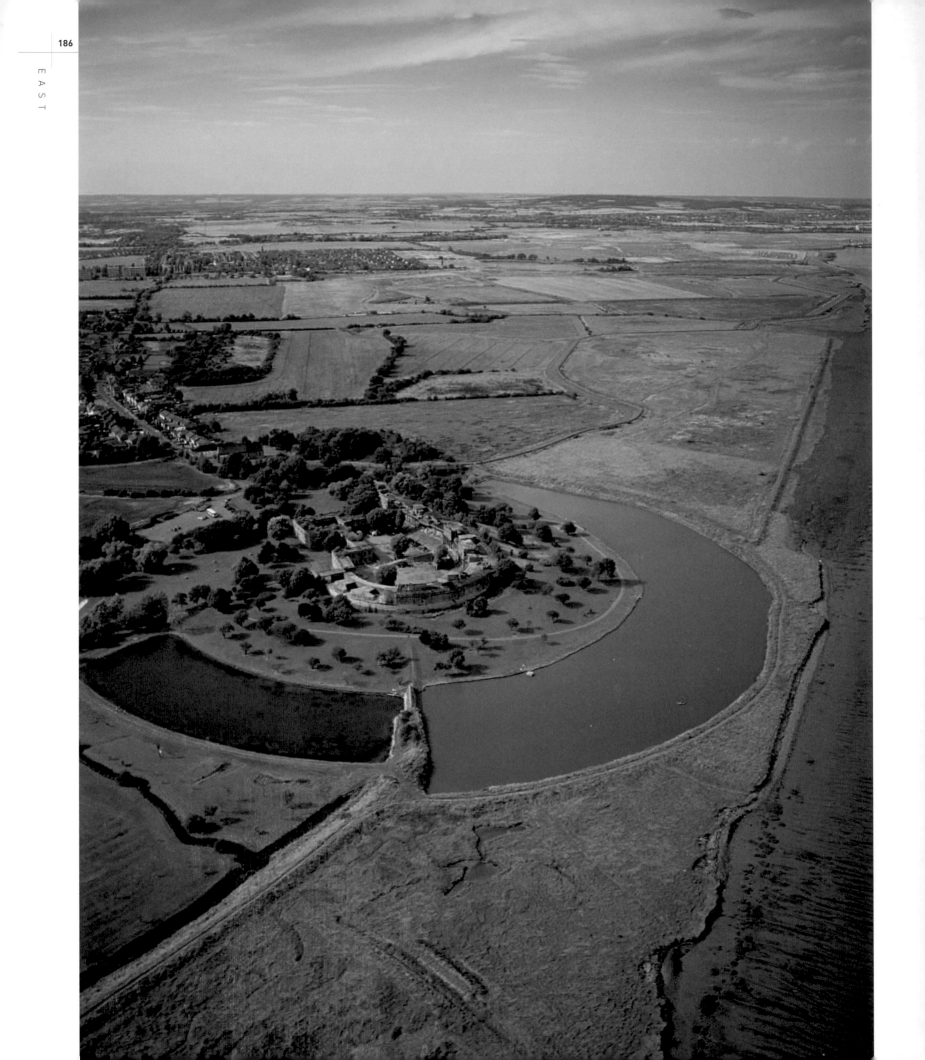

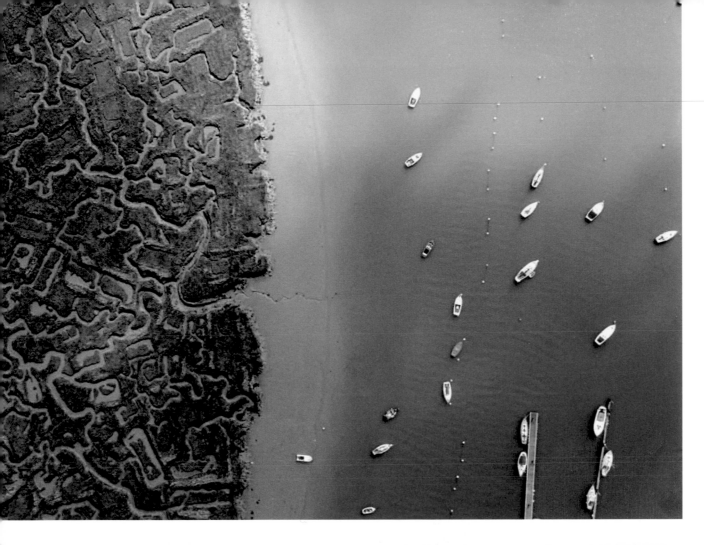

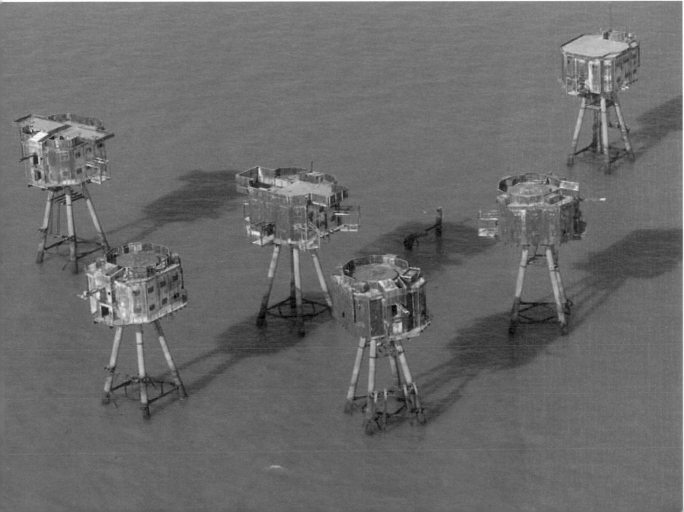

Opposite Coalhouse Fort, close to the Thames and the port of Tilbury, is a well-preserved example of a 'Palmerston Fort' – a group of fortifications built in the Victorian period at the suggestion of Prime Minister Lord Palmerston as a defence against invasion by the French.

Top left The Essex coast's watery answer to Hampton Court Maze ... part of the salt marsh on the massive Blackwater Estuary, the largest in Essex and one of the largest in the whole of East Anglia. Breeding terns visit the area in the summer months and all manner of duck, geese and wading birds spend the winter here.

Left Looming over the Thames like martian invaders from *The War of the Worlds* – these bizarre structures in the Thames Estuary off Whitstable were actually for our defence during the Second World War. Part of a series of Maunsell Army Sea Forts – the brainchild of civil engineer Guy Maunsell – they housed anti-aircraft guns and spotlights.

Picture Credits

1 Adrian Warren / lastrefuge.co.uk; 2/3 Richard Cooke / Alamy; 4, top to bottom, London Aerial Photo Library / Corbis; London Aerial Photo Library / Corbis; van hilversum / Alamy; Available Light Photography / Alamy; Photofina (Aerial) / Alamy; 5, top to bottom, Peter Barritt / Alamy; Skyscan / B Evans; The Photolibrary Wales / Alamy; Yann Arthus-Bertrand / Corbis; Richard Cooke / Alamy; 6, top to bottom, Skyscan / I Bracegirdle; Skyscan / B Lea; Skyscan / R West; Jim Richardson / Corbis; Skyscan / B Evans; 7, top to bottom, Skyscan / E Clack; Michael S. Yamashita / Corbis; Martin H Smith / naturepl.com; Chris Laurens / Alamy; David Angel / Alamy;
8 London Aerial Photo Library / Corbis; 9 Skyscan / I Bracegirdle; 10 left Skyscan / R West; 10 right Richard Cooke / Alamy; 11 left Blom Aerofilms Limited / Alamy; 11 right Skyscan / © K Dwyer; 12 left David Lyons / Alamy; 12 right Jason Hawkes / jasonhawkes.com; 13 left Available Light Photography / Alamy; 13 right Skyscan / B Evans; 14/15 London Aerial Photo Library / Corbis; 16 Skyscan / © LAPL; 17 Jason Hawkes / jasonhawkes.com; 18/19 nagelestock.com / Alamy; 20 Skyscan / B Evans; 21 Jason Hawkes / jasonhawkes.com; 22 Skyscan / D Rowland; 23 top Colin Garrat: Milepost 92 ? / Corbis; 23 bottom David Tipling / naturepl.com; 24/25 van hilversum / Alamy; 26 Photofina (Aerial) / Alamy; 27 Denny Rowland / Alamy; 28/29 Skyscan / J Farmar; 30 Denny Rowland / Alamy; 31 Jason Hawkes / jasonhawkes.com; 32/33 Skyscan / J

Farmar; 34/35 Available Light Photography / Alamy; 36 Hemis / Alamy; 37 Skyscan / B Evans; 38 Hemis / Alamy; 39 Jason Hawkes / jasonhawkes.com; 40 top Denny Rowland / Alamy; 40 bottom James L. Amos / Corbis; 41 James L. Amos / Corbis; 42 Available Light Photography / Alamy; 43 Available Light Photography / Alamy; 44/45 Photofina (Aerial) / Alamy; 46 Jason Hawkes / jasonhawkes.com; 47 Skyscan / J Farmar; 48 Jason Hawkes / jasonhawkes.com; 49 top Skyscan / J Farmar; 49 bottom Skyscan; 50/51 Skyscan / B Evans; 52 John Farmar Ecoscene / Corbis; 53 top Jason Hawkes / jasonhawkes.com; 53 bottom John Farmar Ecoscene / Corbis; 54/55 Peter Barritt / Alamy; 56 Blom Aerofilms Limited / Alamy; 57 Peter Barritt / Alamy; 58 Jason Hawkes / jasonhawkes.com; 59 Jason Hawkes / jasonhawkes.com; 60 top Jason Hawkes / jasonhawkes.com;
60 bottom Jason Hawkes / jasonhawkes.com; 61 britainonview / Eden Project; 62 Skyscan / B Evans; 63 top Skyscan / B Croxford; 63 bottom Anthony R Collins / Alamy; 64/65 Skyscan / B Evans; 66 Skyscan / B Lea; 67 Richard Cooke / Alamy; 68 Jason Hawkes / jasonhawkes.com; 69 Skyscan / © HindSight; 70 top Skyscan / B Evans; 70 bottom Richard Cookes / Alamy; 71 Skyscan / B Evans; 72/73 nagelestock.com / Alamy; 74/75 The Photolibrary Wales / Alamy; 76 britainonview / Alan Novelli; 77 Skyscan / B Evans; 78 top Robert Harding Picture Library Ltd / Alamy; 78 bottom Adam Woolfitt / Corbis; 79 top Skyscan / B Lea; 79 bottom Skyscan / W Cross; 80 Jason Hawkes / jasonhawkes.com;
81 Jason Hawkes / jasonhawkes.com; 82 top The National Trust Photolibrary / Alamy; 82 bottom Camera Lucida / Alamy; 83 Skyscan / R West; 84/85 Yann Arthus-Bertrand / Corbis; 86 David Lyons / Alamy; 87 Jason Hawkes /

jasonhawkes.com; 88 Jason Hawkes / jasonhawkes.com; 89 top David Lyons / Alamy; 89 bottom Yann Arthus-Bertrand / Corbis; 90 Skyscan / © K Dwyer; 91 Jason Hawkes / jasonhawkes.com; 92 Jason Hawkes / jasonhawkes.com; 92/93 Jason Hawkes / jasonhawkes.com; 93 left Michael Diggin / Alamy; 94/95 Richard Cooke / Alamy; 96 Jason Hawkes / jasonhawkes.com; 97 Skyscan / © K Dwyer; 98 Skyscan / © K Dwyer; 99 scenicireland.com / Christopher Hill Photography / Alamy; 100/101 Robert Mayne / Alamy; 102 top Skyscan / © K Dwyer; 102 bottom scenicireland.com / Christopher Hill Photography / Alamy;
103 scenicireland.com / Christopher Hill Photography / Alamy; 104/105 Skyscan / I Bracegirdle; 106 Skyscan / G Wright; 107 Skyscan / © M Thompson; 108 Blom Aerofilms Limited / Alamy; 109 top Skyscan / W Cross; 109 bottom Genevieve Leaper Ecoscene / Corbis; 110 Skyscan / B Lea; 111 Skyscan / © M Thompson; 112 Dae Sasitorn / ardea.com; 112/113 Skyscan / B Lea; 114/115 Skyscan / B Lea; 116 Jason Hawkes / jasonhawkes.com; 117 Jason Hawkes / jasonhawkes.com;
118 Skyscan / R West; 119 Skyscan / R West; 120 Skyscan / W Cross; 121 Skyscan / W Cross; 122/123 Skyscan / R West; 124 Richard Cooke / Alamy; 125 Jason Hawkes / jasonhawkes.com; 126 Skyscan / R West; 127 Skyscan / R West; 128 Jason Hawkes / jasonhawkes.com; 129 top David Robertson / Alamy; 129 bottom Skyscan / R West; 130 top Jean Guichard / Corbis; 130 bottom Skyscan / R West; 130/131 Skyscan / R West; 132/133 Jim Richardson / Corbis; 134 Jim Richardson / Corbis; 135 Skyscan / R West; 136 top left Skyscan / R West; 136 top right doughoughton / Alamy; 136/137 Worldwide Picture Library / Alamy;

138 Jason Hawkes / jasonhawkes.com; 139 Skyscan / © C Tait; 140/141 Jim Richardson / Corbis; 142/143 Skyscan / B Evans; 144 Jason Hawkes / jasonhawkes.com; 145 Jason Hawkes / jasonhawkes.com; 146 Richard Cooke / Alamy; 147 Skyscan / R West; 148 Jason Hawkes / jasonhawkes.com; 149 top Jason Hawkes / jasonhawkes.com; 149 bottom Jason Hawkes / jasonhawkes.com; 150 top Skyscan / R West; 150 bottom Skyscan / B Evans; 151 top Skyscan / R West; 151 bottom Skyscan / R West; 152/153 Skyscan / E Clack; 154 Jason Hawkes / jasonhawkes.com; 155 Skyscan / B Evans; 156/157 Skyscan / E Clack; 157 Jason Hawkes / jasonhawkes.com; 159 top Skyscan / © LAPL; 159 bottom Jim Gibson / Alamy; 160/161 Michael S. Yamashita / Corbis; 162 Dae Sasitorn / ardea.com; 163 Skyscan / © LAPL; 164 Skyscan / W Cross; 165 top Jason Hawkes / jasonhawkes.com; 165 bottom Jason Hawkes / jasonhawkes.com; 166/167 Skyscan / © LAPL; 168 left Skyscan; 168 right Mr.Nut / Alamy; 169 Mr.Nut / Alamy; 170/171 Martin H Smith / naturepl.com; 172 Martin H Smith / naturepl.com; 173 Blom Aerofilms Limited / Alamy; 174/175 Eric and David Hosking / Corbis; 176/177 Kevin Allen / Alamy; 178 Blom Aerofilms Limited / Alamy; 179 top Martin H Smith / naturepl.com; 179 bottom Kevin Allen / Alamy; 180/181 Chris Laurens / Alamy; 182 Skyscan; 183 Chris Laurens / Alamy; 184 Robert Harding Picture Library Ltd / Alamy; 185 Skyscan / © K Allen; 186 Jason Hawkes / jasonhawkes.com; 187 top Richard Cooke / Alamy; 187 bottom Chris Laurens / Alamy; 188 Skyscan / © LAPL; 189 Skyscan / © K Allen; 191 David Angel / Alamy.

Acknowledgements

A project like *Coast From The Air* is one that demands the efforts of many people. I'd like to say a particularly heartfelt thank you to Cameron Fitch and Shirley Patton at BBC Books/Ebury Publishing for all their help and input. I'd also like to thank picture researcher Laura Barwick and designer Bobby Birchall for making this a stunningly attractive book. Many thanks are also due to James Gill at PFD.

For Trudi, Evie and Archie.

Neil Oliver

Below A wave-beaten arm of rock topped by the remains of an Iron Age hillfort shelters the hamlet of Porth Dinllaen, on the Llyn Peninsula. Rising on the horizon in the background is another hillfort – the 5-hectare site of Garn Fadryn.

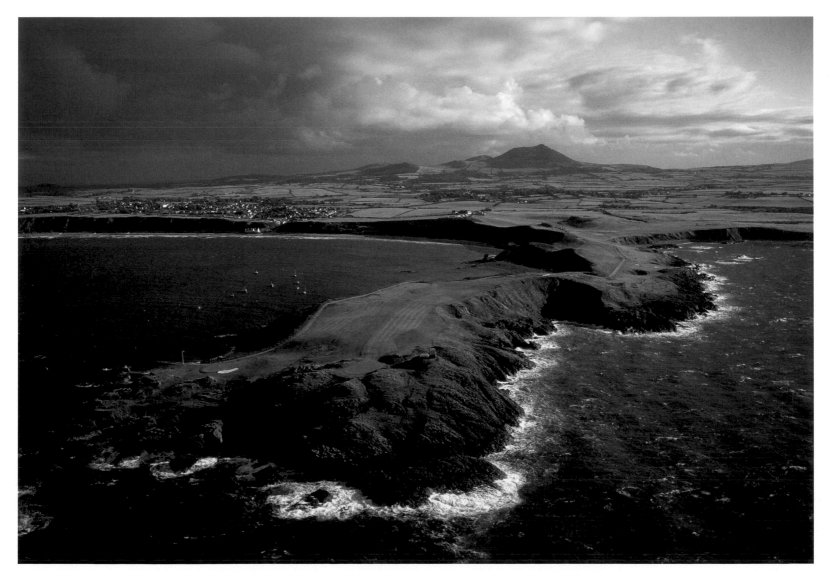

This book is published to accompany the television series entitled
Coast, first broadcast on BBC2 in 2006.

10 9 8 7 6 5 4 3 2 1

Published in 2007 by BBC Books, an imprint of Ebury Publishing.
A Random House Group Company.

The Random House Group Limited Reg. No. 954009

Addresses for companies within the Random House Group can be
found at www.randomhouse.co.uk

A CIP catalogue record for this book is available from the British
Library.

ISBN 978 1 84607 266 6

The Random House Group Limited supports The Forest
Stewardship Council (FSC), the leading international forest
certification organisation. All our titles that are printed on
Greenpeace approved FSC certified paper carry the FSC logo.
Our paper procurement policy can be found at
www.rbooks.co.uk/enviroment.

Commissioning editor: Shirley Patton
Project editor: Cameron Fitch
Copy editor: Tessa Clark
Designer: Bobby Birchall, Bobby&Co Design
Picture researcher: Laura Barwick
Production: David Brimble

Set in Din
Printed and bound by Firmengruppe APPL, aprinta Druck,
Wemding, Germany
Colour separations by GRB Editrice Ltd. London